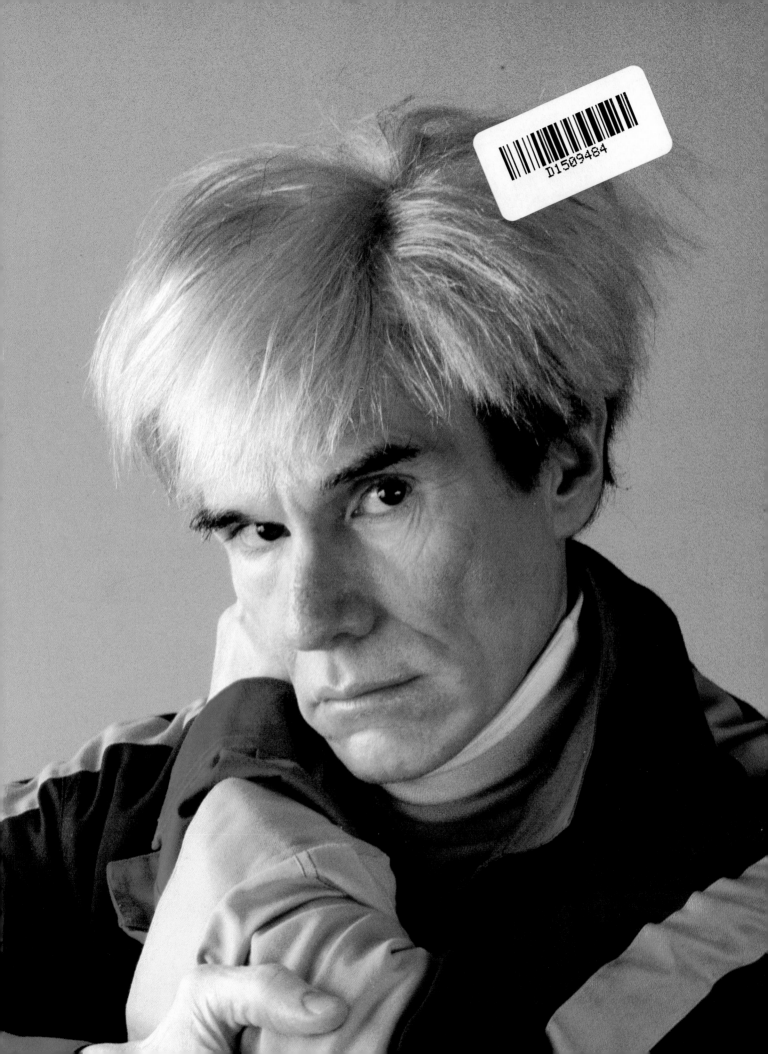

Andy Warhol

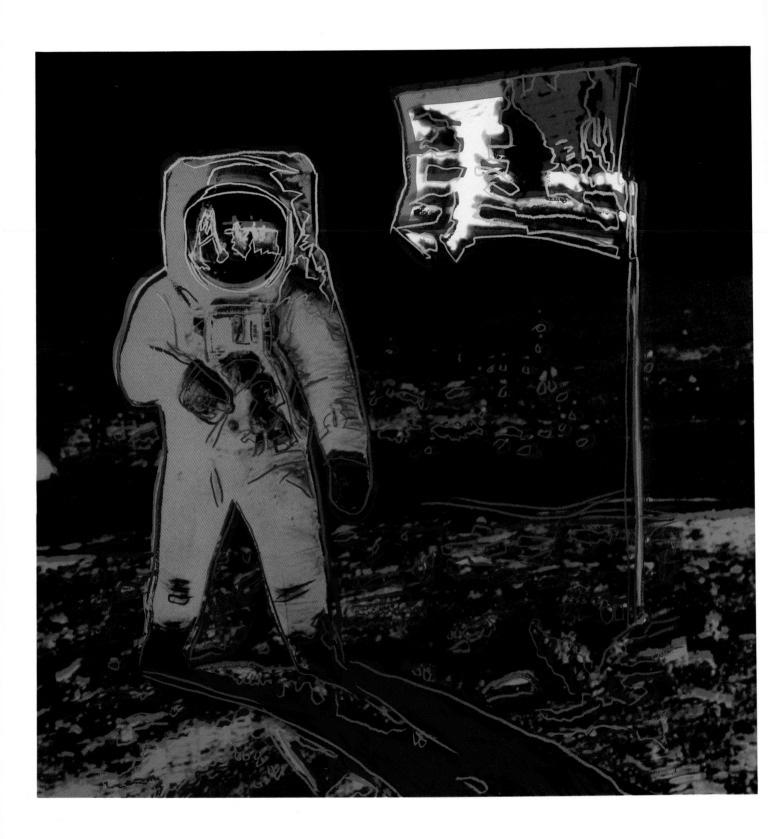

Moonwalk, 1987
Silkscreen on museum board, 38 x 38 in.
Courtesy Ronald Feldman Fine Arts, New York

MODERN MASTERS SERIES

Andy Warhol

Carter Ratcliff

ABBEVILLE PRESS · NEW YORK

Andy Warhol is volume four in the Modern Masters series.

Art director: Howard Morris
Designer: By Design
Editor: Nancy Grubb
Production manager: Dana Cole
Picture researcher: Doreen Maddox
Chronology, Exhibitions, Public Collections, and Selected Bibliography
compiled by Anna Brooke

FRONT COVER: *Marilyn*, 1964. Plate 82.

BACK COVER: *Lifesavers*, 1985. Screenprint, 38 x 38 in. Courtesy Ronald Feldman
Fine Arts, New York.

END PAPERS: Andy Warhol, 1983. Photographs by Christopher Makos.

Marginal numbers in the text refer to works illustrated in this volume.

Library of Congress Cataloging in Publication Data

Ratcliff, Carter.
 Andy Warhol.

 (Modern masters series)
 Bibliography: p.
 Includes index.
 1. Warhol, Andy, 1928– . I. Title. II. Series.
N6537.W28R37 1983 760'.092'4 83-3835
ISBN 0-89659-385-1
ISBN 0-89659-386-X (pbk.) ISSN 0738-0429

Fourth printing

Contents

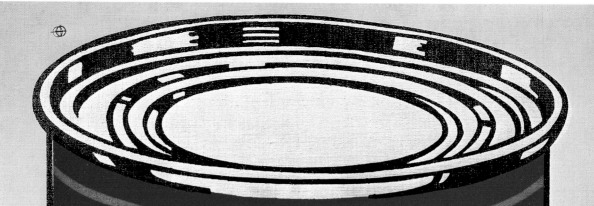

Introduction

Andy Warhol's soup cans and Claes Oldenburg's hamburgers, Roy Lichtenstein's comic-book panels and James Rosenquist's mock billboards—these Pop art images leaped directly from the sprawling, vacuous expanses of America's consumer culture to the precincts of high aesthetic seriousness. And, of course, much of the art world was horrified. Serious painting and sculpture had offered, among much else, a refuge from hamburger joints and girlie magazines, and, more generally, from the pressures of advertising, the movies, and television. When Pop art appeared in the early 1960s, a second generation of Abstract Expressionists was just hitting its stride, preparing a full-scale assault on the aesthetic heights occupied by Willem de Kooning, Jackson Pollock, Barnett Newman, and others. Pop art was widely taken as an insult to the hopes and values of these artists and to the modernist tradition they were trying to sustain.

It was bad enough that Andy Warhol dared to present an image of Dick Tracy as a work of art. It was even worse that certain critics were prepared to take such paintings seriously, among them Gene R. Swenson of *Artnews* and the art historian-critic Robert Rosenblum. Worse still, Pop art was recruiting practitioners at an alarming rate. By the middle of the 1960s, images of banal objects were commonplace in ambitious art. Aggressively self-expressive abstraction came to look old-fashioned. The most stylish nonfigurative work of the 1960s had a chilly, hard-edged look that critics eventually agreed to call Minimal. Opposed to Pop art in many ways, Minimalism shared with it a cool, impersonal look—an air of detachment. It seemed, around 1965, that the painterly warmth, the expressive passion, of the previous decade was utterly defeated. Pop art had led the assault, and Warhol looked more and more like its leading strategist. Then, in 1965, he announced that he was a "retired artist" and that he would now devote himself to making movies. There was something Garboesque about this sudden decision to abandon an audience clamoring for his paintings of soup cans and his Brillo-box sculpture; and there was a kind of logic in the way Warhol's movies drifted toward parodies of Hollywood

1. *Campbell's Soup Can*, 1964
Silkscreen on canvas, 35¾ x 24 in.
Courtesy Leo Castelli Gallery, New York

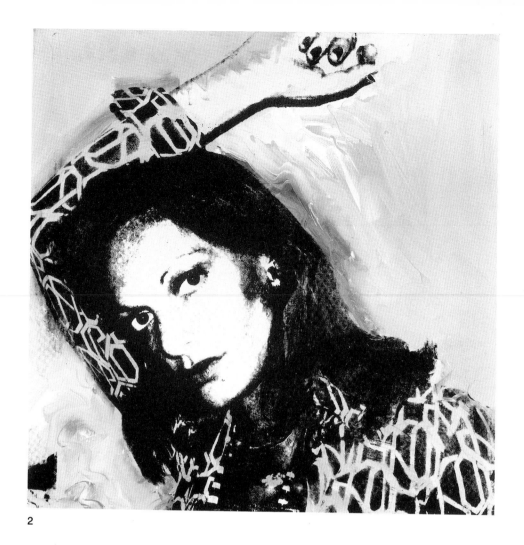

2

excess—improvisatory extravaganzas featuring such underground "superstars" as Brigid Polk, Edie Sedgwick, and Viva. Warhol himself became a star, a culture hero, as he elaborated his obsession with stardom. His abiding subject has been glamour and how to generate it. He doesn't so much create images as seek them out, ready-made and shimmering with allure. Then he intensifies that shimmer.

Andy Warhol may well be America's best-known artist. Only such figures as Norman Rockwell and Andrew Wyeth provide him any competition, while on the international scene, his aura rivals that of Salvador Dali. None of this is to say that Warhol is widely loved. Rather, he keeps the spotlight on himself by preserving the controversy that surrounded all of Pop art when it first appeared two decades ago. While Roy Lichtenstein is now recognized as a refined, ironic, serious manipulator of found images, Warhol has refused to redeem the mundane side of his art. Thus the respect accorded to him by international museums continues to outrage much of the public. In the 1970s, when Warhol turned for subject matter to the worlds of fashion and show business, he gave his bravura portrait style strong overtones of crassness—even vulgarity. He is ruthless in exposing the machinery of glamour, yet he refuses to stand in judgment. This is not his only refusal. Warhol adamantly declines to make his art a vehicle of self-revelation. We

2. *Diane von Furstenberg*, 1974
Acrylic and silkscreen on canvas, 2 panels,
each 40 x 40 in.
Diane von Furstenberg

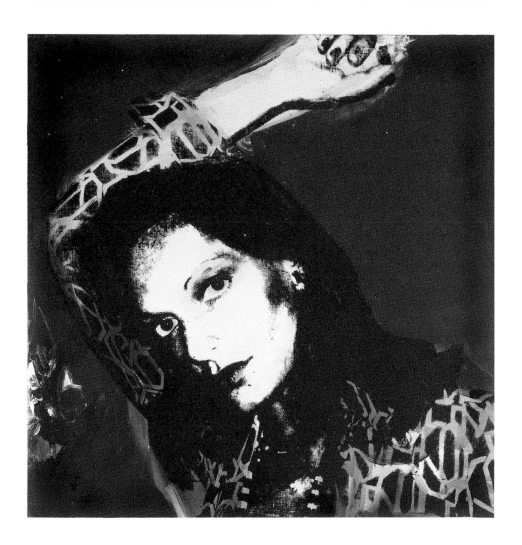

know what fascinates him, but never exactly why. This puts him in strong contrast to, say, Claes Oldenburg, who has made consumer objects into surrogate selves of a powerfully, sometimes embarrassingly expressive kind.

An artist's motives are always obscure, even if he is given to self-analysis. In *The Philosophy of Andy Warhol* (1975), *Andy Warhol's Exposures* (1979), and *POPism* (1980), Warhol talks a great deal about himself, but only in that flat, sometimes faintly mocking manner that has become his trademark—and a conversational style basic to the American social repertoire of the late twentieth century. Like his paintings, his autobiographical ramblings are filled with facts, empty of revelations. "If you want to know all about Andy Warhol," he said in 1968, "just look at the surface of my paintings and films and me, and there I am. There's nothing behind it."[1] This, we assume, is not true. In fact, we tend to believe that the more an individual, an art form, even a culture insists on its outward image, the more there is going on behind it. The seemingly absolute impenetrability of Warhol's surfaces is what gives him and his art their persistent interest. We are drawn by what stays hidden, all the more so because Warhol's Pop imagery seems to veil something basic—perhaps disturbing—about our culture, about us. Since there is no question of revealing this secret directly, we must gather what we can from the surface of the artifacts he is willing to provide us.

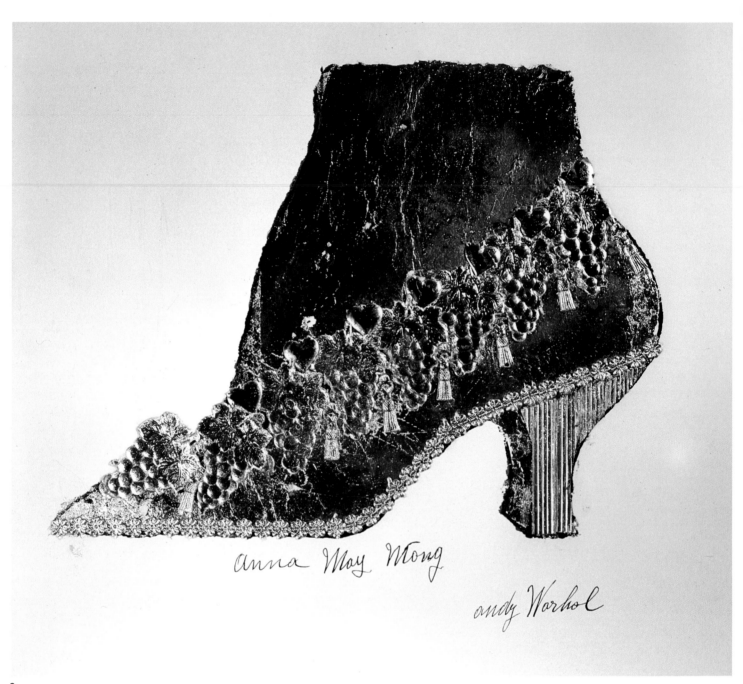

anna May Wong

andy Warhol

3

1 Pre-Pop

Over the years, Warhol has said—or let interviewers believe—that he was born in Cleveland, Philadelphia, and Pittsburgh. According to a birth certificate reproduced by Jean Stein and George Plimpton in *Edie: An American Biography*, the artist was born on September 28, 1930, in Forest City, Pennsylvania, a small town northeast of Scranton. (Warhol insists that the birth certificate is a forgery.) He is listed as "Andrew Warhola." The surname is Czechoslovakian. "When I think of my high school days," he says, "all I can remember, really, are the long walks to school, through the Czech ghetto with the babushkas and overalls on the clotheslines, in McKeesport, Pennsylvania. I wasn't amazingly popular, but I had some nice friends. I wasn't very close to anyone, although I guess I wanted to be, because when I would see the kids telling one another their problems, I felt left out."[2] McKeesport is an industrial town at the fork of the Monongahela and the Youghiogheny rivers. The nearest big city is Pittsburgh. Warhol has never said when his family moved from the Scranton area to western Pennsylvania, so we don't really know where he suffered the "three nervous breakdowns" of his childhood—"One when I was eight, one at nine, and one at ten. The attacks—St. Vitus Dance—always started on the first day of summer vacation. . . . I would spend all summer listening to the radio and lying in bed with my Charlie McCarthy doll and my un-cut-out cut-out paper dolls all over the spread and under the pillow."[3] A friend from the 1960s remembers Warhol telling her that he began drawing then, "copying the Maybelline ads of Hedy Lamarr."[4]

Andy's father, Ondrej Warhola, had emigrated from Czechoslovakia to the United States in 1912. Though he found work in the Pennsylvania coal fields, he wasn't able to send for his wife, Julia, until 1921. Warhol remembers that his father was frequently away on business trips to the coal mines, so he didn't see much of him. He and his mother, though, were close—in fact, she lived with him in Manhattan for nearly thirty years. When Andy was a boy, she would read to him "in her thick Czechoslovakian accent as best she could and I would always say 'Thanks, Mom,' after she finished with Dick Tracy, even if I hadn't understood a word. She'd give me a Hershey Bar every time I finished a page in my coloring book."[5]

3. *Anna May Wong*, c. 1956
Gold and silver leaf on paper, 13 x 10½ in.
Collection of Richard Holmes

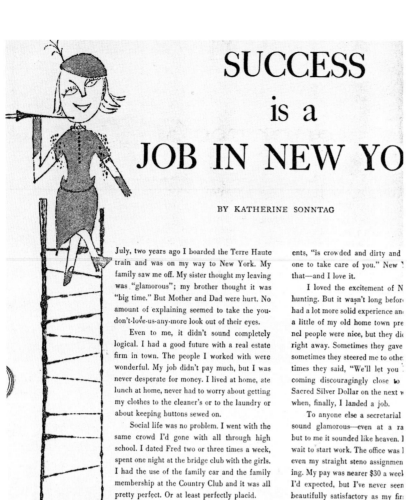

SUCCESS

is a

JOB IN NEW YO

July, two years ago I boarded the Terre Haute train and was on my way to New York. My family saw me off. My sister thought my leaving was "glamorous"; my brother thought it was "big time." But Mother and Dad were hurt. No amount of explaining seemed to take the you-don't-love-us-any-more look out of their eyes.

Even to me, it didn't sound completely logical. I had a good future with a real estate firm in town. The people I worked with were wonderful. My job didn't pay much, but I was never desperate for money. I lived at home, ate lunch at home, never had to worry about getting my clothes to the cleaner's or to the laundry or about keeping buttons sewed on.

Social life was no problem. I went with the same crowd I'd gone with all through high school. I dated Fred two or three times a week, spent one night at the bridge club with the girls. I had the use of the family car and the family membership at the Country Club and it was all pretty perfect. Or at least perfectly placid.

But after ten months, I was squirming. I loved my family, our house and the town. But none of it was really mine—even my job belonged in part to Dad who'd helped me get it. All through college I'd dreamed of a New York career. When I found myself getting edgy with everybody back home, I made reservations and took the train.

"New York," said my par-

ents, "is crowded and dirty and one to take care of you." New that—and I love it.

I loved the excitement of N hunting. But it wasn't long befor had a lot more solid experience an a little of my old home town pre nel people were nice, but they di right away. Sometimes they gave sometimes they steered me to othe times they said, "We'll let you coming discouragingly close to Sacred Silver Dollar on the next w when, finally, I landed a job.

To anyone else a secretarial sound glamorous—even at a ra but to me it sounded like heaven. wait to start work. The office was even my straight steno assignmen ing. My pay was nearer $30 a weel I'd expected, but I've never seen beautifully satisfactory as my fir This time, I felt, it *really* was min informed by Special Delivery, w (Mother still cherishes the belio lunch every day with Don Amec was I. I'd come to the Big City job—on my own.

At first, I was too busy sigh lonely. My legs still ache at the of the Statue of Liberty. But bei to Charles Boyer the (Continued

DRAWINGS BY WARHOL

4

After high school, Warhol entered Carnegie Institute of Technology in Pittsburgh. It was September 1945, and the school was filled with returning veterans, among them Philip Pearlstein, now a leading realist painter. "I got to know Andy pretty well," says Pearlstein. "He would come over to my house to work because he didn't have room at home. There were some nieces and nephews who wouldn't let him work in peace, and they'd destroy his work. His [two] brothers made fun of him—they thought he was strange because he was doing art."[6] Warhol had trouble at Carnegie, chiefly in his academic courses. Nonetheless, he got through his four years on schedule, graduating in June of 1949 with hopes of becoming an art teacher in the public schools.

During the summers he had worked at the Joseph Horne depart-

ment store in Pittsburgh. Part of his job was to arrange window displays. He also looked "through *Vogues* and *Harper's Bazaars* and European fashion magazines for a wonderful man named Mr. Volmmer." Warhol says he "got something like fifty cents an hour, and my job was looking for 'ideas.' I don't remember ever finding or getting one."[7] But, Pearlstein recalls, the fashion magazines "gave him a sense of style and other career possibilities [besides teaching]. So I talked him into going to New York that summer of 1949. He said he wouldn't go unless I went, he just didn't feel secure enough. We each had a couple of hundred dollars."[8]

Settling in with Pearlstein for a stay that would last about eight months, Warhol began showing his portfolio to Manhattan art directors. In a time when aspiring commercial artists presented themselves in suits and ties, Warhol was shabby in sneakers, chino pants, and a shirt open at the neck. His portfolio was a brown paper bag. And he was shy, excruciatingly so. He nevertheless made attempts to ingratiate himself with secretaries, assistant art directors, anyone who could help him. It was his work that seems to have opened doors the widest. That first summer in New York, Tina Fredericks of *Glamour* magazine gave Warhol an assignment—illustrations for an article called "Success Is a Job in New York." He also did a one-page spread showing women's shoes. These early shoe drawings have a reticent elegance, quite fittingly so, for the subject is a line of sensible-looking pumps with low heels. Warhol was capable from the outset of hitting the right note.

Warhol's earliest published drawings show a device that was to serve him well throughout his commercial art career of the 1950s—a tentative, blotted ink line produced by a simple monotype process. First he drew in black ink on glazed, nonabsorbent paper.

4. *Success Is a Job in NY*, 1949
Courtesy GLAMOUR. Copyright © 1949 (renewed 1977) by the Condé Nast Publications Inc.

5. *Two Children*, c. 1953
India ink transfer on paper, 23 x 29 in.
Kupferstichkabinett Basel

5

Then he would press the design against an absorbent sheet. As droplets of ink spread, gaps in the line filled in—or didn't, in which case they created a look of draftsmanly spontaneity. This is very much an effect, a premeditated sign of improvisatory heat—expressionist calligraphy brought to heel by the demands of commercial illustration. Warhol had a virtuoso's control of this method, and art directors of the 1950s found it adaptable to nearly any purpose. In 1951 Warhol made a picture for CBS Radio's advertisement of a report on crime. It shows a young man shooting himself up with heroin. Here the broken, blobby line reads as anguished sensitivity. On a 1955 album jacket, for RCA Victor's recording of Ravel's *Daphnis and Chloe*, the same line generates an air of pastoral refinement.

When Warhol left the Pearlstein's apartment, he ended up in a basement apartment at 103rd Street and Manhattan Avenue, which he remembers as "more or less an Art Commune," filled with young men and women all new in the city and all ambitious. Warhol made few friends, for he worked even harder than the others. During the day, he made the rounds of editorial offices. Evenings were for parties and making contacts. Late nights he spent on his assignments. The "Art Commune" broke up when the landlord announced the building would be torn down. Warhol moved to a cold-water flat in the east seventies, then to a duplex on Lexington Avenue between Thirty-third and Thirty-fourth streets. At some point in these migrations (no one, including Warhol himself, is clear about when), the artist's mother arrived at his door and announced, as he recalls, that she had come to live with "my Andy." Warhol "thought she'd get tired of the city pretty quick and miss Pennsylvania and my brothers and their families. But as it turned out, she didn't, and that's when I decided to get [a] house uptown"—a four-story townhouse at the corner of Lexington and Eighty-seventh Street.[9] It was the mid-1950s by now, and Warhol was on his way to the top of the commercial art world.

He was still "Raggedy Andy," the forlorn, waiflike creature in sneakers and chinos who had opened his portfolio in the offices of *Harper's Bazaar* only to see a cockroach crawl out. Warhol says he got the job anyway because the magazine's art director, Carmel Snow, "felt so sorry for me." This is unlikely. Snow and her counterparts in Manhattan's leading design offices had an immediate appreciation of Warhol's skill, and they soon learned that he could be relied upon. He met his deadlines and maintained his quality. I. Miller Shoes came to count on him almost exclusively for its ad campaigns. There were book jackets for New Directions and illustrations for Doubleday's edition of *Amy Vanderbilt's Complete Book of Etiquette*. RCA commissioned more album jackets, *Dance Magazine* gave him cover assignments, and the major fashion magazines called steadily for illustrations. And Warhol contributed to corporate image-building campaigns, with designs for the Upjohn Company, the National Broadcasting Company and others.

Around 1953 Warhol took on an agent, Fritzie Miller. Three years later he had made such an impact that the Art Directors Club gave him an Award for Distinctive Merit, for an I. Miller ad. In 1957 he received the same prize for another of his I. Miller layouts and, for

6. *Title Page for "25 Cats Name [sic] Sam,"* c. 1954
Watercolor on paper, 9⅜ x 6⅛ in.
Collection of Richard Holmes

7. *Title Page for "In the Bottom of My Garden,"* c. 1956
Watercolor on paper, 8¾ x 11⅛ in.
Collection of Richard Holmes

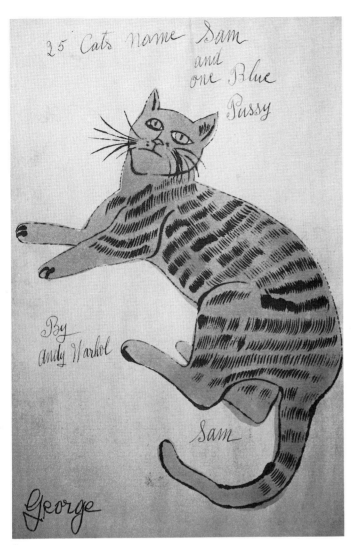

6

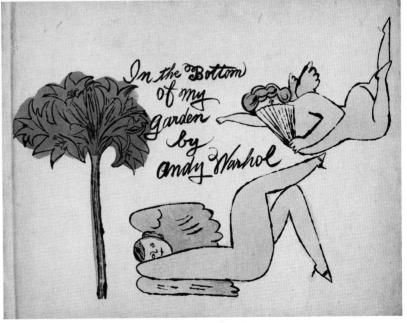

7

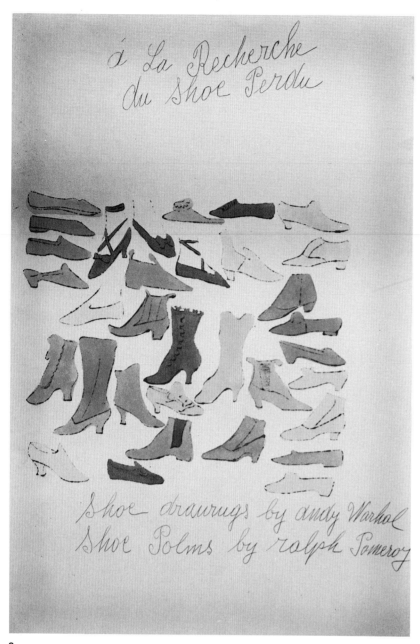

à La Recherche du Shoe Perdu

Shoe drawings by andy Warhol
Shoe Poems by ralph Pomeroy

8

still another published that year, Warhol received the Art Directors Club Medal, its highest award. At the same time he was pursuing another career as well—that of a serious artist. Here he was not so successful. In a decade dominated by the heroics of Willem de Kooning and Jackson Pollock, Warhol was showing fey, delicate ink drawings of boys and shoes and cupids.

In 1952 the Hugo Gallery presented *Fifteen Drawings Based on the Writings of Truman Capote.* Reporting in the *Art Digest,* James Fitzsimmons (later the founding editor of *Art International*) said that "Andy Warhol's fragile impressions" reminded him of "Beardsley, Lautrec, Demuth, Balthus and Cocteau. The work has an air of preciosity, of carefully studied perversity. . . . At its best it is an art that depends upon the delicate tour de force, the communi-

8. *Title Page for "A la Recherche du Shoe Perdu,"* c. 1955
Watercolor on paper, 9¾ x 13½ in.
Collection of Richard Holmes

9. *A la Recherche du Shoe Perdu,* c. 1955
Watercolor on paper, 9¾ x 13½ in.
Collection of Richard Holmes

cation of intangibles and ambivalent feelings."[10]

In the early 1960s, when Warhol set about becoming a serious, as opposed to a commercial, artist, he admired the work of Jasper Johns and Robert Rauschenberg. He had met them, even bought some of their art, yet they didn't seem to like him. A mutual friend, Emile de Antonio, explained why. "You're too swish," De said, "and that upsets them." Also, he added, Warhol was "a commercial artist, which really bugs them because when *they* do commercial art—windows and other jobs I find them—they do it just 'to survive.' They won't even use their real names. Whereas *you've* won *prizes*! You're *famous* for it!"[11] Though Warhol has never changed his personal style, he did abandon commercial art as decisively as he possibly could. The line between his first and second careers is astoundingly sharp. To make his break, he jumped from the "delicate tour de force" described by Fitzsimmons to pictorial effects of the most brutal kind. After all, Warhol exhibits a kind of cruelty when he substitutes the hard-edged image of a Coke bottle or a Campbell's soup can for the confessional frenzies of an Action painter. It was an extraordinary tactic, and a long time in making its appearance.

Throughout the 1950s, Warhol continued to show his personal work in Manhattan galleries, and it continued to get respectful, faintly bored reviews. Writing for *Artnews* in 1956, Parker Tyler said of Warhol's whimsical drawings of shoes, that "smothered in 3

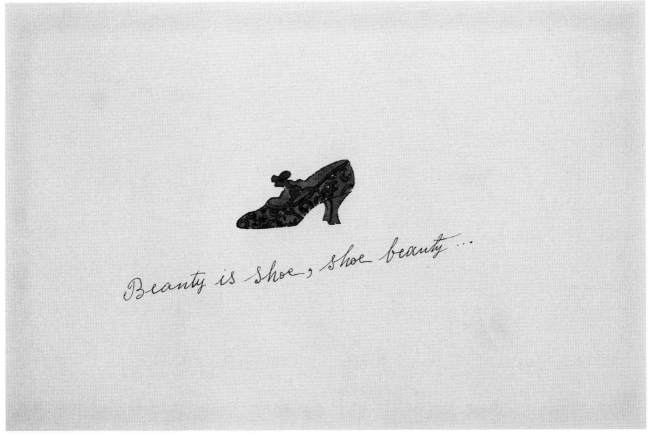

9

gold-leaf and decorative commercial cutouts in gold (tassels, cupids, conventional borders), they have an odd elegance of pure craziness. If one doubted they were fetishes, his doubt would be dispelled by noticing that an evening slipper is inscribed to Julie Andrews and a boot to James Dean."[12] In fact, each of the entire batch of shoes bore a star's name. In January 1957, *Life* magazine reproduced the lot, thus excusing New York critics from any careful consideration of Warhol's art.

Many of Warhol's drawings never made their way to the walls of Manhattan galleries, much less the pages of national magazines. These were the greeting cards, portrait sketches, and book illustrations he made for friends. *Love Is a Pink Cake* appeared in 1953, with Warhol's drawings accompanying limericklike verses by Ralph Ward. The subject is famous couples from myth and history—Napoleon and Josephine, Daphne and Apollo. Ward's tone is coy and suggestive. Warhol, perhaps in response to the stature of these personages, has firmed up his line so that it reads as a sly takeoff on Neoclassical clarity. The next year Warhol designed a book called *Twenty-five Cats Name* [sic] *Sam and One Blue Pussy*, with a text by Charles Lisanby. Other book subjects were cupids and elves (*In the Bottom of My Garden*, c. 1956) and joke recipes (*Wild Raspberries*, 1959, with Suzie Frankfurt).

Sometime in the middle of the 1950s, Warhol adapted his I. Miller illustrations to a series of "shoe-poems" by Ralph Pomeroy. Most of these are one-liners of an exceedingly arch nature: the penultimate line of Keats's "Ode on a Grecian Urn," for example, becomes "Beauty is shoe, shoe beauty." In these drawings, the impersonal elegance of Warhol's ad graphics becomes, if not quite personal, at least quirky. Once again, his touch fits the occasion without telling us much about Warhol himself, save that his sense of style is extraordinarily acute. And his energy never flagged. There were only about one hundred copies of *A la Recherche du Shoe Perdu*, as Pomeroy and Warhol called their collaboration. Nonetheless, it was a formidable job to produce that many copies of a fourteen-plate booklet by hand, as Warhol did. His blotting method helped, for it provided him with a hand-scale equivalent of a printing press. Further, it allowed him to recruit others to do much of the unskilled labor required by the project, as he would do again when he became a Pop artist. The controversies over who actually made certain of Warhol's silkscreen-on-canvas paintings originated during those evenings in the 1950s when he and a batch of his friends would gather together to put out an edition of some fey little book.

Warhol's personal efforts in this early period are sophisticated yet minor. Meaning resides in the subtlest of verbal and visual nuances, many of which have utterly faded by now. His commercial work stands up better, if only because it is not so precious, though it too seems very distant. For an entire decade, even a bit more, Warhol put an astounding amount of energy and refinement into work of the most perishable nature. At some point during the middle of the 1950s, he seems to have caught glimpses of the possibility that fine art possessed staying power. Painting, not mere illustration, could lift him out of time and its seasons, and offer a place in history. In

10. *Wild Raspberries*, 1959
Watercolor on paper, 17½ x 11¼ in.
Collection of Richard Holmes

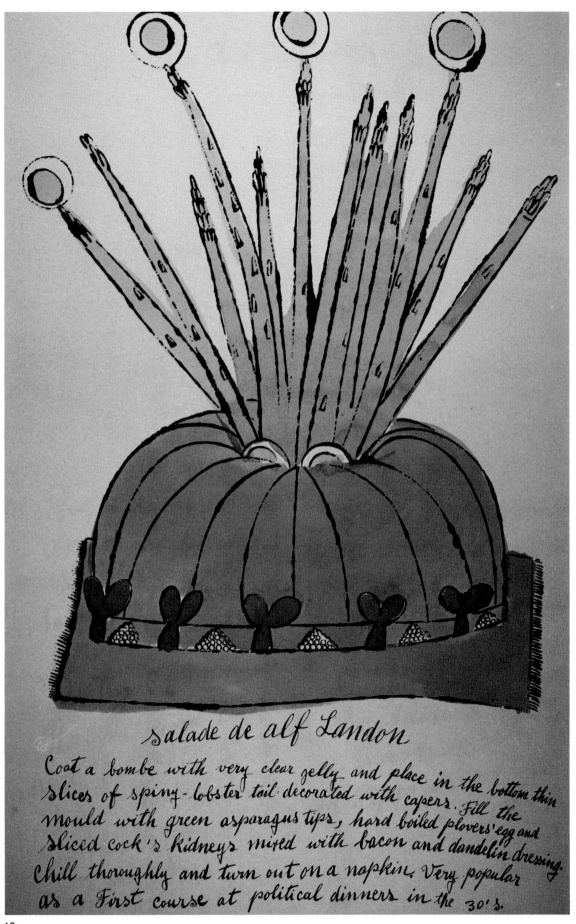

salade de alf Landon

Coat a bombe with very clear jelly and place in the bottom thin
slices of spiny-lobster tail decorated with capers. Fill the
mould with green asparagus tips, hard boiled plovers' egg and
sliced cock's kidneys mixed with bacon and dandelin dressing.
Chill thoroughly and turn out on a napkin. Very popular
as a First course at political dinners in the 30's.

1956 Warhol's friend Charles Lisanby, a television set-designer, said he was planning a trip around the world. Hearing of the project, Warhol said he wanted to come along. Lisanby agreed, and in June they left San Francisco for the Far East. Japan, Hong Kong, Indonesia, Southeast Asia—they trekked through them all, until Lisanby came down with a fever and they booked a flight from India to Rome. There Lisanby recuperated, and they traveled on to Florence, where Charles "insisted on Andy's going to every church and museum, and Andy seemed to enjoy that. Andy's reactions to art were never very verbal. Faced with a Titian or a Botticelli he might produce a mild 'Wow!' or 'Great,' but that would be the end of it. Lisanby once asked him what he really wanted out of life, and Andy replied, rather memorably, 'I want to be Matisse.' Lisanby interpreted this to mean that he wanted to be as famous as Matisse, so that anything he did would be instantly marvelous."[13] Commercial art produces a high income and wins prizes at the Art Directors Club, but serious art gives an artist an aura. It makes him a star.

Within a few seasons, Warhol had begun his unsuccessful attempt to become friends with Johns and Rauschenberg, the hottest young art-stars in town and almost the only ones to offer any challenge to the prevailing style of Abstract Expressionism. In 1953, Rauschenberg had purchased a de Kooning drawing, and then, with the older artist's perplexed permission, erased it. Rauschenberg presented this erasure as a gesture as creative, in its way, as any Action painter's assault on a canvas. Meanwhile, Johns had developed a chilly, premeditated version of the Abstract Expressionist brushstroke, which he put to work on images of American flags, alphabets, sets of numbers, and other preformed subjects. In place of painterly heat, painterly ice; instead of the self revealed, plaster fragments of the body in small cubicles above the black, blue, and red target of Johns's *Target with Four Faces* (1955). So long as de Kooning, Pollock, and company had dominated the Manhattan gallery world, Warhol could operate only on its periphery. Now Johns and Rauschenberg were suggesting that the aesthetic topography was shifting. Warhol's clever shoes and cupids would always be peripheral, but it might be possible to establish a new center. He began to buy modestly priced works by contemporary artists. And the pictures he made for himself started to change.

In 1961 Ivan Karp was working as director and talent scout for the Leo Castelli Gallery. He remembers Warhol negotiating with him over a drawing of a light bulb by Jasper Johns, and eventually buying it for three hundred fifty dollars. Warhol "was very reticent and shy: he seemed extremely perceptive about what was going on in the art world. He asked me if there was anything else of unusual interest in the gallery. I took out a painting by Roy Lichtenstein to show him. It was a painting of a girl with a beach ball held over her head. . . . Andy, looking at it, said in shock, 'Ohhh, I'm doing work just like that myself.' "[14] Karp agreed to come to his studio for a look. Warhol showed him paintings of cartoon subjects, some done in a messy, Abstract Expressionist manner, others treated more cleanly and coldly. Karp said he preferred the latter, echoing a judgment already made by Warhol's friend Emile de Antonio. De had said of this hard-edged imagery that "it's our society, it's who

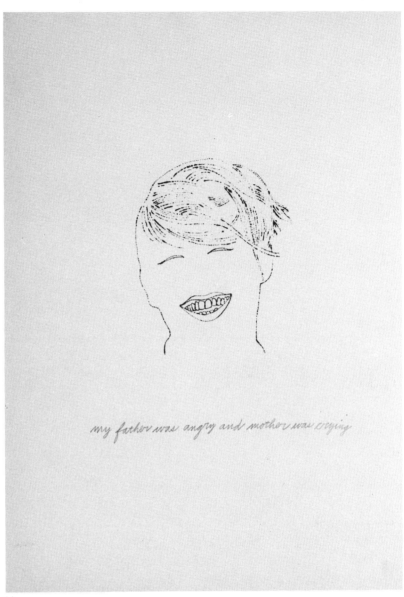

my father was angry and mother was crying

11

11. *There Was Snow in the Streets*, c. 1952
India ink transfer on paper, 11 x 8½ in.
Collection of Richard Holmes

we are, it's absolutely beautiful and naked."[15] He saw the future of American art in Warhol's impersonality. But the art world had no place for the artist himself. Leo Castelli was the only dealer willing to show what very soon came to be known as Pop art, and he had already taken on Roy Lichtenstein with his comic-book paintings. There was no room on the roster for Andy Warhol.

It is not and perhaps never will be known whether Lichtenstein or Warhol was the first to displace commercial images intact from the media to modernist painting. Neither artist has claimed priority, much less hinted that the other stole the idea from him. In *POPism*, Warhol recalls Henry Geldzahler's description of the early years: " 'It was like a science fiction movie—you Pop artists in different parts of the city, unknown to each other, rising up out of the muck and staggering forward with your paintings in front of you.' "[16]

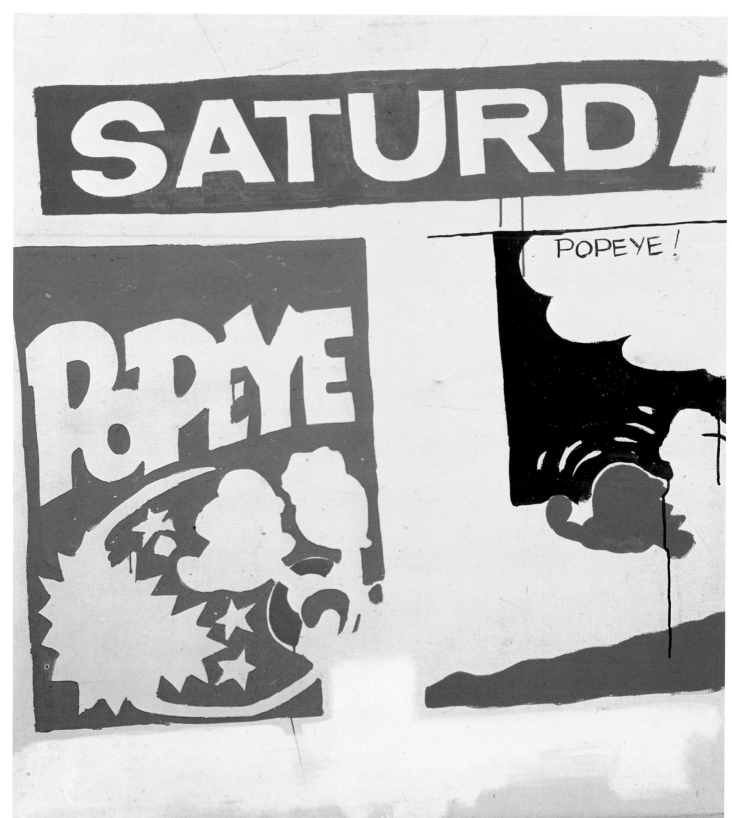

2 Pop

Roy Lichtenstein and Andy Warhol seem to have arrived independently at the same possibility. Once there, they proceeded very differently. Lichtenstein's Pop images are elegantly finished and, beneath their blatant content, offer highly sophisticated variants on formal devices long traditional to Western painting. Thus critics occasionally—and, I think, correctly—suggest that he has strong links to modernism's most refined practitioners, even to such abstractionists as Mondrian and other geometric painters of the 1930s. Blending the vulgar and the fastidious, he shows some of Jasper Johns's ironic detachment. Warhol is detached, as well, though it is always risky to impute irony to him or to his images. There is always the chance that he is correct when he says that he and his art are all surface, with nothing hidden underneath. Warhol's art may, in fact, offer the allure of absolute nothingness. Whether or not this is so, we can say with certainty that Warhol has devoted some of his image-maker's finesse to avoiding the pictorial refinement that provides Roy Lichtenstein with his oblique claim to good taste and high style.

Castelli gave Lichtenstein a show in 1962. Meanwhile, Karp and Geldzahler tried to find another gallery willing to exhibit Warhol's Pop images. The New York dealers all refused, in outrage or simply fearful that comic-strip characters, do-it-yourself images, and before-and-after pictures of nose jobs were not the stuff of high art. As a consequence, Warhol's earliest Pop paintings were never seen in galleries, surfacing only in museum surveys of his work. The first of these was in 1965, at Philadelphia's Institute of Contemporary Art—only a few seasons after these first canvases were painted and yet, in the speeded-up calendar of the 1960s, this passage of time was enough to give these early works a dated look. *Saturday's Popeye* (1960), for instance, never had a chance to look brand new in public, yet it is basic to the development of American Pop art.

Warhol has taken a fragment of the funny papers—one and a half Popeye panels, plus a portion of a logo—and reduced it to patterns of black and white and red and blue. These forms drift at an angle on an expanse of unprimed canvas. The subject was ready-made, the treatment has a familiar starkness, yet Warhol permits himself

12. *Saturday's Popeye*, 1960
Acrylic on canvas, 42¾ x 39 in.
Courtesy Galerie Bischofberger, Zurich

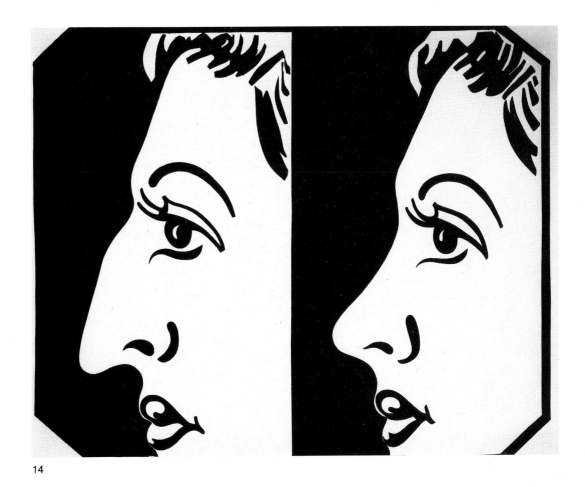

14

13. *Dick Tracy*, 1960
Casein on canvas, 70⅛ x 52½ in.
Private collection

14. *Before and After III*, 1962
Acrylic on canvas, 72⅛ x 99⅞ in.
Private collection

some brushy passages of white along the lower edge of the painting. The black background to the right exhibits a few drips. Warhol mocks these echoes of painterliness, '50s-style, by deploying them with cool deliberation. Likewise, a draftsmanly scrawl enlivens the surface of *199 Television* (1960) without bringing it to expressive life. Warhol demonstrates the ease with which conventions of artistic energy become illustrational devices. In his *Dick Tracy* and *Superman*, both from 1960, the demonstration continues, though the hard edges of the cartoon style have begun to dominate. Although there are still drips and smudges in the *Nancy* and *Popeye* paintings he did the following year, the completely impersonal touch of the 1962 Soup Cans and *Before & After* has nearly arrived. 13 15, 14

There are three versions of *Before & After*. All of them reproduce an illustration from an advertisement for cosmetic surgery. The woman on the left has a severely aquiline nose and, as a consequence, looks quite mature. On the right, her nose has been "corrected" and she looks girlish. Warhol has borrowed and blown up a crude style of drawing, so this can be seen as a blunt painting on the extraordinarily subtle subject of beauty. *Before & After* makes no personal revelations; it opens onto no transcendental vistas. Warhol's is an entirely earthbound sensibility. If our automatic responses to *Before & After* enmesh us in our culture's most destructive clichés about beauty, then the canvas also draws high art into that same web of banality. All the big scale and authoritative pres-

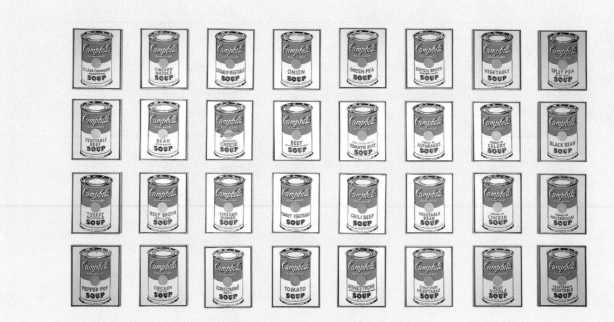

15

ence of a New York School painting can be put at the service of an empty image of physical beauty, which suggests that the line between high and low art is artificial at best. Once again, Warhol makes no judgment about this. With *Before & After*, any hint of satirical impulse disappears forever. Nor is there any point in calling such art campy—a celebration of images so bad they eventually come to look good. Camp is satire in reverse, whereas Warhol refuses to take up a point of view from which satirical gestures of any sort might be made. He is more like a still center, a mirror in front of which we and the entire culture strike our various attitudes.

As the 1961–62 season wore on, Warhol grew increasingly frantic. He still couldn't get a one-man show in New York, though the Ferus Gallery in Los Angeles exhibited a series of his Campbell's Soup Cans. The local reaction was unfavorable but hardly indifferent. Down the street from the Ferus establishment, another dealer put a stack of actual soup cans on display, with the sign, "Get the real thing for 29¢." Meanwhile, Emile de Antonio had been pressuring Eleanor Ward to give Warhol a show at her Stable Gallery in New York. As Warhol remembers it, the three of them met and, after De had asked her point-blank if she was going to take Warhol on, "She took out her wallet and looked through the bill compartment. Then she held up a two dollar bill and said, 'Andy, if you paint me this, I'll give you a show.' "¹⁷ She did, in the fall of 1962, 17, 18 after Warhol had produced a series of dollar bill paintings. The response to his first New York show was immediate and powerful. Within the Manhattan art world, at least, Andy Warhol was famous.

15. *32 Soup Cans*, 1961–62
Acrylic on canvas, 32 panels, each 20 x 16 in.
Courtesy Irving Blum, New York

16. *Handle with Care—Glass—Thank You*, 1962
Acrylic and silkscreen on linen, 82 x 67 in.
Collection Marx, West Berlin

17. *One Dollar*, 1962
Pencil on paper, 17½ x 23½ in.
Private collection

18. *80 Two-Dollar Bills*, 1962
Silkscreen on linen, 82½ x 38 in.
Wallraf-Richartz Museum, Cologne

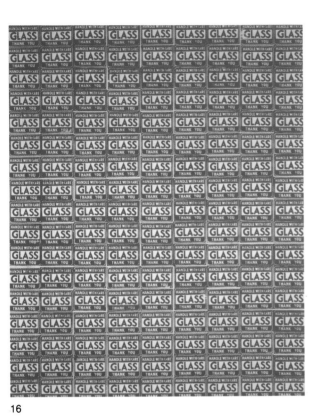

16

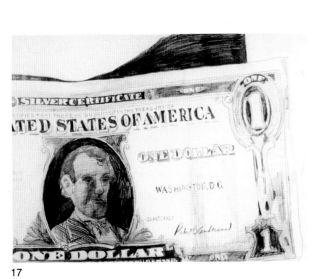

17

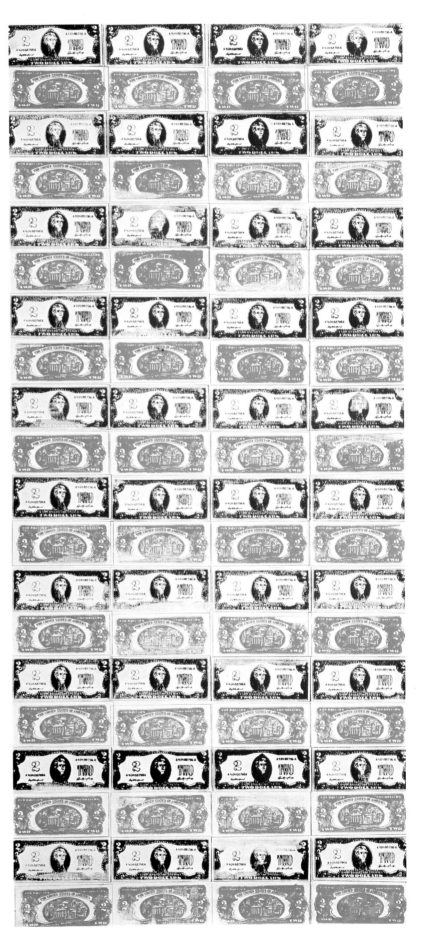

18

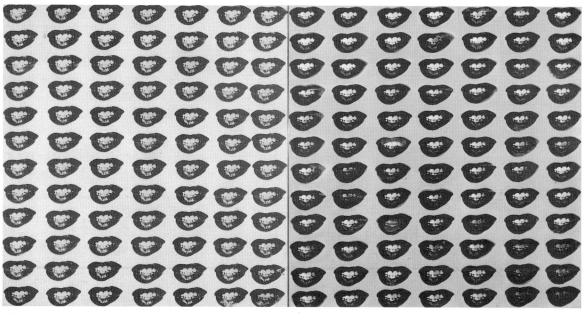

19

With its *Red Elvis* and variations on the Marilyn motif, the Stable show can be seen as an homage to fame in the larger world, though it was inevitable that critics would choose to see Warhol as a social commentator, a painter using the devices of commercial art to expose the mediocrity and exploitiveness of popular culture. Warhol can indeed help us to see such things, though most of us are able to see them for ourselves. Pop art as satire was a fiction invented by art critics to explain why Warhol or Lichtenstein or James Rosenquist would bother with popular culture in the first place. Gene R. Swenson got closer to the point, I think, in his comment on Warhol's Stable exhibition: "He simply likes the people he paints."[18] It must be understood, though, that Warhol likes best those whose images shine the brightest—better yet, those who *are* images. Warhol likes stars.

In the 1970s Warhol himself began to ascend to celebrity status. This led to meetings with such stars as Liza Minelli and Elizabeth Taylor. In 1962 he knew them only as a fan knows them, through the media. His '62 model Elvis derives from a smouldering close-up photo of the singer's face. Repeated thirty-six times in black silkscreen ink on a background of screaming red, the image loses some of its intensity; no photograph, no matter how striking, can maintain its impact under this kind of pressure. To repeat it is to empty it. Elvis's broodingly sexy expression begins to look like the thinnest of masks—and toward the top of the canvas, the ink actually does thin out, leaving grayish patches in place of the sharp black on red effect that fills the rest of the painting. Still, as the usual sort of power fades, a new one takes its place. We begin to read the thirty-six Elvises as a single form, held together by the field on which they float. Sooner or later we come to see this work not so much as a picture of Elvis as a picture of a picture, a device for making us conscious of how bluntly the images of the media assault us.

Though he has never presented his art as social criticism, Warhol offers no defense of his subject matter—nor of himself. He simply responds to demands that, it often seems, he is the first to detect.

22

19. *Marilyn Monroe's Lips*, 1962
Synthetic polymer, enamel, and pencil on canvas,
left panel: 82⅜ x 80¾ in.;
right panel: 82¾ x 82⅜ in.
Hirshhorn Museum and Sculpture Garden,
Smithsonian Institution, Washington, D.C.

20. *Big Torn Campbell's Soup Can*, 1962
Acrylic and silkscreen on canvas, 72 x 54 in.
Kunsthaus Zurich

When the Manhattan art world of the early 1960s wanted the calculated vulgarity of Pop images, Warhol's calculations were, as it turned out, the most acute. Of all the Pop artists, only he made no appeal to modernist refinement or the ideals of expressionist integrity. His pictures of soup cans, movie stars, and dollar bills refuse nearly all redeeming links to traditions of high pictorial seriousness. Thus they serve as cruelly accurate mirrors of the anxieties about its own values that the Manhattan art world was suffering that season. Perhaps expressionist anguish, explosive spontaneity, unmediated sincerity—ideals that had guided so many artists through the 1950s in New York—were unattainable. Perhaps the self wracked by Kierkegaardian fear and trembling did not have to be the primary subject of high-style painting. And so, just possibly, the deadpan of Warhol's art reflected a proper indifference to all of the previous decade's frenzied philosophizing. His coolness helped crystallize widespread doubt (often expressed as contempt), and the tactic of unflappable detachment has served him well ever since. He not only hit the right note in the early 1960s, but one that has resonated throughout his career as a painter, sculptor, film maker, and art celebrity.

Of all the Marilyns in Warhol's 1962 exhibition, the *Gold Marilyn* is the most striking. It is a series of broken taboos. First of all, the gold violates the sanctity of the monochrome field as established by such somber practitioners as Ad Reinhardt. Further, Yves Klein, the French avant-gardist, had already performed this violation. His all-gold paintings appeared in 1960, so Warhol trampled the unwritten agreement by which an artist is granted sole rights to his innovations. Next, he has violated the nonobjective severity of monochrome with a figurative image, and a debased, movie-magazine image at that. His treatment of Marilyn Monroe's face is a travesty of screen-star make-up and hairdressing, a cluster of flat, garish blocks of color that don't even correspond very closely to the details of her face. Yet we recognize her immediately, perhaps even more quickly than we do when she is given standard media treatment. There is a canniness, almost a delicacy, to Warhol's crudities, for they all serve to give an image more impact—provided, always, that his deliberate roughness doesn't offend the eye so severely that it refuses to respond.

The Marilyn variations include a tondo showing the head very large; a single panel with five rows of five faces; a diptych that doubles that format; another diptych, each panel of which bears eighty-four images of her teeth and smiling lips. And there are more. Yet Marilyn Monroe did not dominate Andy Warhol's 1962–63 season; the Campbell's soup can played that role. For those who were offended by his first New York show, this was the most outrageous image. For those who were won over, this did the most to convince them of Warhol's audacity and strength. As for the artist, he said that he painted all those soup cans because they reminded him of his childhood, when he ate Campbell's tomato soup every day. This mock-explanation served, as usual, to leave the viewer stranded with an image so clearly and bluntly what it was that all comment seemed inadequate. It was as if Warhol were encouraging his audience to be as laconic and noncommittal as he.

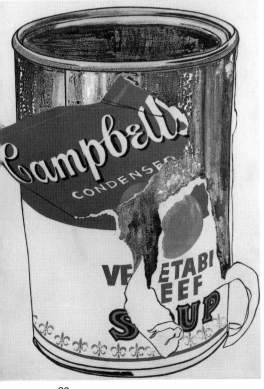
20

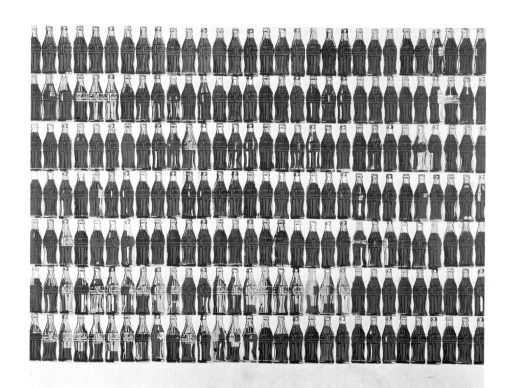

21

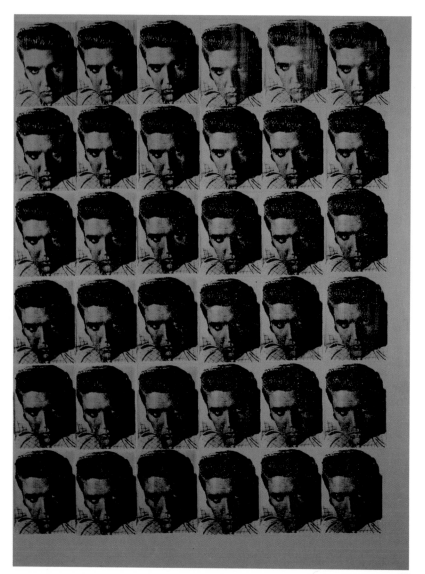

21. *210 Coca-Cola Bottles*, 1962
Oil on canvas, 82½ x 105 in.
Private collection, New York

22. *Red Elvis*, 1962
Acrylic and silkscreen on linen, 69½ x 52 in.
Courtesy Galerie Bischofberger, Zurich

23. *Gold Marilyn Monroe*, 1962
Synthetic polymer, silkscreen, and oil on canvas,
83¼ x 57 in.
The Museum of Modern Art, New York
Gift of Philip Johnson

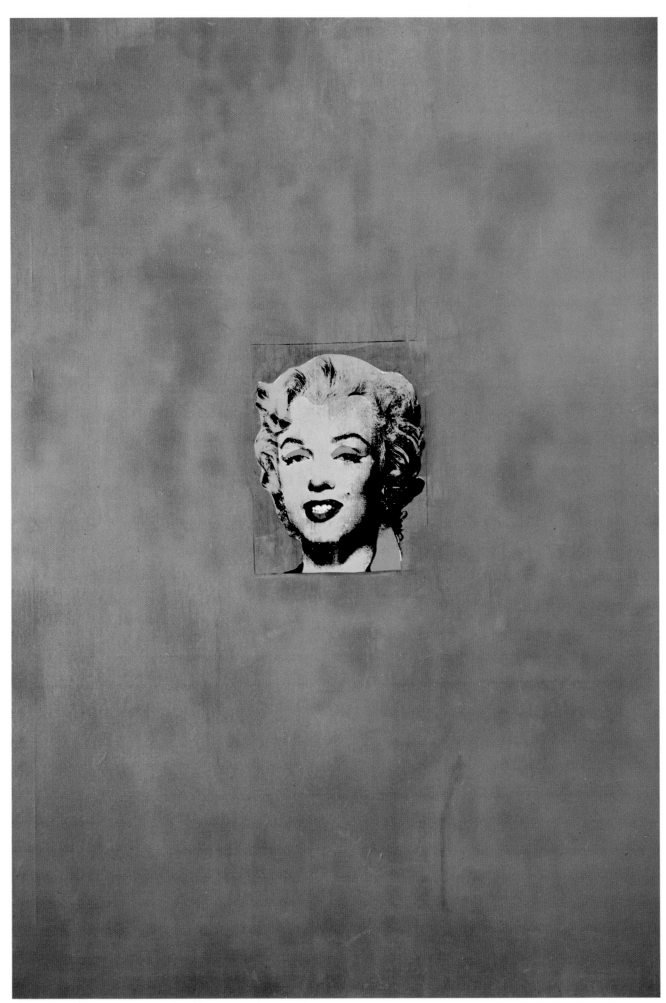

24

25

26

24. *Do It Yourself (Violin)*, 1962
Oil on canvas, 54 x 72 in.
Private collection

25. *Do It Yourself (Narcissus)*, 1962
Pencil and crayon on paper, 23 x 18 in.
Kupferstichkabinett Basel

26. *Do It Yourself (Seascape)*, 1962
Acrylic on canvas, 54 x 72 in.
Collection Marx, Berlin

What was mysterious—and remains so—is Warhol's reason for wanting to be so clear, so lucid, so relentlessly superficial.

Early in 1963 Warhol found that his townhouse studio, never very neat, had become unworkably cluttered. He set up shop in an abandoned firehouse on East Eighty-seventh Street and soon afterward hired a young poet named Gerard Malanga to help him with the silkscreen process. Early the next year he moved again, this time to a loft at 231 East Forty-seventh Street. This studio came to be known as the Factory. It attracted an extraordinary collection of art fans, hangers-on, and habitués, one of whom remembers, "When I first knew Andy they were working on the Marilyn Monroes. Malanga and Billy Name [who lived in the Factory and covered all its walls with aluminum foil] did most of the work. Cutting things. Placing the screens. Andy would walk along the rows and ask, 'What color do you think would be nice?' "[19] In the fall of 1963, Warhol had another show at the Ferus Gallery in Los Angeles—Liz Taylor instead of Marilyn Monroe, and more Elvises. "On the Elvis Presley silk screens," Gerard Malanga says, "the image appears slightly imposed over itself, maybe three or four times. That was an idea I picked up from a photographic process and in-

31

33

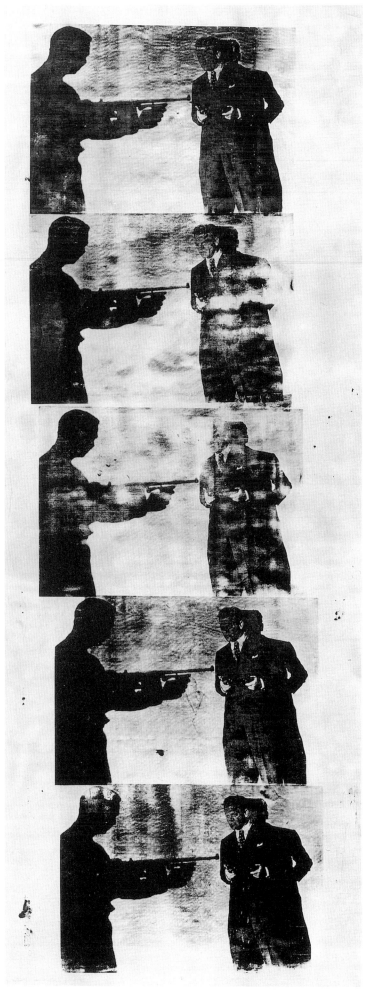

28

27. *Cagney*, 1962
Acrylic and silkscreen on canvas, 204 x 82 in.
Collection Marx, Berlin

28. *Ginger Rogers*, 1962
Pencil on paper, 24 x 18 in.
Kupferstichkabinett Basel

29. *Silver Marlon*, 1963
Acrylic and silkscreen on canvas, 70 x 80 in.
A. Alfred Taubman, Bloomfield Hills, Michigan

30. *Troy Donahue*, 1962
Silkscreen on canvas, 80¾ x 60 in.
Gian Enzo Sperone, New York

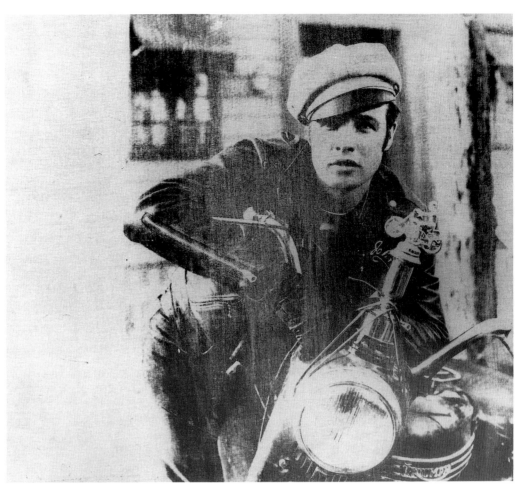

29

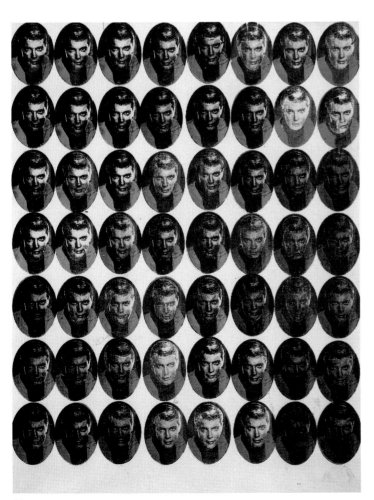

35

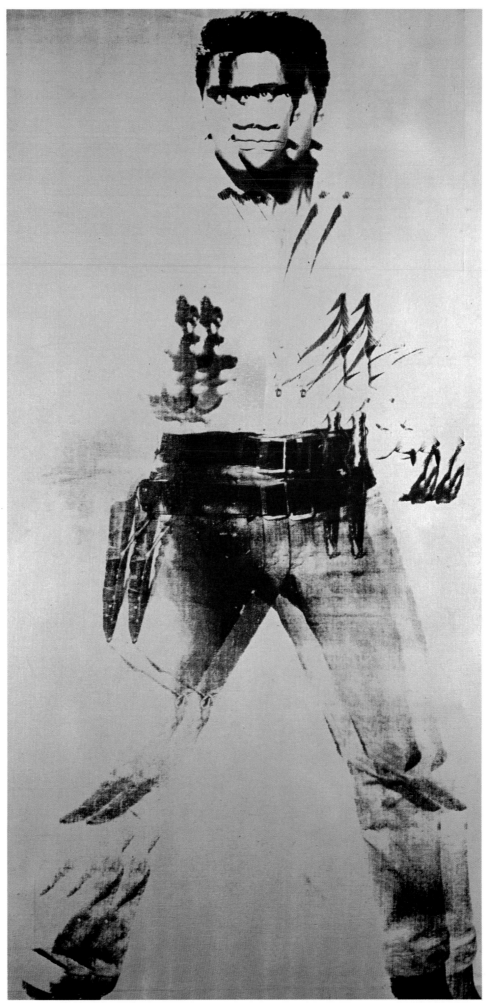

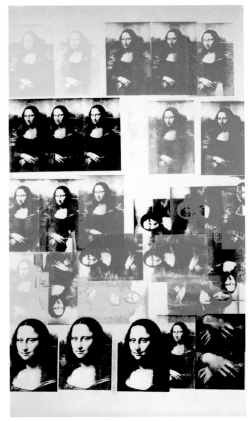

32

33

troduced to Andy. . . . Cecil Beaton had done something like that in one of his early photograph books—a kind of trick stop-motion effect."[20]

There have always been artists who worked at the center of an immense entourage. Warhol's Factory crowd was large, yet he didn't exercise his authority in any domineering way. He was passive instead, a void toward which others gravitated with their anxieties, their ambitions, and, occasionally, their useful ideas. One reliable source of good suggestions was Warhol's friend Henry Geldzahler. Warhol says, "It was Henry who gave me the idea to start the Death and Disaster series. We were having lunch one day in the summer [of 1962] . . . and he laid the *Daily News* out on the table. The headline was '129 DIE IN JET.' And that's what started me on the death series—the Car Crashes, the Disasters, the Electric chairs. . . ." Warhol had done front pages before—*A Boy for Meg*, with a picture of Princess Margaret, appeared in 1961. Royal personages are, of course, stars, and victims of plane crashes are not. They are anonymous. It is the event itself that glows in our imaginations, with a ghastly brilliance, to be sure. Still, Warhol's *129 Die (Plane Crash)* of 1962 is as empty of overt feeling as his renderings of dance diagrams and nose-job advertisements. 34

Though *129 Die* is a screenprint, there is evidence of the artist's hand in the illustration of the fallen plane. In the Death and Disaster paintings that followed, all sign of Warhol's touch gives way to the rough impersonality of the photo-screen. *Optical Car Crash* 37

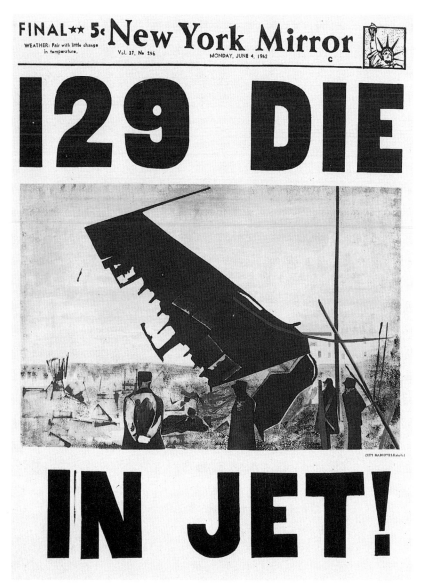

34

(1962) shows the image of an accident victim so blurred, so layered, so haphazardly repeated that the printing process itself seems to have suffered a catastrophe. The Disaster series makes unnerving equations—the series encompasses a variety of car-crash images, as well as renderings of an empty electric chair. Does Warhol suggest that highway death is a form of execution? Or that enforcement of a death sentence is a kind of accident? In 1963 he produced his *Thirteen Most Wanted Men*, grainy blowups of New York City police photos. (The following year, these images appeared briefly on the exterior of the New York State Pavilion at the New York World's Fair, before being whitewashed over for political reasons.) Warhol's approach to these fugitives from the law is little different from the treatment he accords to Marilyn, Elvis, and Liz. These criminals are stars of a sort, thanks to their appearance in the moment's image barrage, and stardom is the equalizer in Warhol's world. Any image that gains his full attention is as powerful, in his

34. *129 Die (Plane Crash)*, 1962
Silkscreen on canvas, 83 x 38 in.
Wallraf-Richartz-Museum, Cologne

35. *Suicide*, 1962
Silkscreen on paper, 40 x 30 in.
Courtesy Leo Castelli Gallery, New York

36. *Ambulance Disaster*, 1963
Acrylic and silkscreen on canvas, 124 x 80 in.
Collection Marx, Berlin

37. *Optical Car Crash*, 1962
Silkscreen on linen, 82 x 82 in.
Oeffentliche Kunstsammlung,
Kunstmuseum Basel

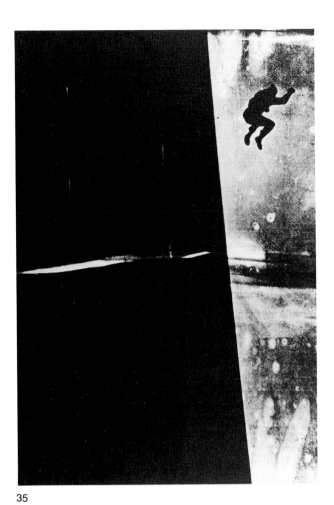

35

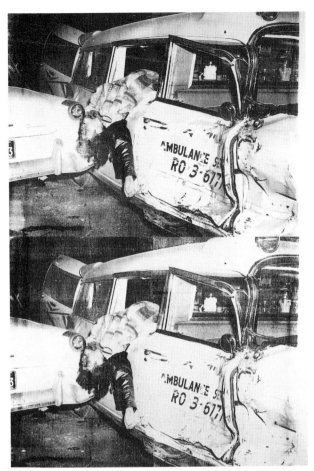

36

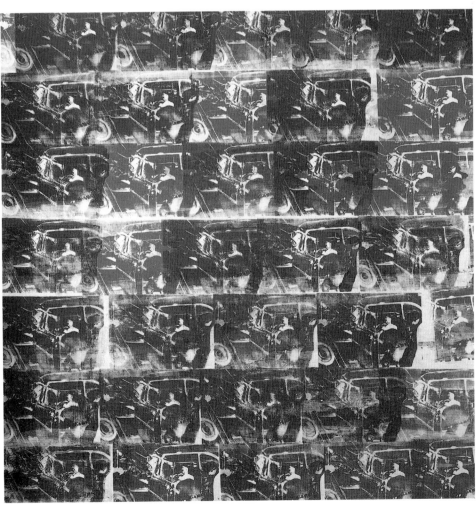

37

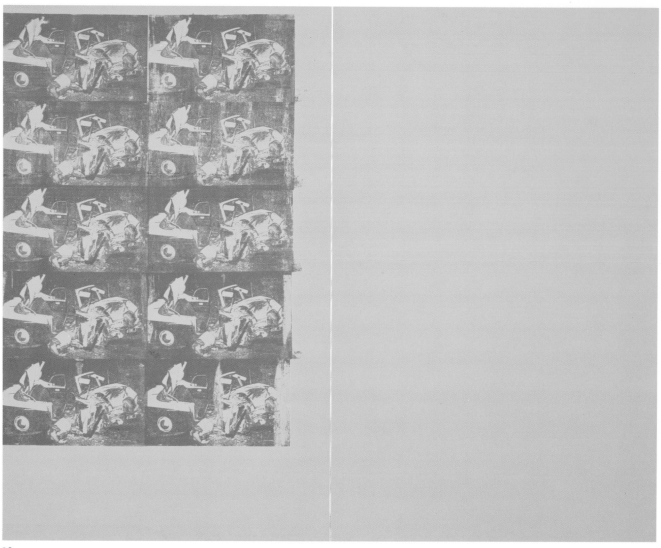

38

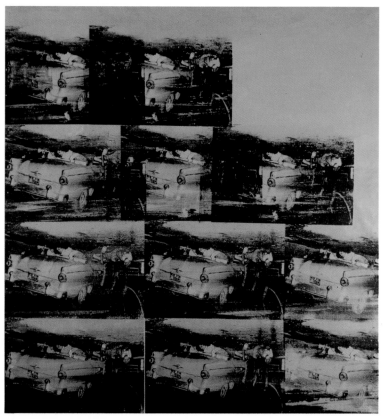

39

38. *Orange Car Crash*, 1963
Silkscreen on linen, 132 x 165 in.
Wallraf-Richartz-Museum, Cologne

39. *Five Deaths Eleven Times in Orange
(Orange Car Crash)*, 1964
Silkscreen on linen, 87 x 83 in.
Museo Civico, Turin

40. *Red Race Riot*, 1963
Acrylic and silkscreen on linen, 138 x 83 in.
Wallraf-Richartz-Museum, Cologne

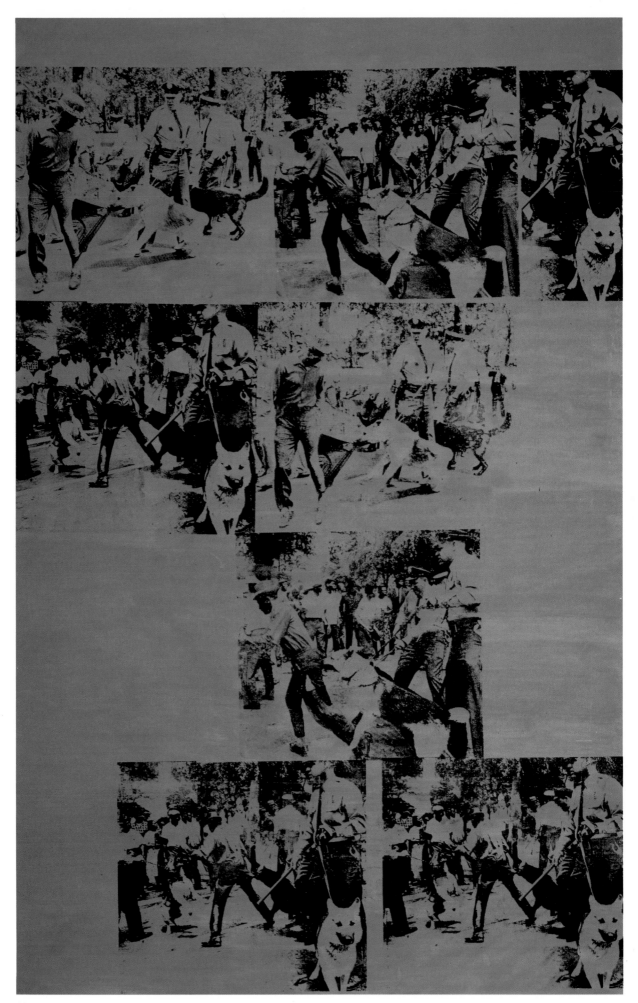

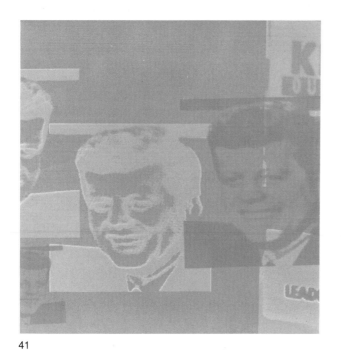

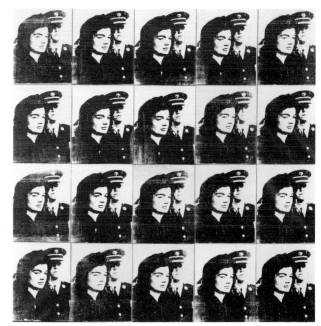

41

42

eyes, as any other. Yet there's a need to be extremely careful here, or we'll slip into the mistake of seeing Warhol as a social critic.

Andy Warhol never tries to blur the lines between wanted criminals and those movie actors who, in a different way, are also very much desired. Much less does he imply that there is anything criminal—or even culpably exploitative—about Hollywood stardom. It is only in the realm of image that all stars are equal. Only when facts turn into photographs and a photograph becomes a Warhol painting does the scene of a fatal crash take on an equality with an electric chair empty and waiting. Warhol's point about these equations, if indeed he makes any point at all, is that the image realm is unified by a pervasive silence, the deathly stillness that settles over a subject when it becomes sheer spectacle—and in some of the Electric Chair canvases the cropping permits us to see, above and to the right of the chair, a sign demanding just that: "SILENCE." In *Orange Car Crash* (1963), Warhol repeated ten imprints of his most often used accident image next to a blank panel. Silence equals blankness. *Red Race Riot* (1963) presents news photos of dogs and white policemen attacking black protesters. The viciousness of the scene comes through, and so does the random delicacy with which warm and cool tones of red play off against one another in the work's underlying field. Warhol is forever reminding us of the eye's promiscuity, its attraction to imagery of every sort—informative, shocking, or simply pretty.

President John Kennedy was assassinated in November 1963. Soon after, Warhol began his series of Jackie paintings, images of the President's grieving widow, which continued to 1965. In addition, Warhol made a little-known series of silkscreens on paper called *Flash* (1968), which focus on Kennedy, his seal of office, and the newspaper coverage of his death. The portfolio has an air of bright, inventive design—Warhol angled and layered his visual

41. *Flash: J. F. Kennedy*, 1968
Silkscreen on paper, 21 x 21 in.
Courtesy Ronald Feldman Fine Arts, New York

42. *Twenty Jackies*, 1964
Acrylic and silkscreen on linen, 20 panels,
each 19½ x 16 in.
Collection Marx, Berlin

43. *Sixteen Jackies*, 1964
Acrylic and silkscreen on canvas,
80 x 64 in.
Walker Art Center, Minneapolis

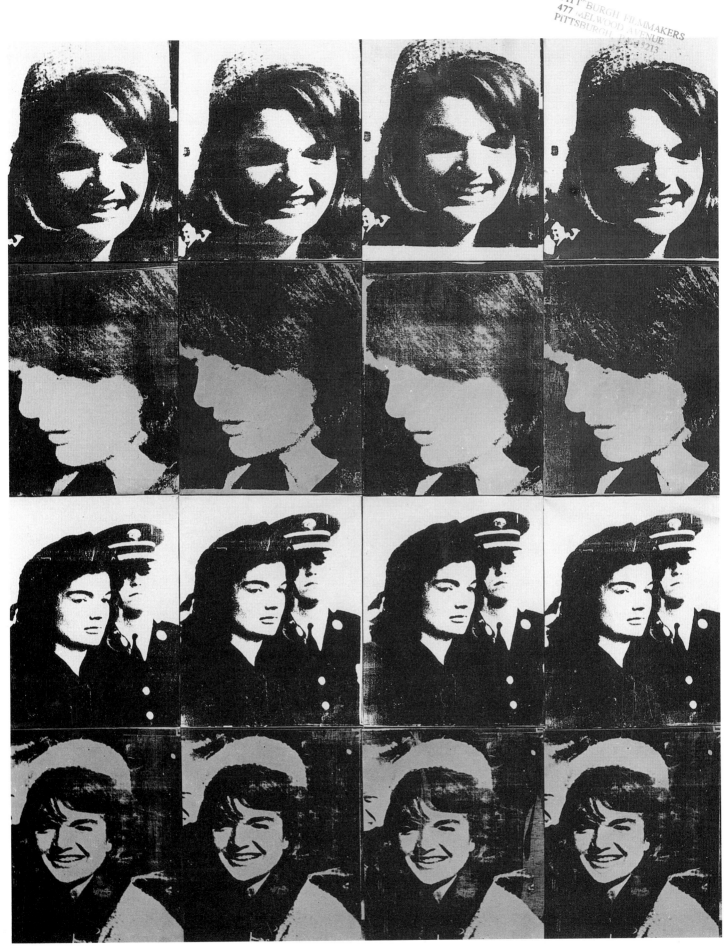

43

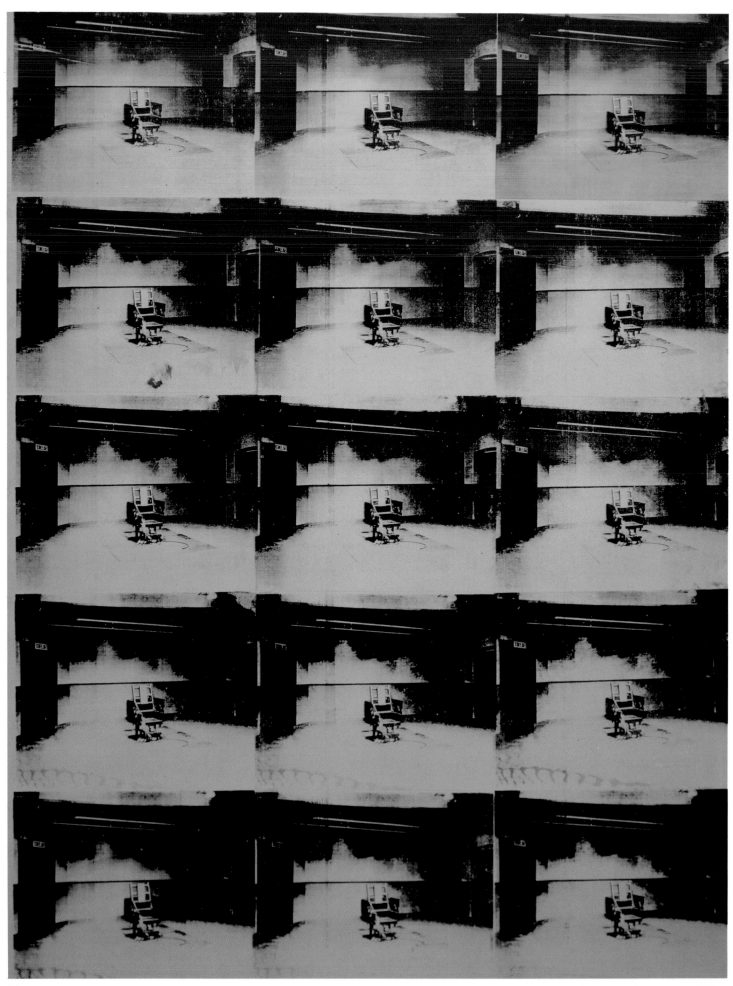

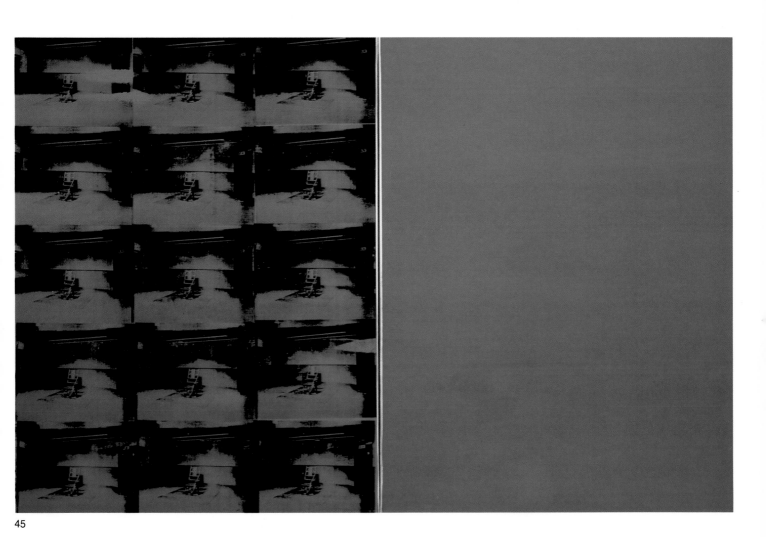

45

44. *Orange Disaster (Electric Chair)*, 1963
Acrylic and silkscreen on linen, 106 x 82 in.
The Solomon R. Guggenheim Museum, New York

45. *Blue Electric Chair*, 1963
Acrylic and silkscreen on canvas, 2 panels,
each 105 x 80¼ in.
Gian Enzo Sperone, New York

scraps with flair. The Jackie pictures are much blunter, with a single image filling the screen or row upon row of them set in a simple grid. One could argue that as time passed and Warhol felt less disturbed by the assassination, he was able to deal with the subject in a livelier way. Yet the Jackies, as well as the Death and Disaster series, were preceded by Elvises and movie-star paintings just as blunt in format. It is nearly impossible to assign an emotional content to the work of this artist, who applies so much energy to detaching himself from his feelings. Warhol recalls that he had "been thrilled having Kennedy as president; he was handsome, young, smart—but it didn't bother me that he was dead. What bothered me was the way the television and radio were programming everybody to be so sad."[21]

As the Disaster series proceeded from 1962 to 1965, concluding with the Atom Bomb, Warhol's career ascended from success to success. In 1964 he had his second exhibition at the Stable Gallery. Just as the Campbell's Soup Cans dominate the memory of his first New York show, so the Brillo Boxes characterize the second. In fact, there was a variety of boxes—Kellogg's Corn Flakes, Mott's Apple Juice, Heinz Ketchup, and Del Monte Vegetables. On raw plywood forms the size and shape of cardboard cartons, Warhol had silkscreened these supermarket logos. The boxes stood in casual stacks, as if the gridded repetitions of his paintings had found their way into three dimensions. The following year, the Minimalist sculptor Robert Morris showed gray, nearly cubical forms. No one has suggested that these severe objects originated in Warhol's boxes—they are, after all, plausible developments from sculptures Morris had made in earlier seasons—yet affinities between Pop and Minimal art seem clear. Warhol's *Gold Marilyn* is a monochrome painting violated by a media image, and his Boxes of two years later assault the Minimalist cube even before the latter had made an appearance.

Only a few seasons after his New York debut, Warhol arrived at the point where the judgments of art critics were irrelevant to his reputation. Some writers despised him, while others struggled to sustain a steady current of praise—not an easy thing to do, considering the unflappable persistence of the Warholian deadpan, in his art as in his person. Toward the end of 1964, Leo Castelli decided that his gallery did have room for two Pop artists after all. Roy Lichtenstein had by then moved beyond his comics paintings to land- and seascapes so stylized that they verged on abstraction. For his first show at Castelli, Warhol showed paintings from his Flowers series. According to Gerard Malanga, this was an image Warhol had found "in a botanical catalogue. He said, 'Here, get this made into a silk screen.' A woman recognized her photograph of poppies and felt she deserved something from him. I could understand her feelings about the matter. It was years before the thing was settled out of court."[22]

Warhol's knack was to remain detached while leaving himself open to an extraordinary range of influences, subtle or devastating, sophisticated or coarse. The most immediate of these influences came from Warhol's entourage. The Factory, as Henry Geldzahler remembers it, "became a sort of glamorous clubhouse with every-

46. *Brillo*, 1964
Painted wood, 17 x 17 x 14 in.
Courtesy Leo Castelli Gallery, New York

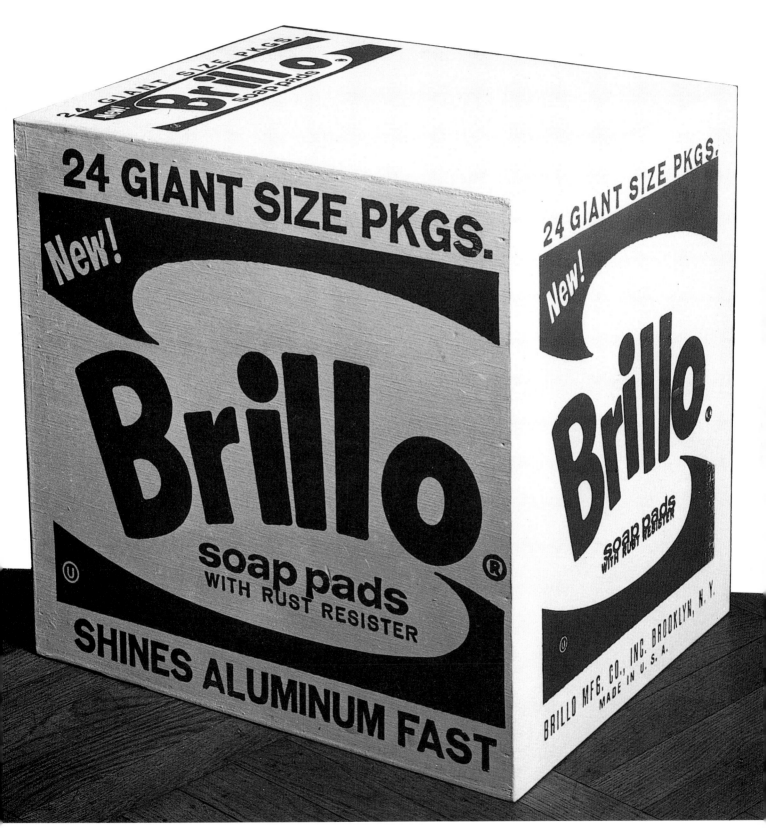

one trying to attract Andy's attention. Andy's very royal. It was like Louis XIV getting up in the morning. The big question was whom Andy would notice"[23]—a question whose importance grew as Warhol began to make 16mm. films. He chose his actors and actresses from the Factory crowd, and an appearance in some of the later movies earned the label "superstar."

Hollywood had obsessed Warhol when he was young and it provided much of the subject matter for his early Pop paintings. Then, when he drove West for his second show at the Ferus Gallery, he found himself as the guest, along with Taylor Mead and several of his Factory friends, of Hollywood denizens Brooke and Dennis Hopper. One evening at the Hoppers' he met Troy Donahue (the

47. Installation of *Brillo Boxes* at Leo Castelli Gallery, New York, 1964

48. *Flowers*, 1964
Silkscreen on canvas, 48 x 48 in.
Courtesy Leo Castelli Gallery, New York

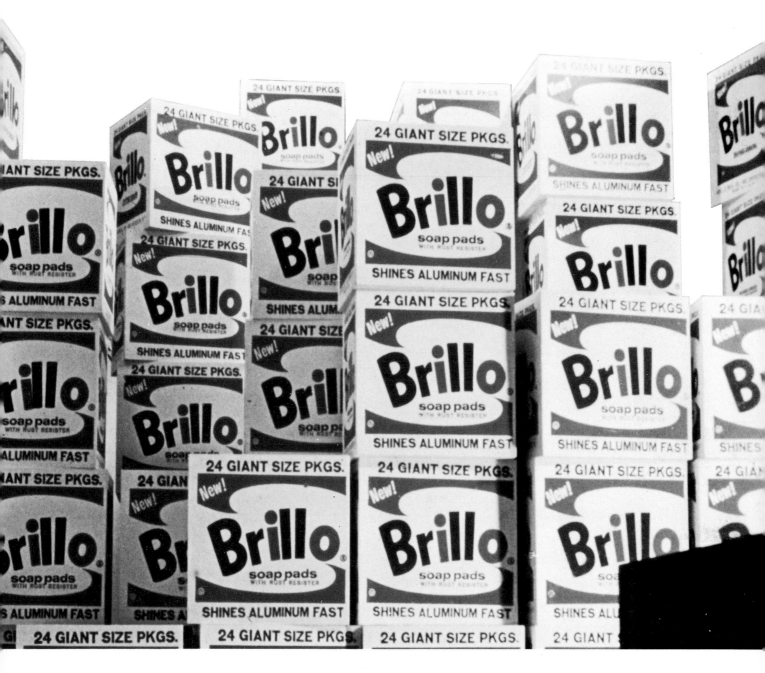

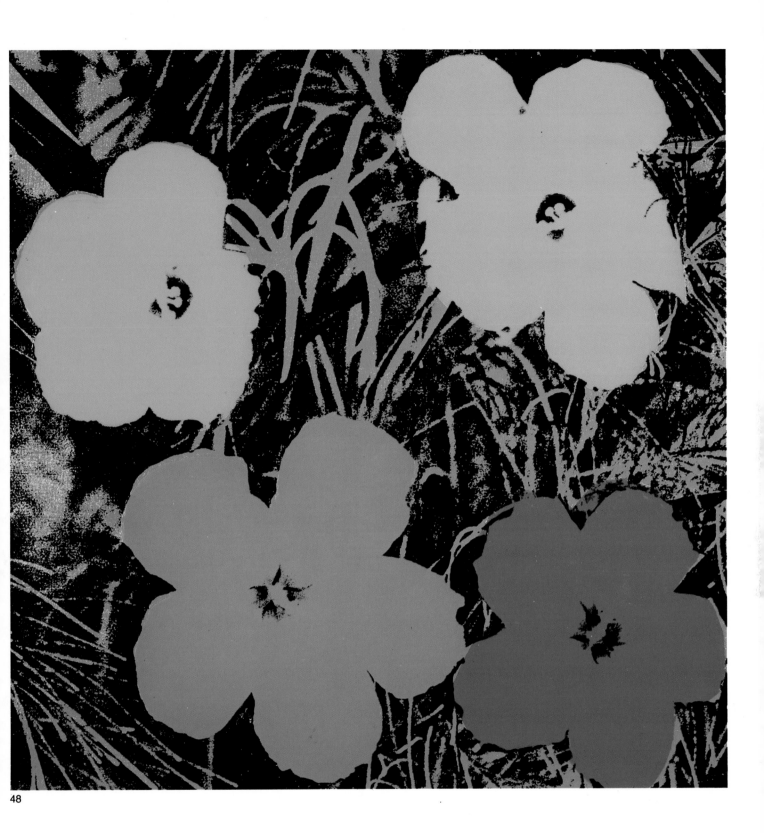

48

49

49-51. Stills from *Lonesome Cowboys*, 1968

30 subject of a 1962 painting), as well as Peter Fonda, Sal Mineo, and other stars. "After a dazzling party like that," Warhol says, "my art opening was bound to seem tame, and anyway, movies are pure fun, art was work."[24] He and his entourage met a young woman named Naomi Levine, an underground cinéaste from New York who was in Los Angeles to raise money for Jonas Mekas's Film-Makers' Co-operative. Warhol persuaded her to play the female lead opposite Taylor Mead in a film that came to be known as *Tarzan and Jane Regained . . . Sort of*. The movie was shot in a bathtub in Warhol's suite at the Beverly Hills Hotel.

When she returned to Manhattan, Naomi Levine made an appearance at the Factory and was recruited for *Kiss* (1963), a series of close-ups of couples kissing. Other superstars featured in this movie were Baby Jane Holzer, Gerard Malanga, the critic Pierre Restany, and the artist Marisol. Naomi performed with Gerard and others, including the poet Ed Sanders. Beginning in the fall of 1963, Jonas Mekas screened a *Kiss* segment before each of his programs at the Film-Makers' Cinémathèque. Then came *Haircut*, which shows a Factory hanger-on named Billy Linich getting his hair cut. It lasts for thirty-three minutes. *Eat* takes forty-five minutes to show Pop artist Robert Indiana eating a mushroom. Other movies whose one-word titles serve as synopses are *Shoulder* (1964), four minutes of dancer Lucinda Childs's shoulder; and *Face* (1965), a close-up of Edie Sedgwick that lasts for over an hour.

The Boxes had brought Warholian subjects out of painting's two dimensions into the space occupied by the viewer. His movies draw his imagery out of painting's timelessness into the temporal dimension we all experience. The more boring they are, the more effectively these films remind us that an image has an uncanny similarity to ourselves—it appears and then, sooner or later, it disappears; it lives and dies. And when its life is minimal, when the potential for action is never realized, this point is all the more pressing. *Empire* (1964) shows the Empire State Building from the forty-fourth floor of the Time-Life Building. It lasts for eight hours. Nothing happens save that the sky darkens and the building lights up. In 1968 Warhol said, "The Empire State Building is a star!"[25]

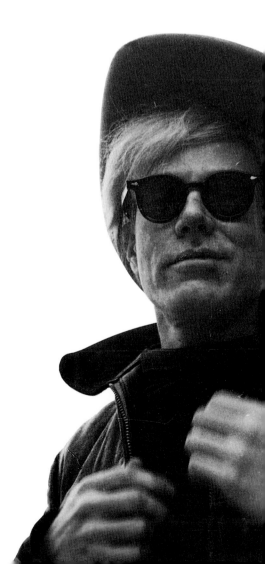

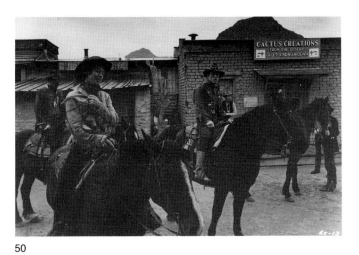

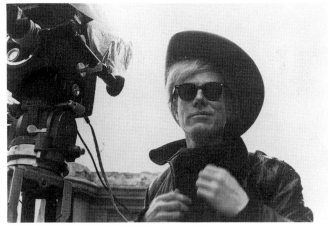

In December of 1964 Warhol made his first sound film, *Harlot*, in which Factory transvestites play the parts of Mae West, Marilyn Monroe, and Jean Harlow. *Harlot* interrupted the filming of *The Thirteen Most Beautiful Women* and *The Thirteen Most Beautiful Boys*, both silent. More attempts at talkies followed, most of them of such poor quality that not even an appreciation of Warhol's off-handedness can redeem them. Then, in the spring of 1965, Edie Sedgwick appeared in *Poor Little Rich Girl*, a seventy-minute re-cord of her on the telephone, lolling on a bed, talking incessantly and always about herself. The first half of the movie is out of focus, and yet even this section conveys the luminosity of her presence. She became Warhol's first-ranking superstar. As the poet René Ri-card, an early fixture at the Factory, has recalled, this period "was the high point of Edie's career. She was the girl on fire with the silver hair close to her head, the eyes, the Viceroy in her fingers, the sleeves rolled up, those legs . . . all you saw was her!"[26]

With their matching hairdos, Andy and Edie began dressing alike, in striped T-shirts, pants, and dark glasses. Baby Jane Holzer, the previously reigning superstar, no longer belonged, with her early-'60s *Vogue* magazine look—tawny bouffant hair and mini-skirt. "It was getting very scary at the Factory. There were too many crazy people around who were stoned and using too many drugs. . . . The whole thing freaked me out, and I figured it was becoming too faggy and sick and druggy. I couldn't take it. Edie had arrived, but she was very happy to put up with that sort of ambiance."[27]

After *Poor Little Rich Girl* came *Vinyl*, a sadomasochistic ex-travaganza featuring a chain-wielding Gerard Malanga in black leather. Edie Sedgwick appears toward the end of the second reel, still smoking and, of course, still talking. *Bitch*, *Restaurant*, and *Kitchen* quickly followed, with Edie starring in all of them. In notes published by the Film-Makers' Cinemathèque, Warhol said that "*Kitchen* is illogical, without motivation or character, and com-pletely ridiculous. It is very much like real life." The Factory's scriptwriter, Ronald Tavel, seconded these thoughts. Brought in to supply dialogue when Warhol went from silent to sound movies,

Tavel says that his job "was to work for no meaning . . . my problem as the scriptwriter was to make the scripts so that they meant nothing, no matter how they were approached . . . Andy had said, 'Get rid of plot.' . . . So I thought what I could introduce was to get rid of characters. That's why the character's names in *Kitchen* are interchangeable. Everyone has the same name, so nobody knows who anyone is."[28]

But the camera knew, in the sense that it rendered a few presences vivid and left the rest bland. Edie Sedgwick is the most luminous creature in Warhol's movies, though Gerard Malanga and the amphetamine-soaked Ondine give her strong competition. Later Viva and Brigid Polk, the astonishing monologuist of *The Chelsea Girls* (1966), achieved full superstardom, Factory-style. These targets of Warhol's movie camera strike us as personalities so utterly externalized, so completely given over to the moment, that they—like Brillo boxes or Campbell's soup cans—exist sheerly as images. Nothing seems more innocuous than a familiar consumer item, but the antics of the Warhol ensemble are on occasion convincingly sinister—or, worse yet, utterly hollow. Yet Warhol's gesture is always the same, nonchalant to the point of iciness, whether he serves up a supermarket product or a superstar presence.

Warhol's indifference to the distinction between high and low art reflects a genuine lack of snobbery. If an image is powerful, he'll admire it. He may even call it beautiful. But that which shines only modestly or flickers with hesitation is invisible to him. All his responses are concentrated in his eye, and his eye is voracious. Touch is beside the point here; Warhol, our leading connoisseur of glamour, has little use for physicality. "Fantasy love is much better than reality love," Warhol has said. "Never doing it is very exciting. The most exciting attractions are between two opposites that never meet."[29] This might sound ironic, an artist's rationale for art sustained by the untouchable allure of pure image, save that Warhol actually shies away from being touched. Viva, the superstar who began to appear in Factory movies in 1967, says that "if you so much as tried to touch Andy, he would actually shrink away. Shrink. I mean shrink backwards and whine. Many times I used to make a grab at Andy, kiddingly, or touch him, and he would cringe. Whine, 'Aw, Viva, awww.' We were all always touching Andy just to watch him turn red and shrink. Like the proverbial shrinking violet."[30]

No doubt Warhol had long felt the impulse to make a self-portrait—what safer, more impalpable state could he achieve than that of a silkscreened emblem? Yet, as was often the case, the crucial push came from outside, when Ivan Karp said to Warhol, "you know, people want to see *you*. Your looks are responsible for a certain part of your fame—they feed the imagination."[31] The 1964 Self-Portraits are warmups for the ones that Warhol made two years later, which now serve as icons of the Pop era—blank yet intricately articulated, with their rough screenprinting, garish colors, and the peculiar dignity with which Warhol rests his chin in his hand. One of his fingers crosses his lips, as if to repeat the injunction of the Electric Chair paintings: "SILENCE." The 1964 Self-Portraits are equally blank but not as richly so.

52. *Self-Portrait*, 1964
Silkscreen on linen, 40 x 36 in.
Mr. and Mrs. Brooks Barron

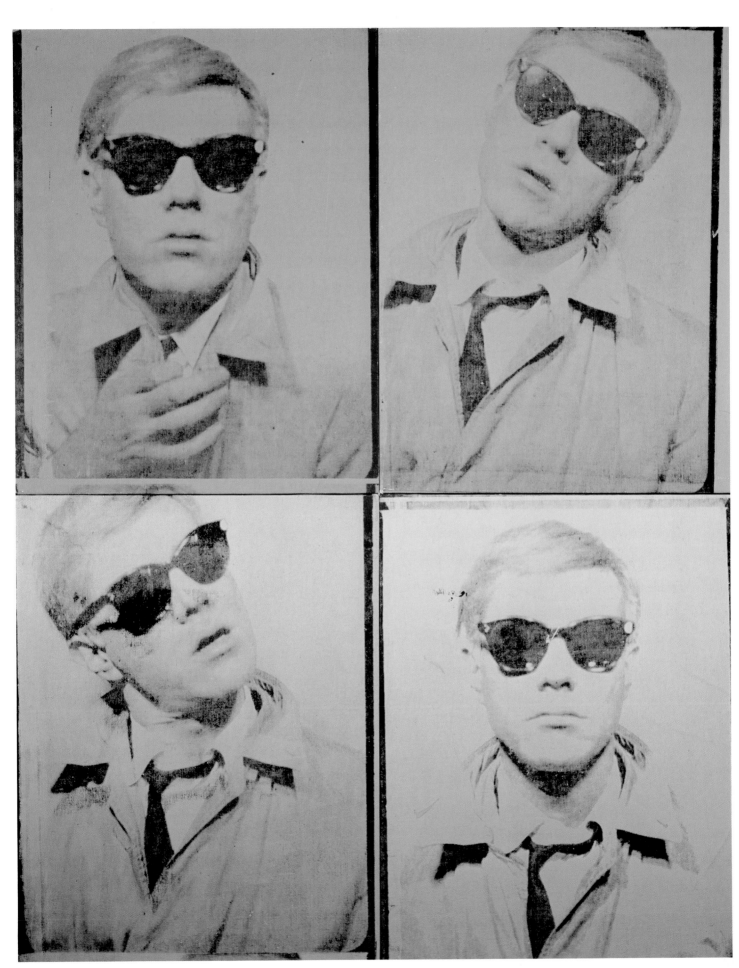

52

Karp also suggested that Warhol "paint some cows, they're so wonderfully pastoral and such a durable image in the history of art."[32] At the time of his *Liz* and *Marilyn* paintings, Warhol had made pictures of Leonardo's *Mona Lisa*. Now he took on another familiar motif. The result was his *Cow Wallpaper*, which he spread across the walls of Ileana Sonnabend's gallery in Paris, for an exhibition there in 1965. Over this pattern of bovine heads he hung more of his *Flower* paintings. Warhol and Edie and Gerard Malanga attended the Paris opening, as did the press, in droves. Warhol was an internationally known phenomenon by now, persistently badgered by reporters and the public, and enjoying it very much. "I was having so much fun in Paris," he recalls, "that I decided it was the place to make the announcement I'd been thinking about making for months: I was going to retire from painting. Art just wasn't fun for me anymore; it was people who were fascinating and I wanted to spend all of my time around them, and making movies of them."[33]

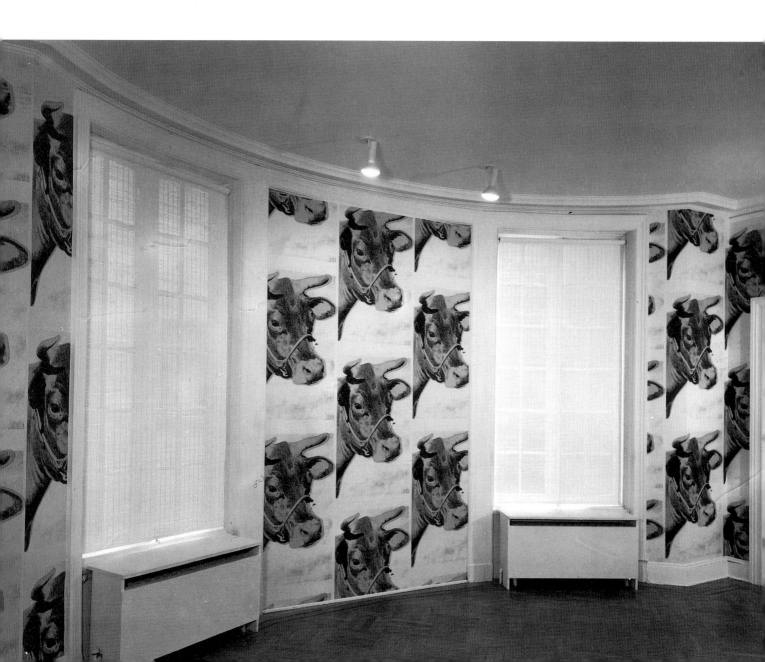

That fall, the Institute for Contemporary Art in Philadelphia put on a retrospective survey of Warhol's five seasons as a Pop artist. The institute's director, Sam Green, primed local reporters, who were already alert to Warhol, his art and his crowd. The Factory films were getting to be widely known, if not seen (and most of them are as interesting to hear about as to see). Further, Edie Sedgwick had been featured in *Vogue* as a "Youthquaker" and in *Life* as "This cropped-mop girl with the eloquent legs." *Newsweek* and *Time* dropped by the Factory, and the latter commissioned a cover from Warhol—a series of photo-booth pictures of young men and women for a feature on "Today's Teen-Agers." There was every reason to expect a good turnout at the ICA in Philadelphia, but "Still," as Warhol recalls, "we didn't expect the mob scene that eventually happened at the opening."[34]

Four thousand artlovers jammed into the institute's two small rooms. Sam Green had Warhol's paintings removed, for their own safety. "It was fabulous," says Warhol. "An art opening with no art!" When Andy and Edie appeared, the crowd screamed and surged forward, forcing them onto a flight of ironwork stairs in the corner of the main gallery. As guards held the crowd back, fans passed up shopping bags, address books, soup cans—all manner of objects—to be autographed. For two hours, Andy and Edie obliged. Later, Warhol "wondered what it was that made all those people scream. I'd seen people scream over . . . rock idols and movie stars—but it was incredible to think of it happening at an *art* opening. . . . But then, we weren't just *at* the art exhibit—we *were* the art exhibit, we were the art incarnate and the sixties were really about people, not about what they did. . . . Nobody even cared that the paintings were all off the walls. I was really glad I was making movies instead."[35]

The daytime Factory scene continued into the evening, and well into the early morning, at Max's Kansas City, a restaurant a few blocks away from Warhol's studio. Here Edie and Gerard and the rest of the superstars met the art world at large, as well as denizens of Manhattan's drug, poetry, and rock music worlds. Max's was the center of underground chic, a place where everything seemed possible to those with sufficient personal flair.

"The Pop idea," according to Warhol, "was that anybody could do anything, so naturally we were all trying to do it all . . . at the end of '65, we were all for getting into the music scene, too."[36] Rock performers—Donovan, the Byrds—had begun to turn up at the Factory. Edie Sedgwick drew Mick Jagger and Bob Dylan into Warhol's orbit. It seems inevitable, in retrospect, that Pop art would make contact with pop music, but no one could have predicted the link that brought them together—a raucous, not particularly successful rock group called the Velvet Underground. Headed by guitarist Lou Reed and electric viola player John Cale, the Velvets had a female drummer and a grinding, aggressive sound that found later echoes in "heavy-metal" rock and, still later, in punk music. Warhol envisioned the Velvet Underground as a back-up band for Nico, a German actress who had appeared in Federico Fellini's *La Dolce Vita* and would soon do a superstar turn in Warhol's *Chelsea Girls*. By the spring of 1966 the Velvet Under-

53. Installation of *Cow Wallpaper*
at Galerie Ileana Sonnabend, Paris, 1965

ground had become the Exploding Plastic Inevitable, which was the original band plus Nico, leather-clad dancers, and a light show heavily dominated by strobe flashes.

As the Exploding Plastic Inevitable settled into its Manhattan base—an immense dance hall called the Dom, on St. Mark's Place—Warhol prepared for a spring show at the Castelli Gallery. Here the Cow Wallpaper would make its New York debut. Instead of paintings there would be Warhol's Silver Pillows, foil-covered plastic envelopes inflated with helium. The Boxes had been sculpture you could stack, like cartons of groceries. The Pillows levitated, like party balloons. Warhol has said that "it was while I was making them that I felt my art career floating away out the window, as if the paintings were just leaving the wall and floating away."[37] In fact, there have been no low points in Warhol's career. Even as his feature-length movies faltered, his notoriety was turning into reliable fame. Within the narrow precincts of the art world, the market for his paintings has been steady and the critical interest intense. Warhol has always responded with new works. Not even his "retirement" of the mid-1960s stopped the flow of canvases, for during this period, he carried out portrait commissions in the manner of *Portrait of Holly Solomon* (1966).

During the spring of 1967, six of Warhol's Self-Portraits appeared in the United States Pavilion at Expo '67 in Montreal. Buckminster Fuller designed a geodesic dome to house the American display. Dubbed "Creative America," it offered a mix of recent painting and sculpture, folk art, and a selection of mass-culture icons. The American cultural establishment was trying to absorb the Pop artists' challenge. Rather than see Warhol, Lichtenstein, et al. as disruptive, perhaps even subversive, the organizers of the U.S. Pavilion chose to put them to work as a link between the world of consumer products and high art—between the elitist complexities of Robert Motherwell, Larry Zox, and Frank Stella and the banalities of movie stars and rock singers. This was a successful tactic, which most of our major museums and educational institutions have adopted. Instead of rejecting Pop art, they have found a comfortable place for it in the recent history of serious painting and sculpture. The artists considered central to the Pop phenomenon have benefited greatly from this policy, though it has done much to obscure the differences between, say, Roy Lichtenstein and Claes Oldenburg. And the difficult aspects of Warhol's art have gone largely unnoticed. His paintings do not, after all, simply provide a transition from consumer culture to high art. They call into question the uses to which we put all of our images, especially images of ourselves.

In October of 1967 Warhol was faced with a series of college lectures, which he did not want to give. In the past he had taken a group of his superstars along whenever he had a speaking engagement. They would do the talking because, Warhol says, "I was too shy and scared to talk myself. . . . I would just be sitting there quietly up on stage like a good mystique."[38] Now the routine had become unbearable, and Warhol dreaded going through it again. Allen Midgette, who appeared in a number of Factory movies, suggested that he go instead. With his hair sprayed silver, like

54. *Cow Wallpaper*, 1966
Silkscreen on paper, 44 x 30 in.
Courtesy Leo Castelli Gallery, New York

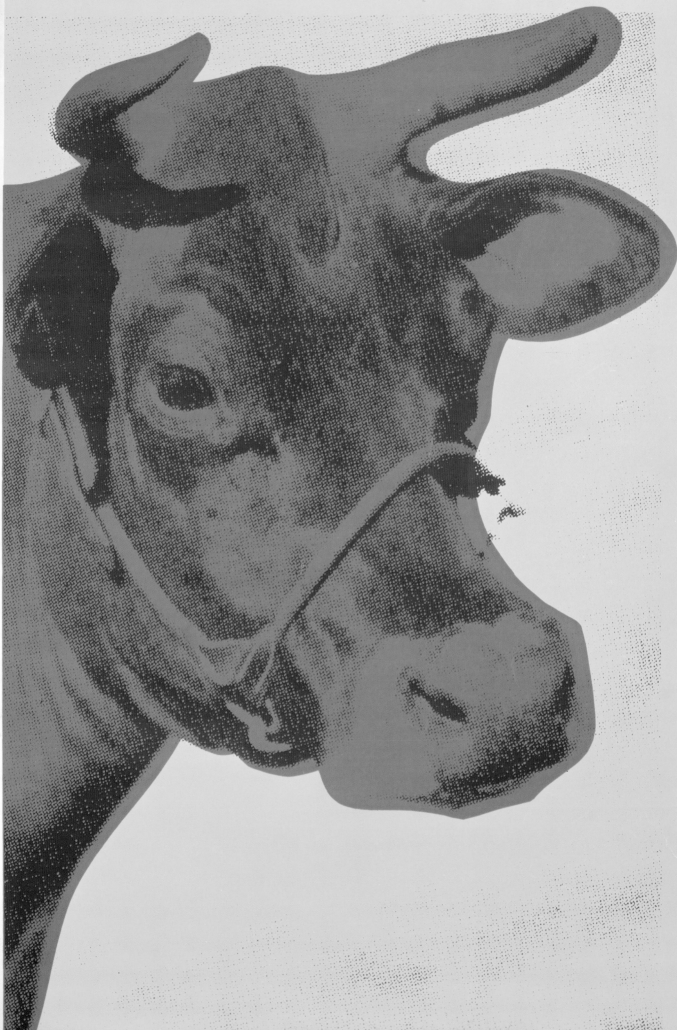

TRIM

TRIM

Andy Warhol

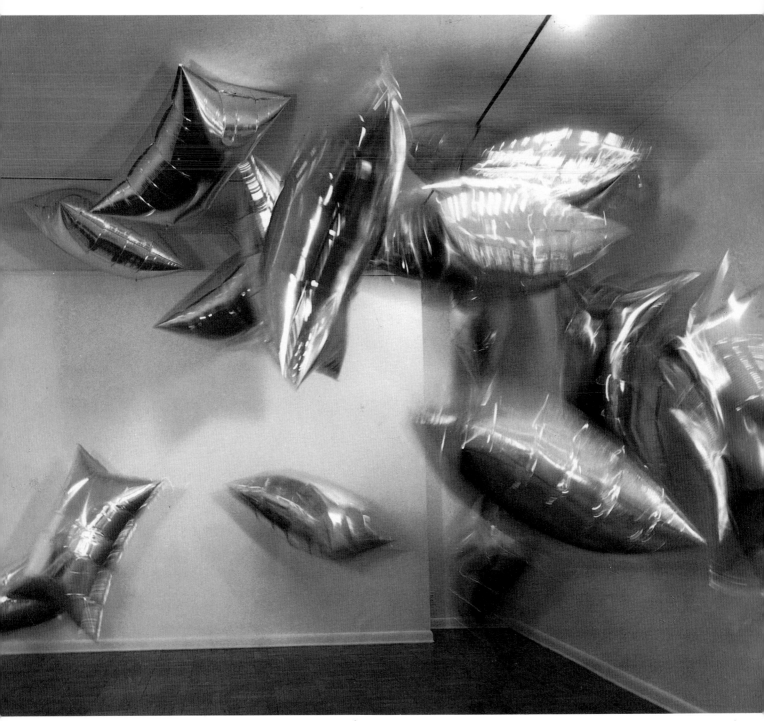

55

Warhol's, he would sit silently onstage, while Paul Morrissey fielded questions. It worked for nearly four months, until a photograph of Warhol in the *Village Voice* made its way out West and gave away the game.

The following spring, Warhol's persistent celebrity got him back on the lecture circuit. Invited to visit several colleges on the West Coast, he took Viva and Paul Morrissey with him. In La Jolla, California, they filmed *Surfing Movie* with Taylor Mead and Ingrid Superstar. Warhol tried to liven up the action by provoking fights between his players, but none of the usual Factory-style squabbles broke out. California had relaxed the entire entourage. It was early June by now. Back in New York, the art world's summer vacation had begun. Late in the afternoon of June 3, Warhol arrived at the Factory, now located at 33 Union Square West. He rode up in the elevator with a Factory regular, Jed Johnson, and Valerie Solanis, the founder and sole member of an organization called S.C.U.M.—Society for Cutting Up Men. Stepping out of the elevator into the studio, they met Fred Hughes, Warhol's business manager, and the art historian Mario Amaya.

There was a phone call from Viva, who had gotten a part in John Schlesinger's *Midnight Cowboy.* As Warhol wearied of Viva's movie gossip, he handed the phone to Fred Hughes and heard a sharp, explosive sound. He turned to see Valerie Solanis pointing a pistol at him and shooting. She shot again. Warhol fell, not knowing whether or not he was hit. He tried to crawl under a desk. Solanis moved closer, still shooting. Warhol was struck by two slugs in both lungs, his stomach, liver, spleen, and esophagus. Next Solanis shot Mario Amaya in the hip. Still able to move, Amaya ran for a back room. Solanis followed him but couldn't push open the doors. Then she tried to force her way into Warhol's office, where Jed Johnson managed to hold the door shut. When she pointed her gun at Fred Hughes, he said, "*Please!* Don't shoot me! Just *leave!*" Solanis went to the elevator, pressed the button, then returned to point her gun at Hughes. When the elevator arrived and the doors opened, he told her, "Just *take* it!," which she did. Three hours later, Solanis turned herself in to the police, with the statement that she shot Warhol because "He had too much control over my life."[39]

Warhol's hospital stay lasted nearly two months. He spent the rest of the summer at home convalescing—working on a series of very small paintings of Happy Rockefeller and watching television. It was a violent season, with the Russian invasion of Czechoslovakia and the demonstrations at the Democratic convention in Chicago. By September, Warhol was able to make daily visits to the Factory, though his wounds were not completely healed. He tired easily, and the Factory crew saw that the shooting had left him with a deep residue of fear. Paul Morrissey suggested as tactfully as he could that the Factory's open-door policy ought to change. Visitors would have to be screened, and it might be a good idea to fit the doors with locks and buzzers. "Paul was right, of course," Warhol says, ". . . but choosing between which kids I would see and which I wouldn't went completely against my style. . . . I was afraid that without the crazy, druggy people around jabbering away and doing

55. *Silver Pillows*, 1966
Helium-filled Mylar, each 48 x 24¼ in.

their insane things, I would lose my creativity. After all, they had been my total inspiration since '64, and I didn't know if I could make it without them."[40]

Warhol spent the last year and a half of the 1960s in a state of suspension. In 1969 he told a California magazine, *Coast FM and Fine Arts*, that Brigid Polk had done all his recent paintings. *Time* followed the story up with a comment from Brigid herself: "Andy doesn't do art any more. He's bored with it. I did all his new soup cans."[41] This was a rerun of Warhol's announcement, made four years earlier, that he had "retired" from painting. This time it was taken seriously, especially by European collectors. Warhol and Fred Hughes reassured them that Brigid had been joking—Andy had never really quit making canvases, his signature was good. Though Warhol's reputation survived, he and his entourage left their role-playing games behind when they moved on from the 1960s to the '70s.

Warhol still made a point of visiting the Factory every day, but he made no films and started no new series of paintings. John Wilcock, the editor and publisher of an underground newspaper called *Other Scenes*, asked Warhol if he wanted to collaborate on a new publication. The artist agreed, and in fall of 1969 *Inter/View* magazine appeared. Gerard Malanga, who had not been seen much around the Factory in recent seasons, reappeared to guide *Inter/View* in the direction of poetry and film, his two chief interests. At a time when most journalists worked up the texts of interviews from notes, this new magazine featured very loosely edited transcripts of cassette tapes. This gave the publication an air of unpolished realism, as if the sound tracks of *Chelsea Girls* and the rest of Warhol's mid-1960s movies had found their way into print.

Whenever Warhol and his circle attempted to push the Factory aesthetic beyond the borders of painting, the results were more interesting as ideas, as Pop-era conceits, than as books, magazines, or movies. Even Warhol's sculpture of 1964–66 has now taken on the look of a curious experiment, while the paintings are as crisp and imposing as ever. His art gains little from the third dimension supplied by sculpture or from the movies' sound and motion. And language, the medium of *Inter/View*, completely dissipates the impact of such imagery. It is the impact of the mundane—rendered so clearly, brought so sharply into focus, that the painting seems to stand apart from everyday life and to illuminate it. Warhol triggers reflexes of recognition so powerful, sometimes, that they count as epiphanies. Yet the meaning of his art doesn't reside in the mechanics of this effect, the efficiency with which a Liz or a Marilyn or a Disaster absorbs our attention. He puts fine-art formats at the service of his media-style flair, yet he does more. He creates a tension between the flat plane of modernist painting, that arena of privileged self-consciousness, and mass-culture images, which we routinely dismiss as impersonal, manipulative, and thus inimical to the needs of individuality. Each of us feels similar tensions between values and meanings we cherish as genuinely our own and those that the media seem to have programmed into us. With a directness, a brevity, that feels very much like wit, Warhol's art confronts us with emblems of this conflict.

56. *A Set of Six Self-Portraits*, 1966
Acrylic and silkscreen on linen, 6 panels,
each 22 x 22 in.
Collection Marx, Berlin

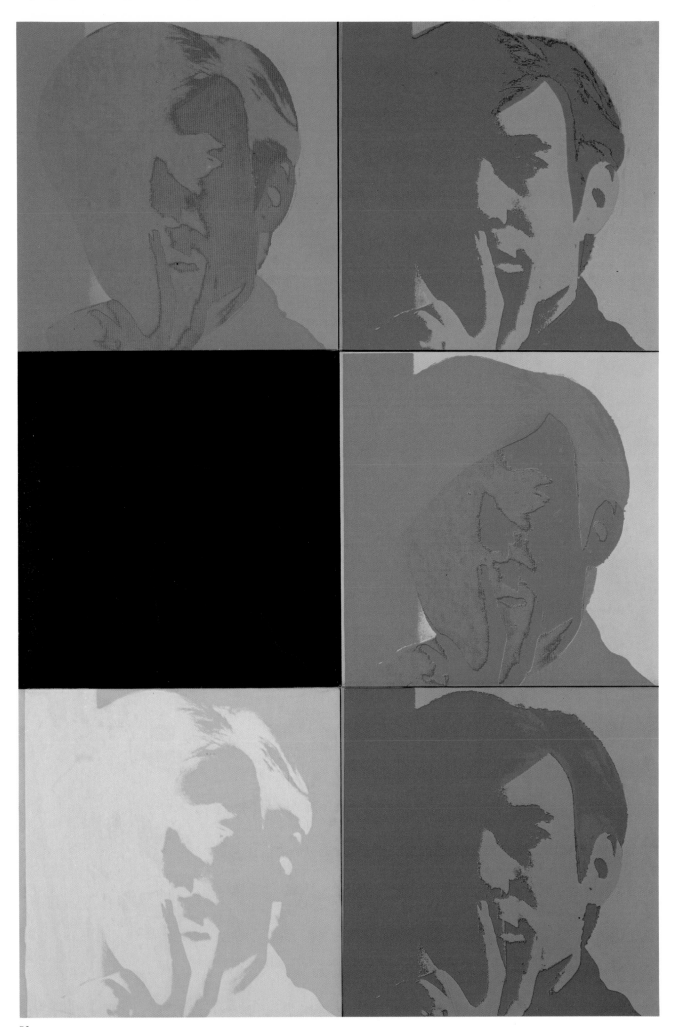

61

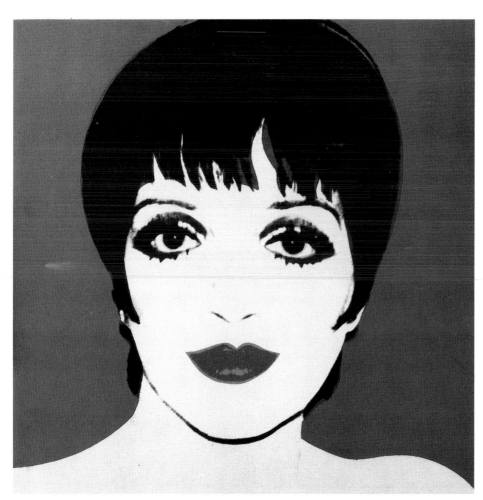

57

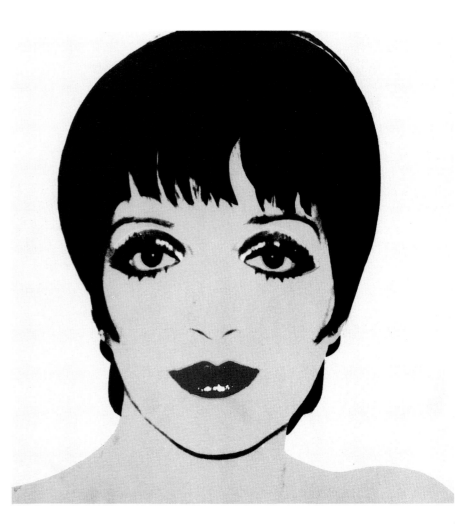

62

3 Post-Pop

As the 1960s ended, Warhol's injuries were slowly but surely healing, yet he found it difficult to forget that he had been pronounced dead on the operating table. During this time he said, "everything is such a dream to me. . . . I don't know whether or not I'm really alive or whether I died. And having been dead once, I shouldn't feel fear. But I am afraid. I don't understand why."[42] Nearly a decade later, he recalled how frightening his fresh scars had been to him, then went on to say that "they were sort of pretty, though, purplish red and brown." In 1969 he would pose, with torso bared, for Richard Avedon, whose photograph provides a detailed map of Warhol's wounds. With shirt removed and surgical corset still on, he posed for the portrait painter Alice Neel in 1970. In her rendering, Warhol's face—eyelids lowered, the mouth sunk to depths beyond melancholy—looks as ravaged as his body. Yet this is not a theatrical pose. Warhol offers himself up as an object, almost a topic for a still life. Having nearly died of a violent assault, he then put the evidence of his wounds on public display. He made images of them, not signs of suffering but emblems of a media topic: the violence of the 1960s.

In 1973 the Factory made yet another move, this time to the north side of Union Square. The earlier studios had been chaotic. This one was neat and orderly. There were receptionists, white walls, furniture carefully chosen from Warhol's Art Deco collection. His first decade as a Pop artist had drawn to a close, though it could be argued that the Warhol 1970s didn't really begin until '71, when he met Bianca Jagger, wife of the Rolling Stones' lead singer, Mick. Now that Warhol was approaching the mainstream of American celebrity, he was eligible for the friendship of the wife of a rock-world megastar. And he became friends with the megastar, too. By Warhol's account, he had known Mick Jagger since 1963, when the Rolling Stones gave their first New York concert. No doubt they met then, but it wasn't until nearly a decade later that they could meet again as public figures of roughly comparable luminosity. Elton John, Alice Cooper, Bryan Ferry—the '70s-model Warhol had access to all of these rock musicians. Shaun Cassidy posed for a cover of *Interview*, which had dropped the arch spelling of its logo

57. *Liza Minnelli*, 1978
Acrylic and silkscreen on canvas, 2 panels,
each 40 x 40 in.
Collection Halston

and become a stylish tabloid dedicated to that corner of the culture where fashion, art, entertainment, and "society" meet. Its pages, presided over by Bob Colacello, featured transcripts of celebrity chatter and brittle, elegant photography.

"I never know what to say to rock stars," Warhol commented in *Exposures*, his illustrated diary of the 1970s. "The one who really leaves me speechless is David Bowie. He recorded a song called 'Andy Warhol.' I don't know if it's a put-up or a put-down."[43] It didn't matter. Warhol's speechlessness, his blank and untouchable exterior, now presented an image negotiable far beyond the boundaries of the Manhattan art world. Warhol met Diana Vreeland, the long-time editor of *Vogue*, and became a regular at the designer Halston's parties. Elizabeth Taylor, Liza Minelli, Marisa Berenson, Muhammad Ali, Paulette Goddard, Willy Brandt—in one capacity or another, Warhol mingled with these and a plethora of other well-known personages. At the Ford White House, he was introduced to Henry Kissinger. When Jimmy Carter was elected, the family invited him to Plains, Georgia. Margaret Trudeau, Ginger Rogers, Salvador Dali, Rudolf Nureyev—Warhol's taste for celebrities became insatiable. As he says, "I have Social Disease. I have to go out every night."[44] During the 1970s, when he wasn't at the White House or Halston's apartment, he was often at the decade's leading disco, Studio 54.

Studio 54 appears to have been, for Warhol, a real-life equivalent of his Pop paintings. He has accepted very few images into his art. Some of them are elegant, others are debased. Nonetheless, they achieve a kind of equality once Warhol has had his way with them. Likewise at his favorite disco, of which he says, "it's a dictatorship at the door and a democracy on the floor. It's hard to get in, but once you're in you could end up dancing with Liza Minelli. Or Rollerina, the drag queen bride who dates on skates. At 54, the stars are nobody because everybody is a star."[45] And, Warhol claims, he got lots of work done there—finding subjects for *Interview* covers, recruiting volunteers for Factory work. Nonetheless, he didn't neglect what one might suppose to be his real work, his painting. In the 1960s Warhol had subverted the values of the Manhattan art world. Then, as his Pop subversions grew widely popular—as they made him, in fact, a star in his own right—he looked for images that would revive the original shock of his art. It is doubtful that Warhol's art has deeply disturbed anyone since roughly 1964. Nonetheless, his subjects of the 1970s are unsettling. The first of them was Chairman Mao.

58 In 1972 Warhol began a series of immense paintings from a blandly official photograph of Mao. Along with the new image came a new style, brushy and free, almost expressionist. In 1974 the

59 Musée Galliera in Paris put on a show of these canvases, hanging them over Warhol's purple on white Mao Wallpaper, a reprise of his Cow Wallpaper of 1966. Familiar strategies were at work here. Just as a grid of Disaster images from 1964 repeats the format of a Campbell's Soup Can painting from two years earlier, the Cows of '66 equal Mao of '72. Image mirrors image, not because the two are similar but because any subject displaced from its context and reduced to an emblem shares a deep deprivation with any other sub-

58. *Mao*, 1973
Acrylic and silkscreen on canvas, 26 x 22 in.
Courtesy Leo Castelli Gallery, New York

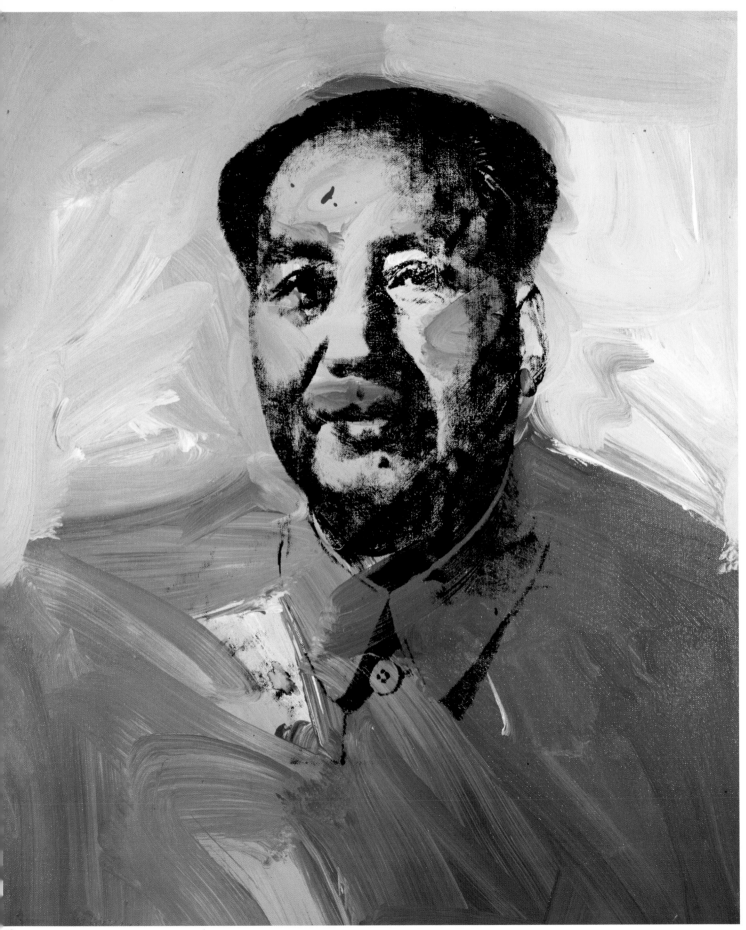

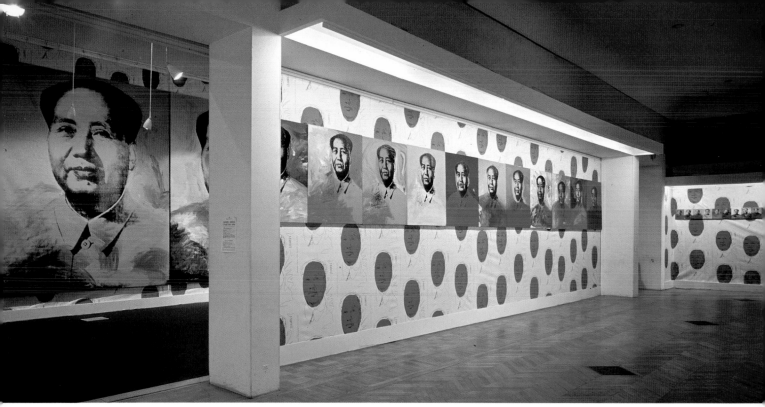

ject treated the same way. So there is tactical continuity linking Warhol's '60s with his '70s. His career is of a piece. Warhol's art can induce claustrophobia, a feeling of imprisonment in a realm where the most extreme divergence—between, say, Liz as Cleopatra and an empty electric chair—collapses under the detachment, the democratic evenhandedness of Warhol's approach. Yet the Cows and the Maos are, after all, sufficiently different that the latter signal a crucial turning in the development of Warhol's art.

At the outset, Warhol insisted on the power of the familiar— whether it was banal (Campbell's and Brillo), vulgar (a gun-slinging Elvis), or unthinkable (highway carnage, suicide, nuclear war). In a world of products, the most successful product is a star, whether it be a singer-turned-movie-actor or an image that haunts the nightly news. Thus Warhol helped expand our idea of the market. It is a place where soup and cleansers are sold, but also where we go for less tangible things—the glamourous auras that surround certain personages and, though we dislike admitting it, certain fears and grisly events. This larger market includes the world of fine art, obviously, for there paintings and sculptures are sold. But not so obviously—until Warhol's art pointed it out with such brutal frankness—the art world is also a vendor of glamour. Warhol challenged us, with his first decade of Pop images, to see how acutely our vision is attuned to the allure of stardom, how often and unconsciously we rely on star-glow for illumination. Even those in the art world who professed to despise Warhol, Lichtenstein, and the rest of the Pop artists tended to substitute art-stars of their own— color-field painters, Minimalists, then Earthworkers and Conceptualists. All of these figures competed in that art market where images and auras, not just objects, are offered for consumption.

Warhol has never objected to this state of affairs, which he did so

59. Installation of *Mao Wallpaper* at *Musée* Galliera, Paris, 1974

60. *Hammer and Sickle*, 1977
Silkscreen on paper, 30 x 40 in.
Courtesy Ronald Feldman Fine Arts, New York

much to reveal—and, indeed, to push to new extremes of sophistication. However, once he had deployed his Pop tactics for a decade, he could hardly spend the next one repeating himself. The Cow Wallpaper, like all of Warhol's 1960s imagery, is a fragment of domesticity, an image drifting into view from the peripheries of everyday life. The Mao faces are just as bovine, perhaps, but alien— one might even say "un-American." Having arrived at the upper levels of the consumer world—those haunts of celebrities where every other face is familiar from the nightly news and the pages of *People* magazine—Warhol opened his art to an icon from China, a nation dedicated to eradicating whatever vestiges of bourgeois consumerism might linger in its citizenry. Now that Chairman Mao has died and been replaced by leaders less hostile to traditional marketplace economies, it is a bit difficult to recall how exotic China seemed to the West just a decade ago. Whether presented as a brutal fanatic or a socialist saint, Mao had the aura of a uniquely single-minded—perhaps even pure—politician. Idealistic and uncompromising, at least in his public pronouncements, he seemed very different from the economic and political leaders of what he called the "decadent" West. Warhol showed uncanny acuteness in introducing the Mao image into his art at a time when the artist himself was just coming to enjoy, full-scale, the benefits of Western "decadence."

Later in the decade, Warhol would exhibit red, white, and black paintings of the Soviet hammer and sickle, another insignia of an alien way of life. In the same year, 1976, he also offered images of 60

60

human skulls, on canvas and in silkscreen prints. Like the cow of the 1964 Wallpaper, the skull is an abiding subject in Western art. Momento mori still lifes have made it so familiar over the centuries that we hardly register its meaning. However, with Warhol's Mao paintings and his Hammer and Sickle images nearby, these Skulls come home to us as emblems of alienation in its most extreme form—death. The critic Peter Schjeldahl has suggested that "the Maos and hammers and sickles relate to the electric chairs and car crashes of the early '60s—the difference being one of class content. The shock value of the earlier painting was in images of plebeian catastrophe, that of the recent paintings in images of historic menace to the ruling class. Warhol offers his patrons both a delicious horror and a promise of emotional mastery over it: they can hang it on their wall."[46] Extending Schjeldahl's remarks to the Skull paintings, one sees how confidently Warhol has made his promises to the audience. These works, with their convincing evocations of death, can also be purchased, framed, and hung on a living-room wall.

During this period, Warhol stepped up his effort to give especially prominent members of his audience a promise of

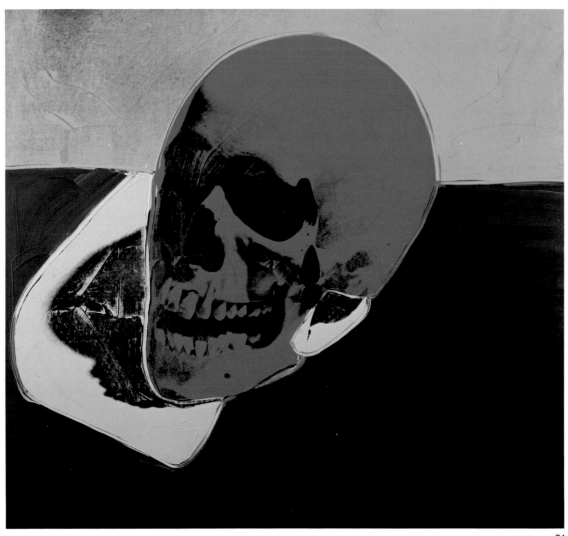

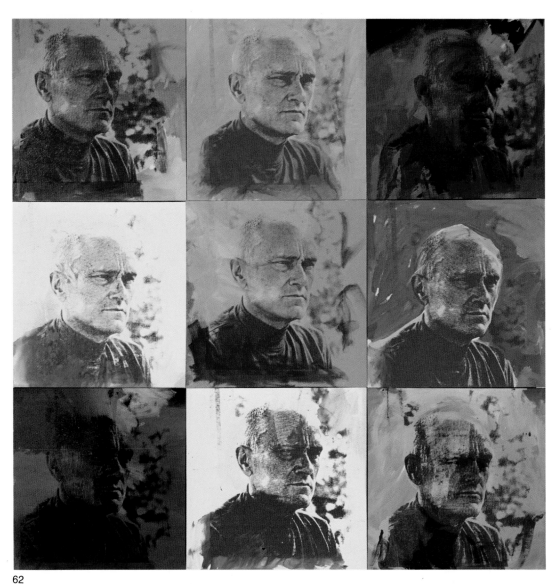

62

61. *Skull*, 1976
Acrylic and silkscreen on canvas, 72 x 80 in.
Courtesy Leo Castelli Gallery, New York

62. *Philip Johnson*, 1972
Acrylic and silkscreen on canvas, 9 panels,
each 96 x 96 in.
Private collection

immortality—an acutely modish version of the formal portrait. These begin with a series of Polaroid snapshots of the patron. The most striking is converted into a high-contrast photo-silkscreen image, which Warhol prints on canvas over brushstrokes of the kind that first appeared in the Mao paintings. These are the *Portraits of the 70s* that formed the subject of a large show at the Whitney Museum of American Art, New York, late in 1979. Warhol deploys an astonishing range of colors and textures in these paintings. His brushy acrylic underlays borrow from the entire repertoire of twentieth-century painterliness. The format of these portraits never varies—two panels, forty inches square, with the black and white image repeated exactly in each panel. Warhol's palette may shift as he goes from the first panel to the second, yet a roomful of these portraits gives the impression of likenesses ground out on an assembly line and then hurriedly decorated to mitigate the harsh, mechanical nature of the process.

In 1972 Warhol broke the rules of this format with a portrait of 62 the architect Philip Johnson. Consisting of three rows of three smallish panels, the painting is eight by eight feet overall. Each

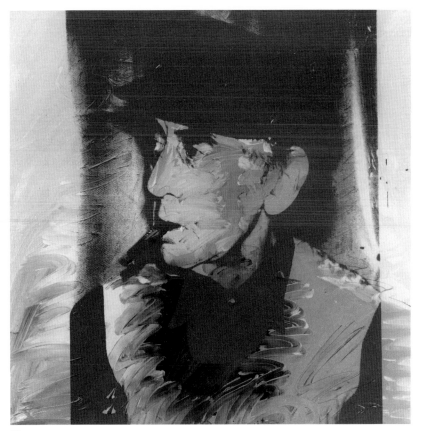

63

bears the same slightly grim image of Johnson, who has long been known as a lively, often ironic presence at the forefront of developments in art and architecture. Warhol flatters most of his portrait subjects—in fact, he has stated that he considers it part of his job to do so. Here he takes a different tack. Perhaps because Johnson is such a prominent figure in Warhol's world, the artist felt no need to improve this subject's image. He presents America's best-known architect as a weathered businessman gazing off to the right at what may well be a dubious prospect for the near-term future. Underlying each of the nine photo-screen faces is an agitated surface of Warhol's mock Action painting. The colors range from icy blue to muddy beige. Some of these acrylic patches echo Johnson's form, others work against it. These variations seem arbitrary, as if the snapshot were an immutable given and the artist's hand could only flutter in its vicinity, applying an accent here and there.

All of Warhol's art has the cosmetic quality of color and pattern laid down to enliven a surface, to generate allure. When one of his images clicks, all of its elements merge into a single plane—that flat barrier behind which, according to Warhol, there is nothing. Yet not every viewer is willing to accept Warhol's assessment of his own depths. Writing in the catalog for the Whitney's *Portraits of the 70s* show, Robert Rosenblum said that Warhol's picture of his mother (1974) breaks through the artist's "aestheticism" to convincing emotion. Here, says Rosenblum, "presides both in clear focus and ghostly fade-outs a photographic image of a bespectacled old lady,

64

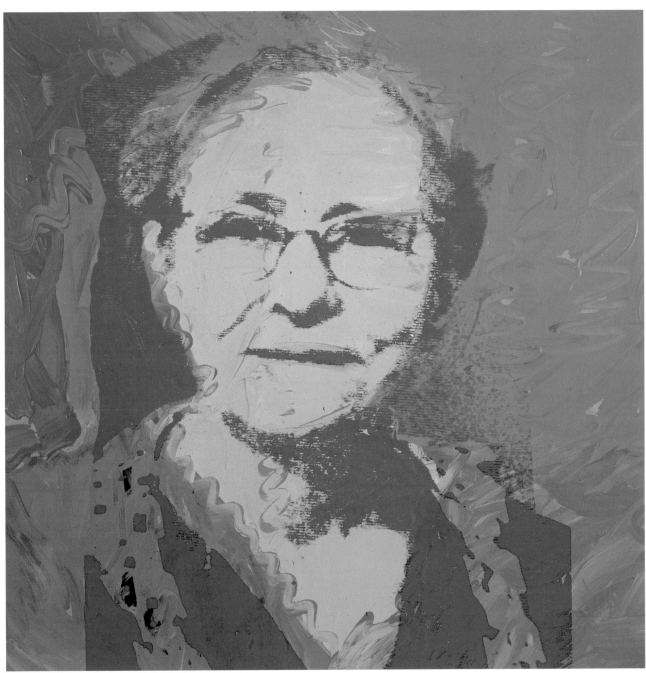

65

63. *Man Ray*, 1974
Acrylic and silkscreen on canvas, 40 x 40 in.
Courtesy Leo Castelli Gallery, New York

64. *Flowers*, 1974
Silkscreen on paper, watercolored by the artist,
41 x 27½ in.
Courtesy Multiples, Inc., New York

65. *Julia Warhola*, 1974
Acrylic and silkscreen on canvas, 40 x 40 in.
Courtesy Leo Castelli Gallery, New York

the artist's mother, a haunting memory at once close and distant. In the midst of this racy and ephemeral company of *Women's Wear Daily* and *Interview,* her glamourless countenance is all the more heart-tugging, an enduring and poignant remembrance of family-things past."[47] One could argue that Warhol has glamourized this domestic presence, his mother, by surrounding her with a halo of delicate—and, furthermore, elegant—color. Or perhaps his portraits of celebrities domesticate them, transforming their power and chic into images of the kind that used to entrance Andy Warhola when he was a bedridden ten-year-old leafing through movie magazines.

66

64 The Flowers of 1974 invite the same double reading. With their fragile delicacy, they recall Warhol's private drawings of the 1950s, not the quasi-abstractions of his 1964 Flowers. These prints have a sweet, homey look. Yet their hominess feels so deliberate, so precisely calculated, that one is not lulled. Warhol has filled the later Flowers, no less than his Maos and Skulls and Disasters, with his determination to establish a surface and to control it, utterly. Flowers appear again in 1974, as a sprightly pattern laid over a pair 66 of prints of the dancer Merce Cunningham. Back to back with the chair he holds behind him, Cunningham leans in profile toward the right-hand edge of the paper. In the second image, the dancer appears twice. Over the original pose, Warhol has printed a second, which brings Cunningham's forehead into contact with the image's border. This is a playful print—a leading figure of the American avant-garde seen through a scrim of wallpaper flowers. And Cunningham is a playful dancer. "I usually accept people on the basis of their self-images," Warhol has said, "because their self-images have more to do with the way they think than their objective images do."[48]

In 1975 Warhol came up with a variant method for arranging color, one that recalls both the garish splotches on the upper eyelids of his Marilyns and the outlined color areas of the Do-It-Yourself paintings of 1962. It evokes traditional collage, as well. This new 67 look appears in two portfolios of ten silkscreen prints: Ladies and 68 Gentlemen, and Mick Jagger. The former is a series of elegant faces, most of them black. Instead of fitting a patch of bright red to a pair of lips, Warhol places a strip of torn paper in the lips' general vicinity. In a printing process that requires up to ten silkscreens, the actual strips of paper disappear, leaving only their collagelike outlines on a smooth surface of Arches paper. Warhol accents eyelids, earrings, the sweep of a scarf the same way. Color is jittery here, unable to settle down. Sometimes bits of red, yellow, and blue spread from the features of a face into a pattern with no discernible purpose save that of activating the image. In the Mick Jagger series, color shifts into a somber range. Though there are hot pinks around eyes and mouth in one of the prints, grays, beiges, and ochers predominate. Warhol conveys Jagger's vividness with harsh contrasts of black and white, slightly out-of-register tracings of the photo-image, and torn-paper effects so violent that color blocks hardly ever match up with the contours of the singer's face. For all their brutality, these images also manage to be delicate.

Warhol carried the manner of his Mick Jagger silkscreens over to

66. *Merce Cunningham I,* 1974
Silkscreen on paper, 30 x 20 in.
Courtesy Ronald Feldman Fine Arts, New York

67. *Ladies and Gentlemen,* 1975
Silkscreen on paper, 39½ x 27½ in.
Schellmann & Kluser, Munich

68. *Mick Jagger,* 1975
Silkscreen on paper, 44 x 29 in.
Courtesy Multiples. Inc.. New York

72

67

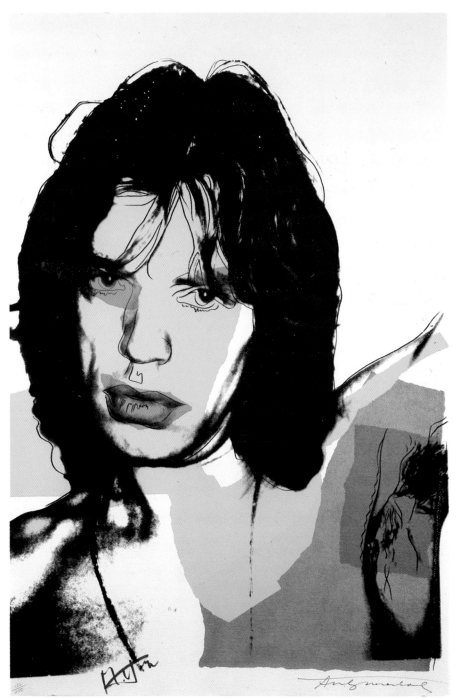

68

73

a pair of Jimmy Carter images in the same medium, though he brightened up the palette a bit. Two years later, in 1977, he published *Jimmy Carter III*, which is black on white—all outline, no free-floating color. The starkness of the image leaves the president's smile looking a bit Dracula-like. This print was accompanied by a cheery bright blue and magenta rendering of Lillian Carter, the President's mother. Our chief executive is a star, no matter which administration is in office, and so are his relatives. For the most part, though, contemporary history has provided Warhol with few portrait subjects. Presidential star glow tends to dim all the other presences in the political arena. During this period, Warhol reached back into his own history for two sitters—his dealer Leo Castelli and Roy Lichtenstein, the Pop painter Castelli chose over Warhol in 1961. *Leo Castelli* (1975) is filled with jarring colors—oranges abut magentas, bluish greens come up against warm yellowish ones. Yet there is a sweet, almost sugary quality to these effects. Castelli's thin, hawklike face looks out with an air of caution. Warhol's *Roy*

69. *Jimmy Carter III*, 1977
Silkscreen on paper, 28¼ x 20½ in.
Courtesy Ronald Feldman Fine Arts, New York

70. *The American Indian* (Russell Means), 1977
Acrylic on canvas, 72 x 84 in.
Courtesy Leo Castelli Gallery, New York

69

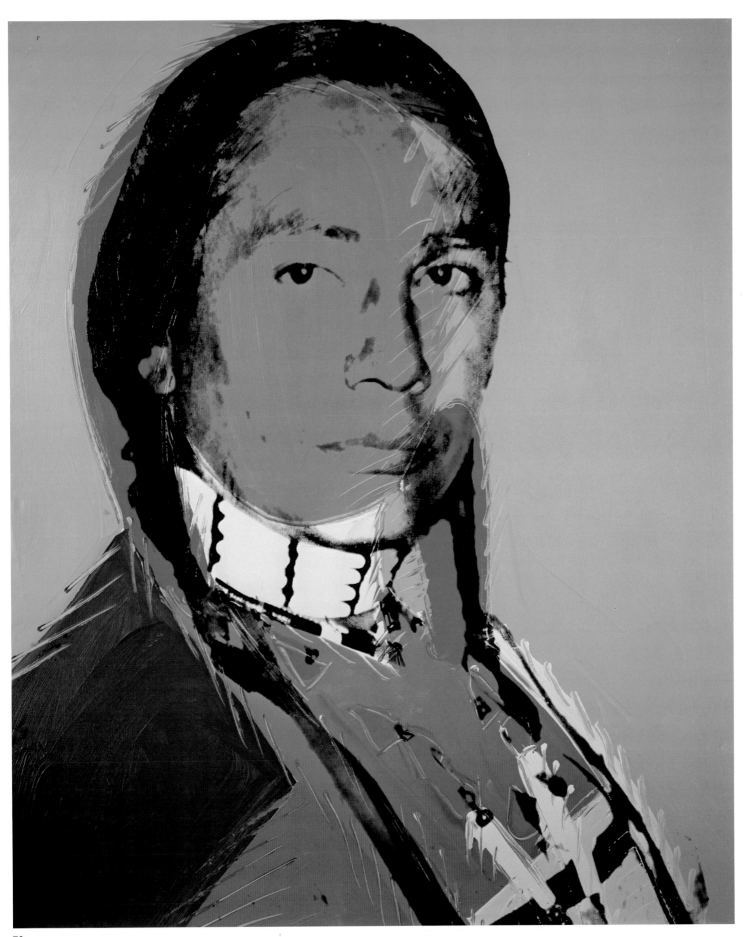

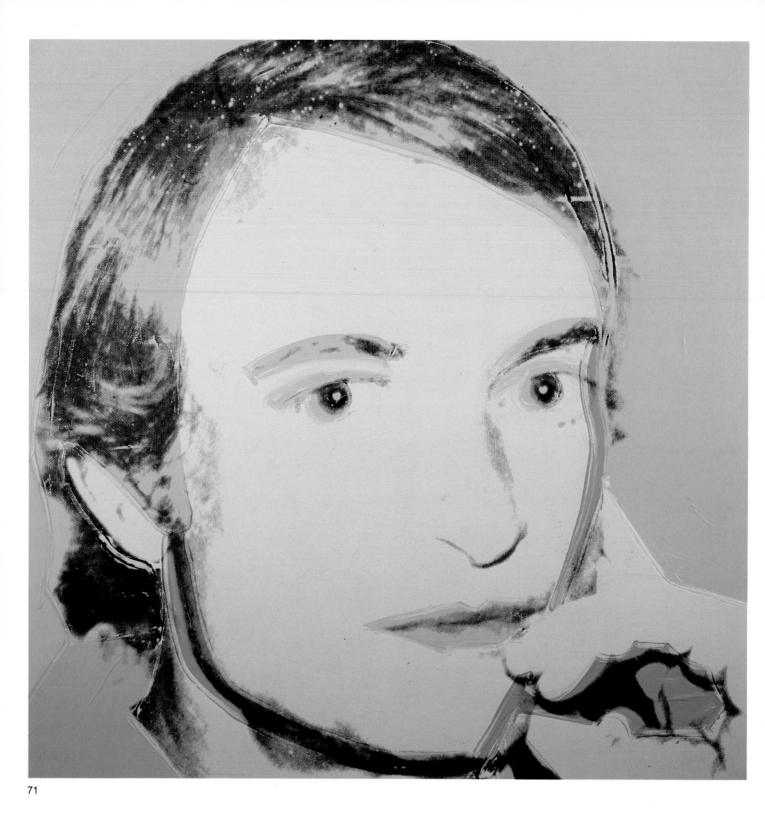

71

71. *Roy Lichtenstein*, 1976
Acrylic and silkscreen on canvas, 40 x 40 in.
Roy Lichtenstein

72. *Leo Castelli*, 1975
Acrylic and silkscreen on canvas, 40 x 40 in.
Courtesy Leo Castelli Gallery, New York

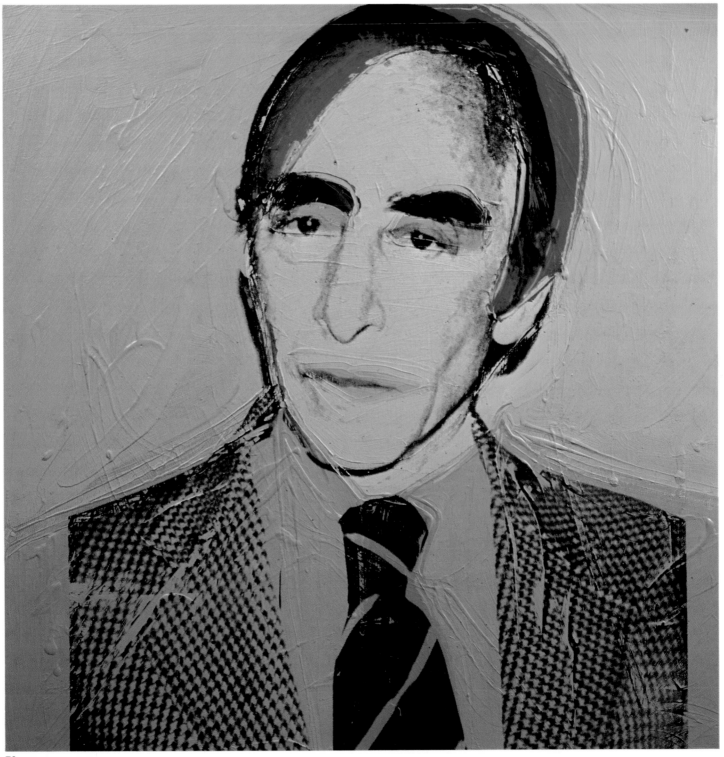

Lichtenstein (1976) is almost laughably tender—sharp features soften into youthfulness, and skin is a spread of baby pink outlined in baby blue.

Warhol's The American Indian (Russell Means) series (1976) shows the same dignified image of a Plains Indian in panel after panel. These canvases recapitulate the repertoire of Warhol's mid-1970s color and gesture. Further, they provide a link between the celebrity portraits and the decade's more threatening images—the Maos, the Hammer and Sickle paintings, and the Skulls. Russell Means, who posed as The American Indian, is a distinctive presence. This is an image of a particular person, a leader in the revolutionary American Indian Movement. Thus, it is an emblem of a challenge as frightening, as alien, to some Americans as "World Communism." Warhol substitutes flourishes of acrylic for traditional war paint, and this is sufficient to domesticate these portraits. They still have a threatening aura, however, all the more so since pictures of the American Indian are capable of arousing pangs of colonialist guilt in Warhol's most sophisticated audience.

The year after The American Indian series, Warhol produced the Torso series, in which a slim male figure turns his back, buttocks, and thighs toward the viewer. Occasionally Warhol exhibited this image upside-down, which pushed it toward abstraction. Yet the outline of a human figure remains clear, no matter how these paintings are displayed. In fact, one could argue that the upside-down position adds a touch of narrative—the hint of bondage, perhaps even torture. With the six silkscreen prints of

73

73. *Sex Parts*, 1978
Silkscreen on paper, 31 x 23¼ in.
Courtesy Ronald Feldman Fine Arts, New York

74. *Gems*, 1978
Silkscreen on paper, 30 x 40 in.
Courtesy Ronald Feldman Fine Arts, New York

75. *Torso*, 1977
Oil on canvas, 50 x 38 in.
Galerie Denise René-Hans Mayer

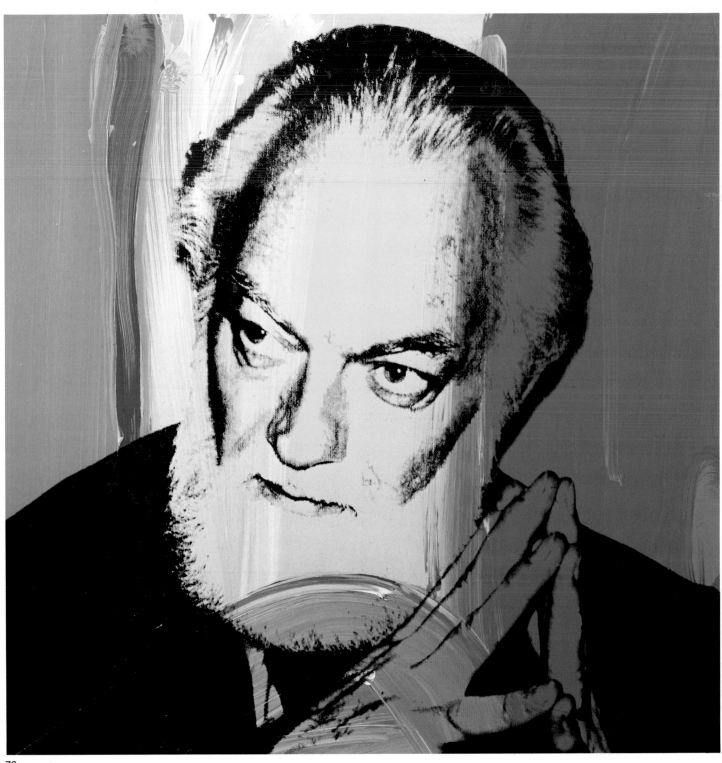

76

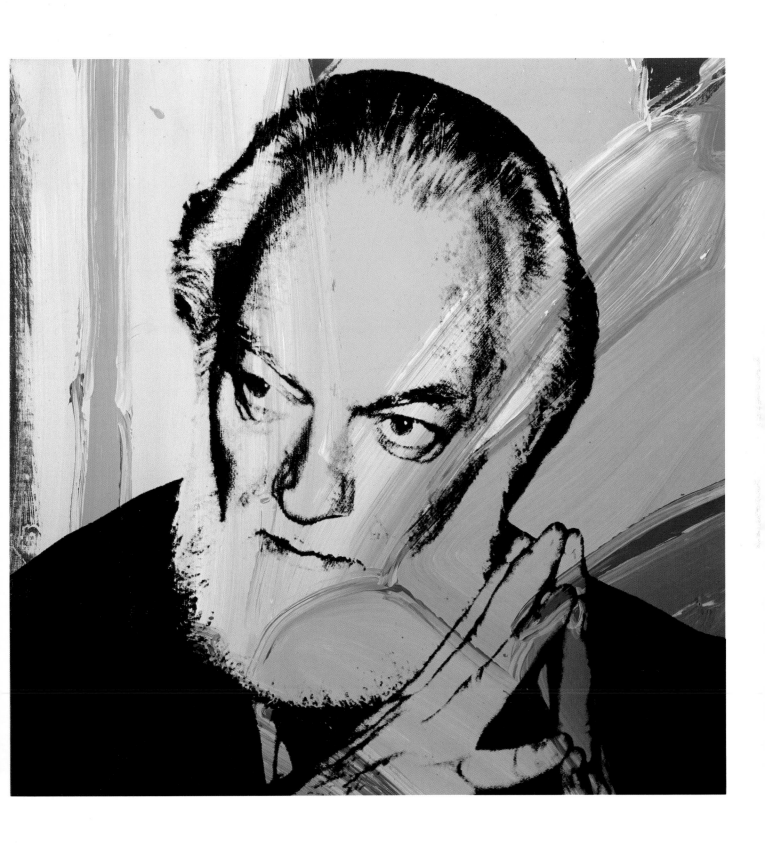

76. *Paul Jenkins*, 1979
Acrylic and silkscreen on canvas, 2 panels,
each 40 x 40 in.
Paul Jenkins

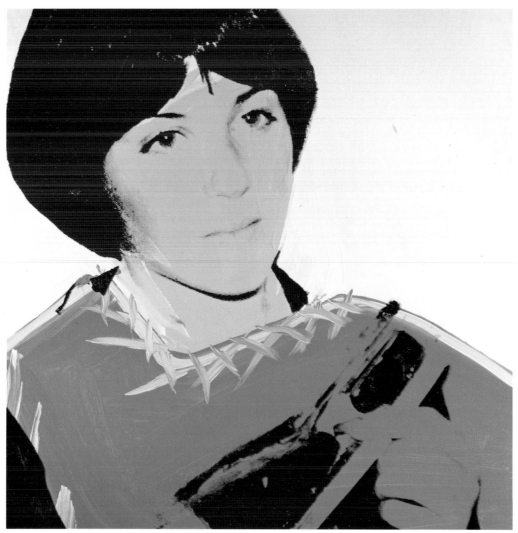

77

73 Sex Parts (1978), Warhol for the first time addressed the theme of violent homosexuality. Each of the prints has a rough black and white photograph of male genitals overlaid with Warhol's scrawling draftsmanship. In *POPism*, Warhol says, "Personally, I loved porno and I bought lots of it all the time—the really dirty, exciting stuff. All you had to do was figure out what turned you on, and then just buy the dirty magazines and movie prints that were right for you, the way you'd go for the right pills or the right cans of food."[49] The more efficiently art or pornography can turn sex into a sheerly visual spectacle, the more fully Warhol approves. Only with the Sex Parts series did he cross the boundary between art and pornography, though each of his prints renders his subjects as impalpable as the bodies in pornographic movies and magazines. All two-dimensional works of art do the same, of course, yet Warhol's style has the power to give allure to untouchability. His art suggests a link between the glamourous and the taboo. Both gain in intensity when only the eyes can possess them—rather, Warhol addresses himself to the voyeuristic side of our characters for which this is the case. When seeing is having, one can control one's experience very tightly. The eye can consume images with precision, as if they were drugs with predictable effects on one's

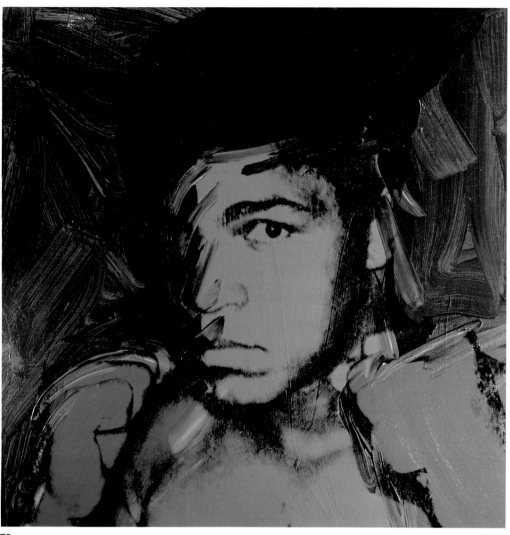

78

77. *Dorothy Hamill*, 1978
Acrylic and silkscreen on canvas, 40 x 40 in.
Richard L. Weisman

78. *Muhammad Ali*, 1978
Acrylic and silkscreen on canvas, 40 x 40 in.
Richard L. Weisman

emotional state.

Gems, another series of silkscreen prints from 1978, are as re- [74] fined (in Warhol's offhand manner) as the Sex Parts are rough. And the Liza Minelli portrait of that year is crisp and sparkling, an up- [57] date of Warhol's movie stars of the 1960s. Once again he lays a bow-shaped patch of red over his subject's lips, though the arcing strips of "eye shadow" are restrained and the texture of Liza's face and of the background behind her head has a new smoothness. With his portraits of the skater Dorothy Hamill, Muhammad Ali, [77, 78] and other star athletes, Warhol runs through his painterly reper- toire once again. Methodically, he annexes another region of star- dom to the universe of his art.

Paul Jenkins spills paint across his canvases in bravura floods. [76] Warhol's portrait of him (1979) mimics this procedure with wide, blurry swatches of color that run from top to bottom of the canvas in complete disregard of his subject's contours. This is really two images—one a black and white photo of Jenkins, the other a gaudy abstraction. Considered on purely formal terms, this portrait does not hold together. Acrylic painterliness refuses to mesh with photo- mechanical reproduction. Yet a knowledge of Jenkins's own work joins the two elements in an emblematic portrait, and one remem-

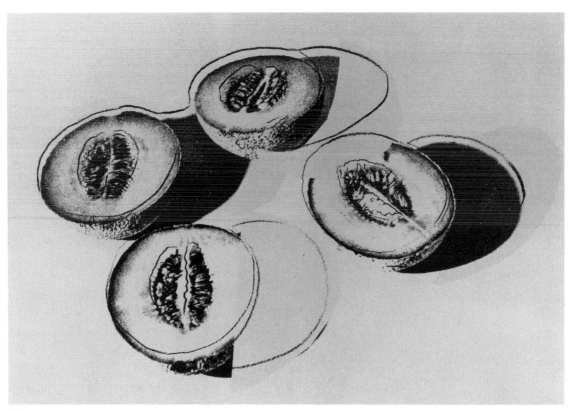

79

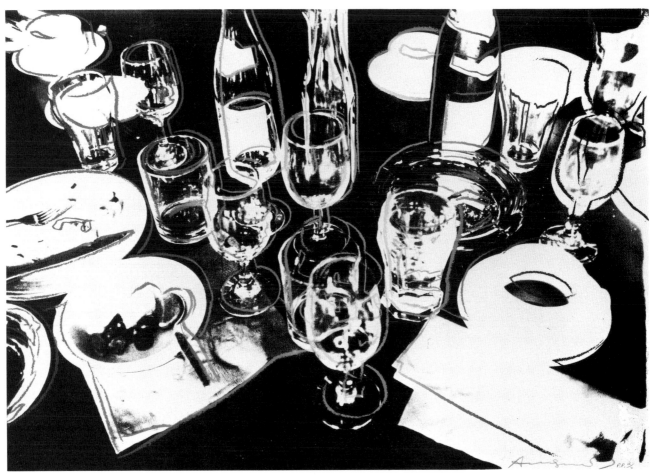

80

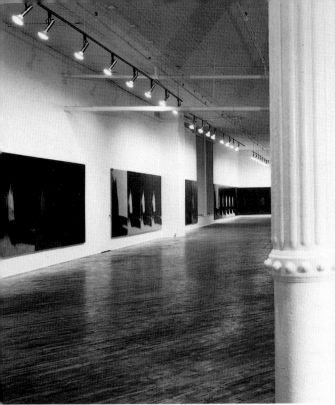
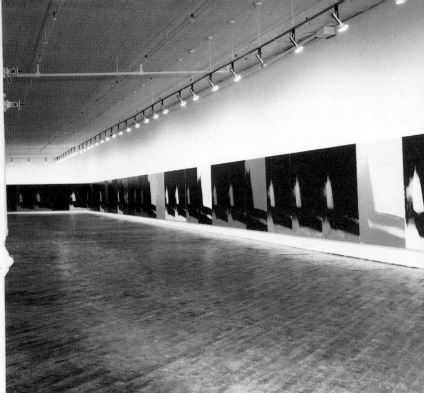

81

79. *Space Fruit: Cantaloupes*, 1979
Silkscreen on paper, 30 x 40 in.
Courtesy Ronald Feldman Fine Arts, New York

80. *After the Party*, 1979
Silkscreen on paper, 21½ x 30¼ in.
Courtesy Ronald Feldman Fine Arts, New York

81. *Shadows*, 1979
Acrylic and silkscreen on canvas, 102 panels,
each 76 x 52 in. An installation of 83 panels
presented by the Lone Star Foundation
Dia Art Foundation, New York
ⁱ Dia Art Foundation, 1979

bers how important to Warhol's work such information has always been. His Soup Cans had the impact they did because we, not only the artist, came to these canvases with deep feelings for (or at least deep familiarity with) Campbell's products. Likewise with all his images. If we hadn't felt their glamour beforehand, Warhol's use of them might well have seemed pointless. He is, then, an extremely "literary" artist, one who expects us to bring a great deal of associated knowledge and feeling to a viewing of his subjects.

With Shadows (1979)—eighty-three versions in various harsh 81 colors of the same ambiguous play of high and low tones—Warhol finally stepped over the border from the figurative to the abstract. If we insist, we can see in the Shadows the corner of a room and a blurry play of light and dark. The title encourages this reading, just as Sunset, attached to a series of prints from 1972, makes it inevita-102 ble that we'll see a roundish blob against a cloudy field of color as a sun sinking toward the earth. Nonetheless, shadows are themselves abstractions of a sort, and it is difficult to see all eighty-three of these panels as pictures of an architectural interior. Sheer repetition numbs the series' figurative content. Warhol has generated this effect throughout his career. Early in the 1960s some critics read his Coke Bottles and Dollar Bills as only ironically representational—filled with recognizable content but interesting chiefly for the formal patterns they spread across the canvas in rigid rows.

Warhol has never stated any concern with the distinctions between abstract and figurative form. His liveliest paintings can be read either way, or perhaps both ways at once. Some motifs—the Disasters, for example—push him toward a kind of realism. Others, like the Shadows, lead him in the opposite direction. Installed in a vast space in New York's Soho district, the Shadows took on the scale of architectural detail—a paint and canvas wains-

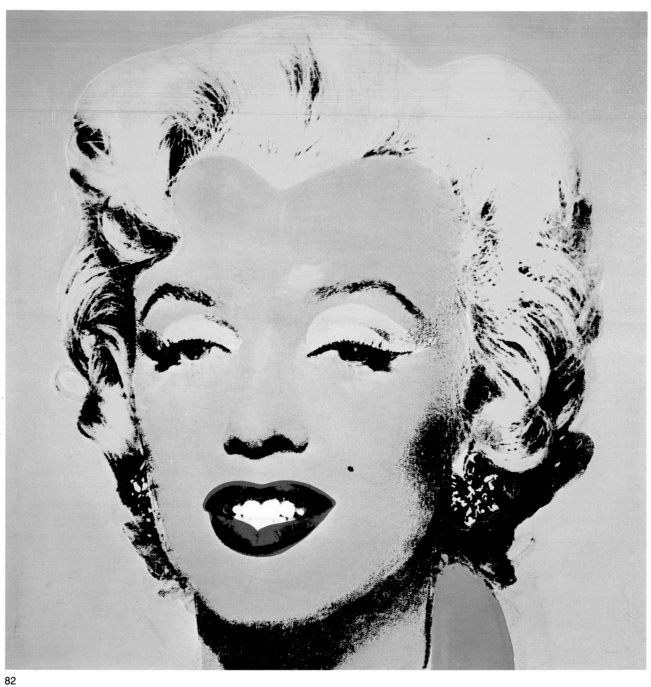

82

82. *Marilyn*, 1964
Silkscreen and oil on canvas, 40 x 40 in.
Courtesy Leo Castelli Gallery, New York

83. *Reversal Series: Four Marilyns*, 1979
Acrylic and silverprint on canvas, 36 x 28 in.
Courtesy Galerie Bischofberger, Zurich

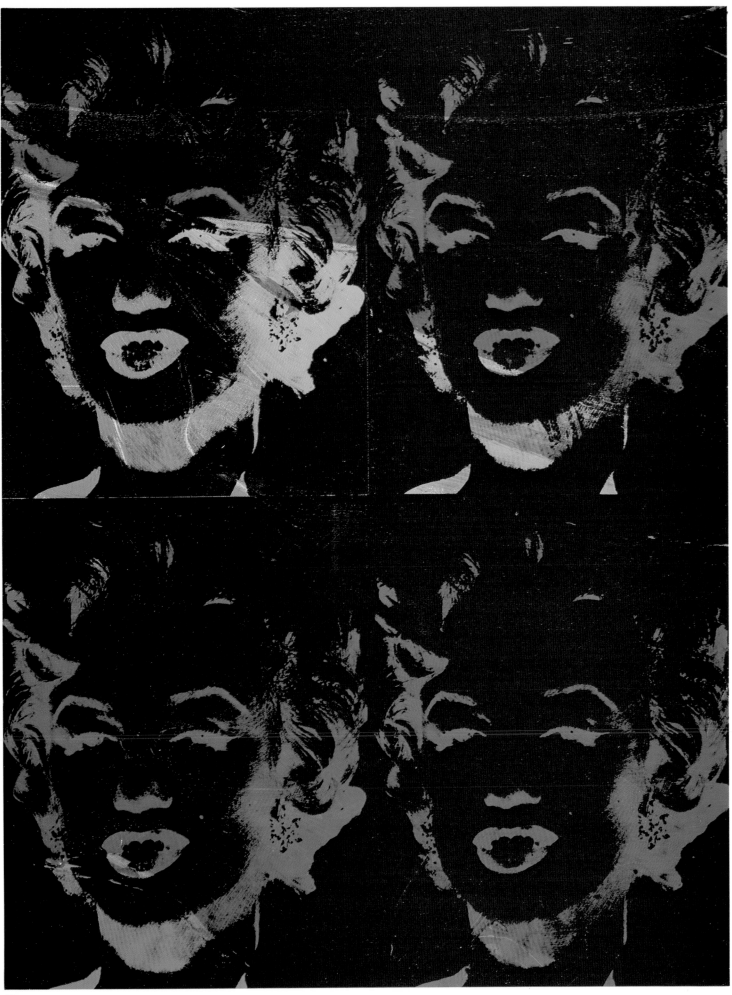

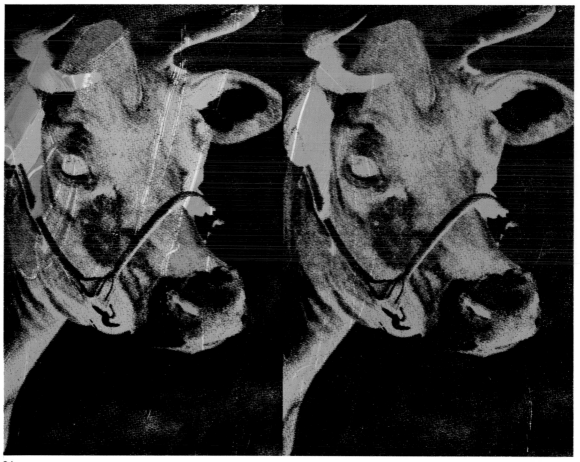

84

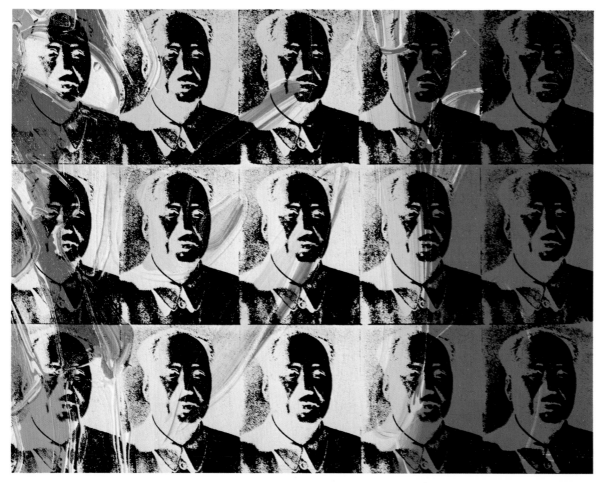

85

86

coting that stretched along three immense walls. For all their garish color, these paintings blended into the background; rather, they were the background. Soon after the installation was opened to the public, a writer for *New York* magazine asked the question journalists have been putting to Warhol for nearly twenty years: the new work is interesting but is it art? Warhol said he would rather think of it as "disco decor."

A silkscreen print called *After the Party*, which also appeared in 1979, takes up a motif familiar from Cubist still lifes, and from the seventeenth century, too—the littered table top. Cups and saucers, bottles and cups sparkle against a dark field, thanks to the high tonal contrast of Warhol's photo image. Because he came in close with a wide-angle lens, these objects seem to stand at various tipsy angles, as if the party's effects had not yet worn off. Looking blurred and shaky, glasses serve as reminders of those who drank from them. Warhol has drawn quick lines of red and yellow around the contours of these forms so that they won't fade out completely. There is a quiet, even a domestic wit to this print. The artist who made it seems not to be, after all, a machine. This Warhol has a taste for the ordinary forms of conviviality, or perhaps we should say, he knows how to present signs of that side of himself.

His Space Fruit silkscreens of 1979 remove peaches, pears, apples, and other such edibles from their usual contexts and launch them against solid blocks of orange, magenta, blue. The backgrounds of these prints read as surfaces from which the fruit seems to be slipping, like apples from Cézanne's table tops. Warhol evokes another modern master here—Matisse, whose late cutouts

80

79

84. *Reversal Series: Two Colored Cows*, 1980
Acrylic and silverprint on canvas, 41¼ x 41½ in.
Courtesy Galerie Bischofberger, Zurich

85. *Reversal Series: Fifteen Small Colored Maos*, 1980
Acrylic and silverprint on linen, 29 x 38 in.
Courtesy Galerie Bischofberger, Zurich

86. *Reversal Series: Retrospective*, 1979
Acrylic and silverprint on canvas, 80¾ x 90 in.
Courtesy Galerie Bischofberger, Zurich

89

seem to have provided the colored shadows of the Space Fruit with their shapes. This oblique homage recalls Warhol's desire, stated in the 1950s, to "be Matisse."

Warhol usually applies positive silkscreen images to painted canvas surfaces. With his Reversals (1979–80) he substituted nega-
83 tives of five earlier motifs—Mona Lisa and Marilyn (both 1962),
84, 85 the Electric Chair (1963), Cow Wallpaper (1966), and Mao (1972). This produced a largely black surface, with wide, brash streaks of color showing through the areas that are dark in the original. The Reversal series provides Warhol's career with a troubling mirror, a night version of itself. Sometimes the negative image is so heavy, so thoroughly black, that it sends a wave of gloom sweeping through the canvas. More often, the effect is theatrical, melodramatic after

87

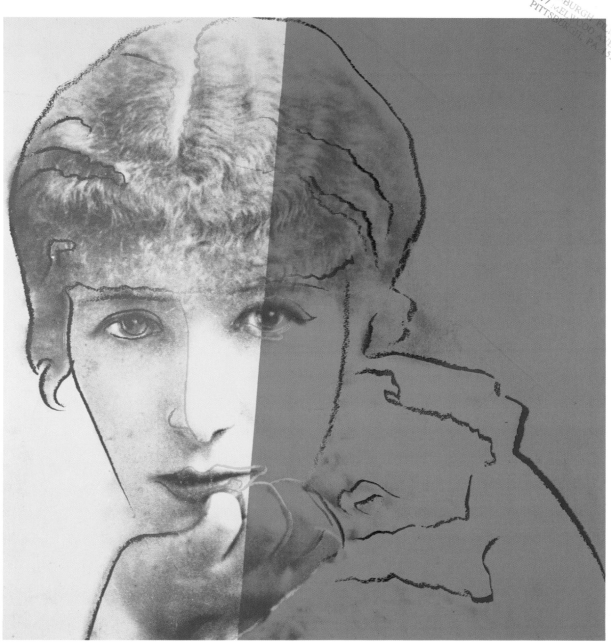

88

87. *Ten Portraits of Jews of the Twentieth
Century: Franz Kafka*, 1980
Acrylic on canvas, 40 x 40 in.
Courtesy Ronald Feldman Fine Arts, New York

88. *Ten Portraits of Jews of the Twentieth
Century: Sarah Bernhardt*, 1980
Acrylic on canvas, 40 x 40 in.
Courtesy Ronald Feldman Fine Arts, New York

a Gothic fashion. The reversed Marilyns, especially, have a lurid 83
glitter. Invoking the dark side of glamour, Warhol suggests that it is
even more glamourous than the varieties of allure to which we've
grown accustomed.

Warhol carried the Reversals on into 1980, along with a series
called Retrospectives, also begun in 1979. Each of the canvases in 86
this latter series combines images from several earlier series, some
screened in negative, some not. The Retrospective paintings, most
of which are huge, include the Campbell's Soup Can, Car Crash,
and Marilyn (all 1962); the Electric Chair (1963); Flowers, Self-
Portrait, and Kellogg's Corn Flakes (all 1964); Cow Wallpaper
(1966); and Mao (1972). Approaching in size the gallery walls
where they were hung, the Retrospective canvases seemed to pro-

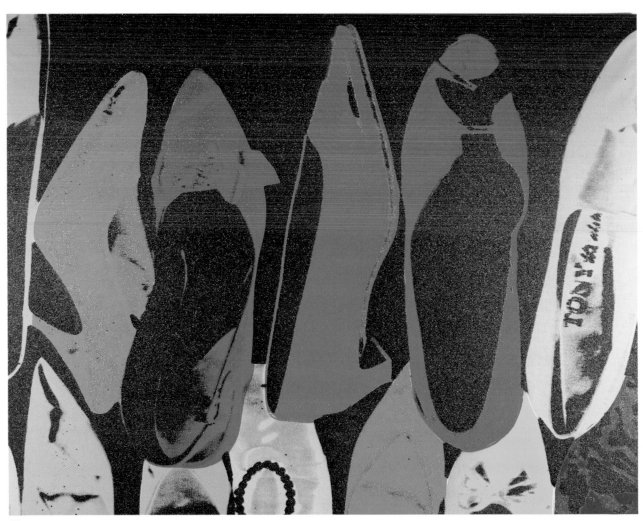

89

vide Warhol's images with a habitat in which they could, after nearly two decades, come to rest—a safe house built from the images themselves. With his Reversals and Retrospectives, Warhol very nearly imposed a self-enclosed structure on his career. These works from 1979–80 make explicit the claustrophobic narrowness that has turned Warhol's art in on itself from the beginning. As we've seen, each of his works is a variant on a single subject: stardom. Warhol's graphic brilliance is at the service of his will, which has made his art a realm of mirror images. However, his brand of claustrophobia is expansive—there is always room in his art for a new image. Warhol might well have stymied himself with the neat finality of the Reversals and the Retrospectives. Instead, he entered the 1980s with a subject that revived his print-making style of the mid-'70s, as if his negative Marilyns, his night versions of Mao, had never appeared. Warhol's Ten Portraits of Jews of the Twentieth Century take up where his Mick Jagger and Jimmy Carter left off in 1975 and '77. Once again, large color-shapes do and, more often, do not match the contours of a face. The artist's pencil line drifts and squiggles in its familiar manner. And Warhol continues to display his skill at picking a photo-image that captures the

89. *Diamond Dust Shoes*, 1980
Acrylic and silkscreen with diamond dust on canvas, 70 x 90 in.
Courtesy Leo Castelli Gallery, New York

90. *Joseph Beuys*, 1980
Acrylic and silkscreen with diamond dust on linen, 100 x 80 in.
Collection Marx, Berlin

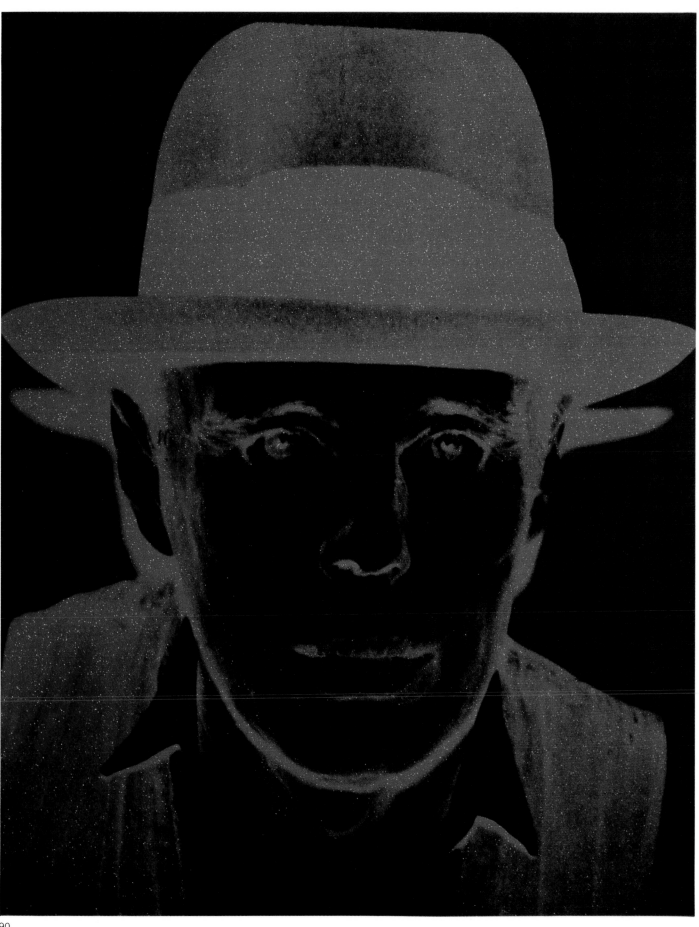

attention with a sharp flash. Even when, as with Martin Buber and Louis Brandeis, a face is not familiar to most viewers, the picture Warhol has chosen comes into focus with the efficiency of a trademark. Ten Portraits of Jews of the Twentieth Century ranges from Albert Einstein and Golda Meir to the Marx Brothers and George Gershwin. Kafka, Freud, Gertrude Stein, and Sarah Bernhardt also appear. Warhol doesn't suggest that, say, George Gershwin's contribution to the century is comparable to Einstein's, only that their images have achieved an approximately equal stature.

Warhol's calculations about stardom always show a demographer's coldness, so his crushes on the glamourous presences of our time never leave him dazed. Glitter is a commodity, and with the Diamond Dust Shoes of 1980 he offered it as a palpable fact. Where the surfaces of these paintings go dark, there is a layer of "diamond dust"—actually a powder produced in the manufacture of industrial diamonds. The canvases of the Diamond Dust Shoes series sparkle, literally, picking up light and sending it over the image in a rough, glowing texture.

Warhol also used "diamond dust" in his portraits of Joseph Beuys (1980). Beuys is a complex and disturbing artist, until recently one of the very few in his native West Germany to confront the questions of fascism and world war. Driven by an anguished conscience and a need to burrow deep into his own fears and obsessions, he is profoundly different from Andy Warhol. All the two have in common is their notoriety. This, of course, is the subject of Warhol's Joseph Beuys paintings, which show the German artist's anxious, charismatic face—topped by a fedora, one of his sartorial trademarks—staring up out of a sparkling field of "diamonds."

In the 1960s Warhol imaged forth entire dollar bills, usually in neat rows, though he sometimes scattered them over canvas. In the Dollar Signs of 1981 he isolated the dollar's symbol, the barred S, rendering it in the breezy, sketchy style that his prints of the last ten years have made so familiar. The critic Thomas Lawson said in response to this series that "Warhol's work has always been empty but now it seems empty-headed. Its great strength was to project nothing. . . . But that nothingness has now developed into something banal, unfortunately proving right all those critics who always hated Pop Art."[50]

The following year, Warhol included his Oxidation paintings (1978) in the exhibition Documenta 7, the immense international show that takes place every five years in Kassel, West Germany. These are delicate, somewhat vacuous abstractions—or that is how one reads them before learning that Warhol made these images by urinating on bronze-coated canvases, which produced blandly attractive patterns. With the Oxidation series, Warhol seems at last to express a clear attitude toward his art: utter contempt. Or is he contemptuous of himself? Of his audience? There is also the possibility that Warhol's Oxidation process is a vicious, infantile mockery of Jackson Pollock's paint slinging. Between Warhol's intention and its result an immeasurable distance unfolds. Considering how it was executed, the prettiness of the Oxidation images is disturbing. Yet these canvases are as blandly attractive as any Warhol has ever made, including the pastel-tinted Sunsets of 1972. Perhaps he

91. *Dollar Signs*, 1981
Acrylic and silkscreen on canvas, 90 x 70 in.
Courtesy Leo Castelli Gallery, New York

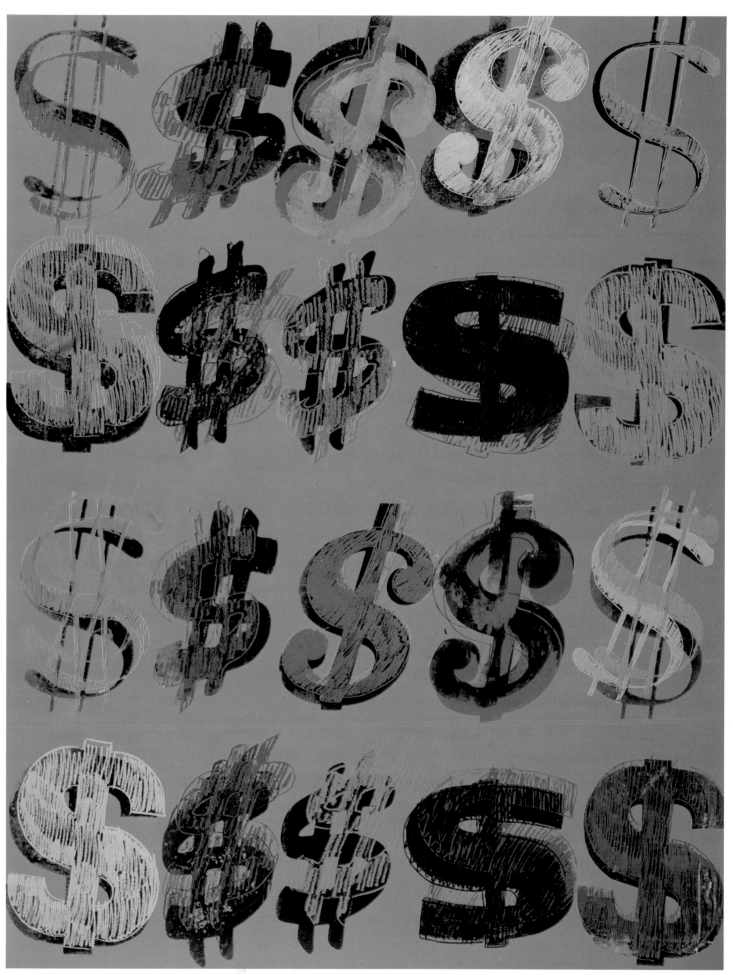

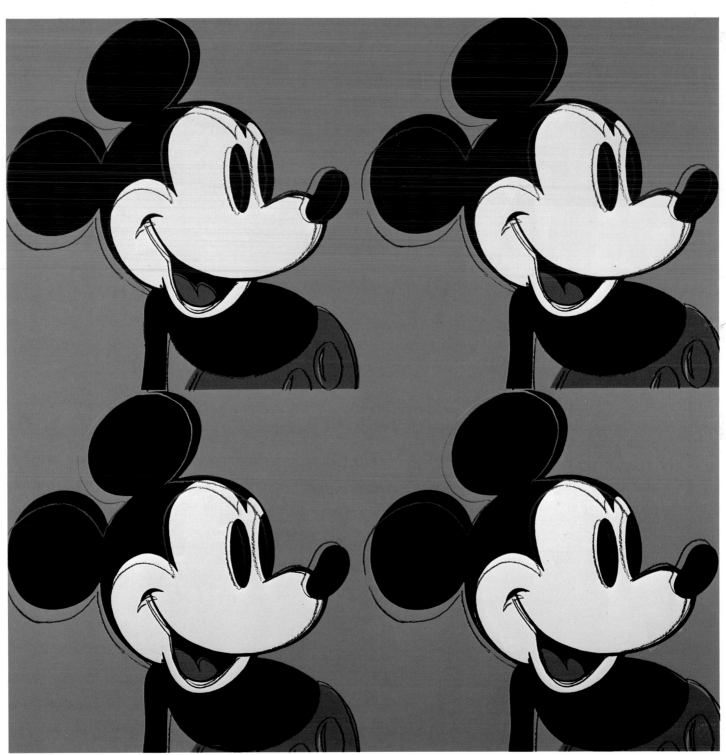

meant no insult to himself or anyone else. Warhol may see urination as simply a way of finding an image, no better or worse than any other. This is unlikely, of course, yet the fact that it might just possibly be the case tells us something about this artist. At least a part of him has always stayed in touch with the nothingness, the vacuum beyond the surface, to which he declared himself devoted well over a decade ago.

Warhol is not, after all, a machine (though he is rumored to have commissioned an Andy Warhol robot capable of answering the sorts of questions journalists and students tend to ask). He is, like all of us, possessed of an inward life. And, as we've seen, his artworks open onto a realm of strong emotions, a gamut ranging from terror to adoration. Yet the private Warhol has always been hidden and seems likely to remain so. His Self-Portraits have changed over the years while remaining the same in their impenetrability. In 1966–67 Warhol assumed a reserved pose for the camera, then let his 1960s palette block out much of the resulting snapshot image. During the 1970s his poses loosened up a bit, in concert with his newly painterly style. There are a number of double and triple images among the Self-Portraits of that decade. They often show him startled—even dismayed—as if he were still not used to the sight of the Polaroid camera. Sometimes he repeats the same shot when he imprints a canvas; elsewhere he offers two or three variations. In 1978 Warhol combined a profile of himself with a three-quarters and a seven-eighths view. For this canvas, he let the focus go soft, erasing most of the lines of his face. His expression is alert and open, if not quite friendly. He has made himself good-looking in a bland, unexceptional way. This *Self-Portrait* recalls Warhol's remark that he "always wanted Tab Hunter to play me in a story of my life—people would be so much happier imagining that I was as handsome as . . . Tab. . . ."[51] Then, after Warhol made the Reversals and the 1970s had ended, he reappeared as one of the figures in his series of Myths (1981).

Among these Myths are *Mickey Mouse*, *Superman*, an Aunt-Jemimah-like *Mammy*, and *Dagwood*, the archetypal comic-book husband. Warhol presents himself as *The Shadow*, who was originally the unseeable hero of a crime serial on radio. Here a ravaged three-quarters profile of the artist looks out at the audience from the right side of the canvas. This portion of the painting is a dark, reddish brown. The rest is a bright cold blue bearing the elongated shadow of Warhol's face. This silhouetted profile refines his nose and chin, strengthens his jaw and, in general, gives him a severe sort of good looks. *The Shadow* recirculates all of Warhol's ruminations about surface and image. It shows the detachment of the Self-Portraits of the 1960s, the directness that appeared now and then in the '70s, and the ambiguity that fills all his work. Which is the real "Shadow," the delicate profile against its blue background or the battered face that observes us from a narrow strip of gloom?

Both and neither. Warhol's integrity consists of an unrelenting indifference to integrity's usual forms—clear stylistic development, strong point of view, a persistent struggle for high quality. He shows us the allure of the amoral power available to the artist whose only concern is to insure that his images are among the season's most

92. *Myths: Mickey Mouse*, 1981
Acrylic on canvas, 60 x 60 in.
Courtesy Ronald Feldman Fine Arts, New York
This interpretation created and copyrighted by
Andy Warhol is derived from an original version of
Mickey Mouse copyrighted © Walt Disney
Productions.

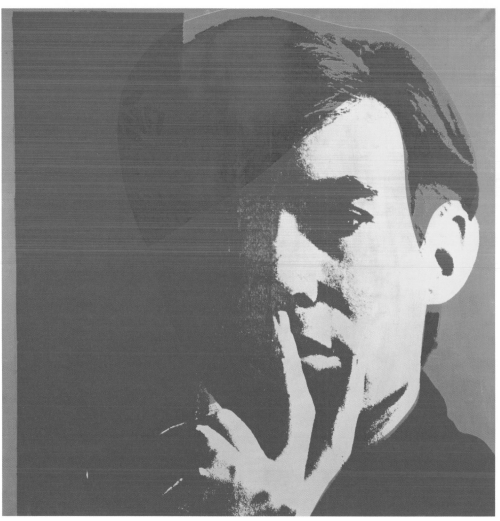

93

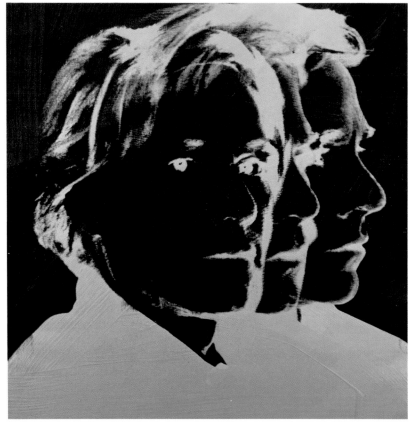

93. *Double Self-Portrait*, 1967
Silkscreen on canvas, 72 x 72 in.
Founders Society Purchase, Friends of Modern
Art Fund
Courtesy of The Detroit Institute of Arts

94. *Self-Portrait*, 1978
Acrylic and silkscreen on canvas, 40 x 40 in.
Courtesy Leo Castelli Gallery, New York

95. *Myths: The Shadow*, 1981
Acrylic on canvas, 60 x 60 in.
Courtesy Ronald Feldman Fine Arts, New York

94

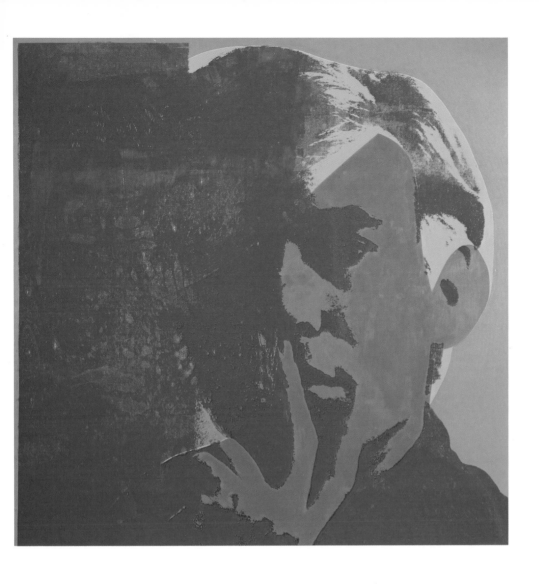

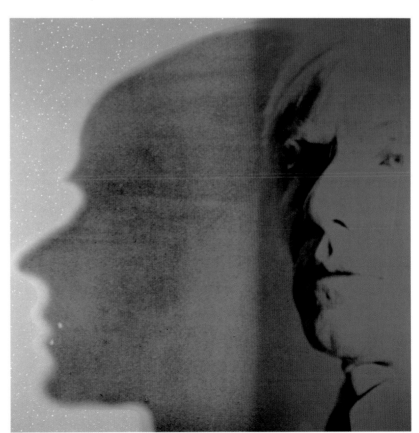

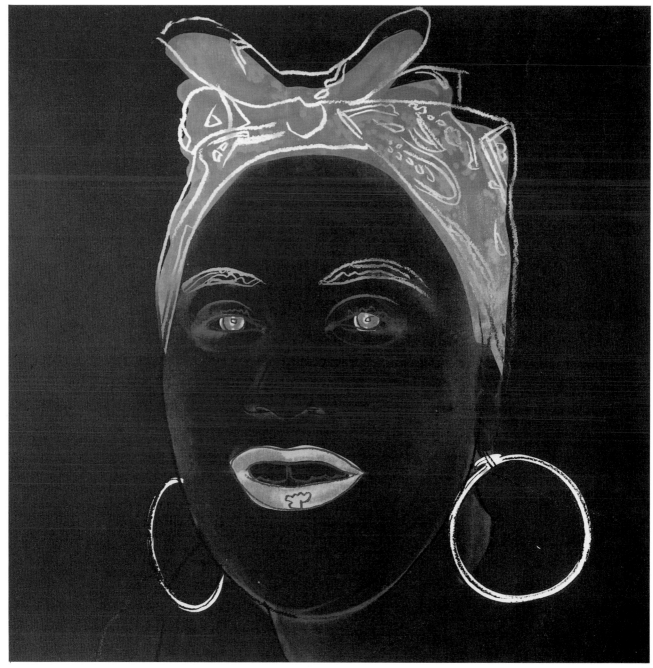

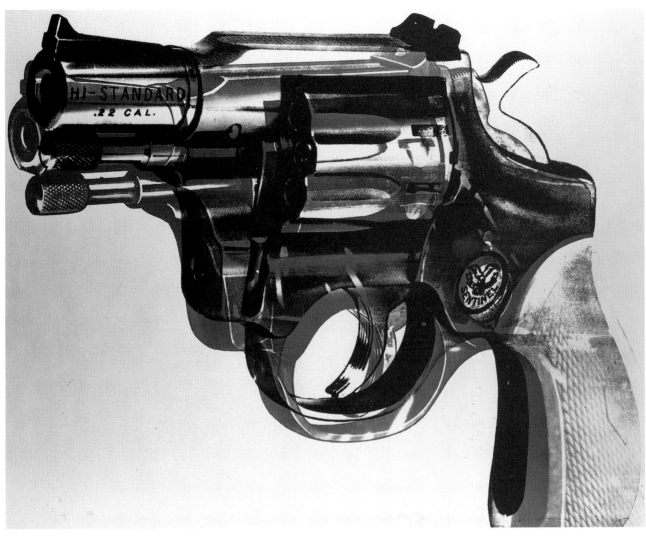

97

96. *Myths: Mammy*, 1981
Acrylic on canvas, 60 x 60 in.
Courtesy Ronald Feldman Fine Arts, New York

97. *Gun*, 1981
Acrylic and silkscreen on canvas, 70 x 90 in.
Courtesy Leo Castelli Gallery, New York

successful. Writing in the *New York Review of Books* in 1981, the critic Robert Hughes said that "It scarcely matters what Warhol paints; for his clientele, only the signature is fully visible. The factory runs, its stream of products is not interrupted, the market dictates its logic. . . . Style, considered as the authentic residue of experience, becomes its commercial-art cousin, styling."[52] Given Hughes's devotion to the early twentieth-century's high modernist painting, these remarks are perfectly fair. Warhol has never cultivated the searching intelligence of, say, Georges Braque or Piet Mondrian. Much less has he tried to match Pablo Picasso's blend of aesthetic adventurousness and respect for Western culture's grand heritage. In Warhol's world of Liz and Marilyn and Campbell's soup there is room neither for Picassoid Minotaurs nor for references to the cycle of ancient myth at whose center stands the labyrinth where the Minotaur lives. Warhol's Myths reside in the funny papers, in movies and ads. And in the mirror. Warhol nurtures the nonlife, the undeath of glamour. He has said that he is "obsessed with the idea of looking in the mirror and seeing no one, nothing."[53]

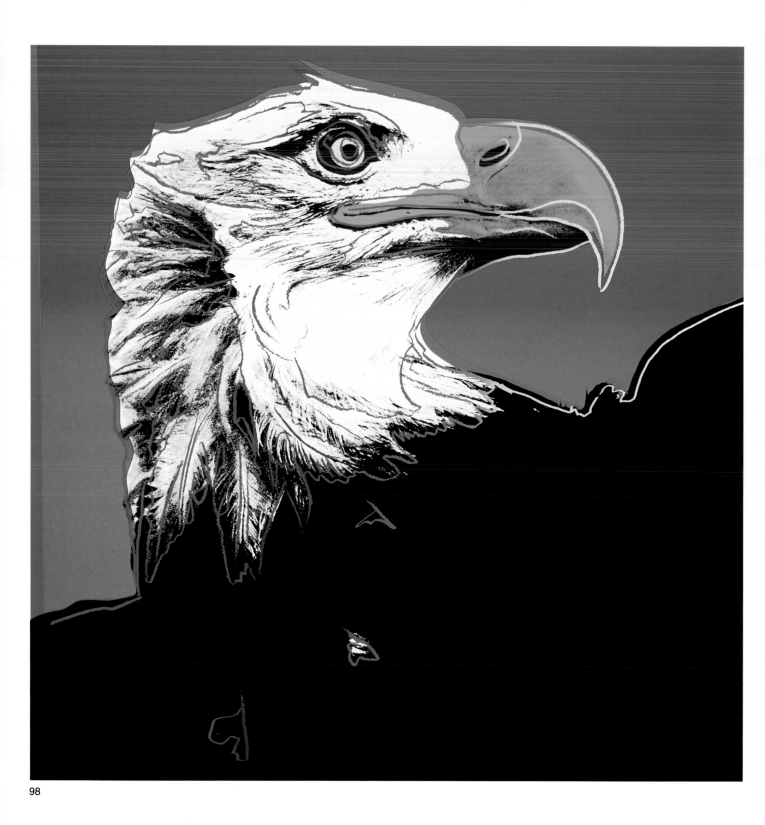

98

98. *Endangered Species: Bald Eagle*
(Haliatus Leucocophalus), 1983
Silkscreen on museum board, 38 x 38 in.
Courtesy Ronald Feldman Fine Arts, New York

This is a terrifying prospect, yet Warhol's art, in sum, may express a yearning for that consummation, that ultimate blankness.

Warhol is sometimes dismissed—or condemned—as unfeeling, an artist who has built a career from the exploitation of others' images and, indeed, other people. Of all the artists, poets, film makers, actors, and musicians who surrounded him in the 1960s, only the rock star Lou Reed survived with a career intact. Some, like Edie Sedgwick and Andrea Feldman, self-destructed. It is far from clear, however, that Warhol should be held responsible for others' failures, though there is no doubt that his art and way of life raise sharp moral questions. On balance, he emerges as not guilty, though this is no simple verdict.

Chance (or the "aleatory," as modernist theory calls it) entered advanced literature in the poems of Stéphane Mallarmé. The Dadas and the Surrealists introduced effects of chance into art. Jackson Pollock worked it into the very textures of his paint. But only Warhol, with his hypersensitive passivity in the face of life and art, has left himself wide open to currents and crosscurrents he cannot control, only inflect. His extreme permissiveness leads to an aesthetic of seeming indifference to values, meanings, and consequences. There is nothing redemptive about his art. He appropriates an image not to improve it but to leave it blunter, starker, more aggressively itself than before. And, in front of his 16mm. Bolex movie camera, his "superstars" seem to have discovered parts of themselves that might have remained hidden forever. Some of these discoveries were disastrous. Likewise, Warhol's most violent paintings and prints confront us with aspects of American life we might prefer to forget.

This is hardly to be deplored. In fact, Warhol's skill at encouraging difficult meanings to come to light can be seen as a latter-day contribution to a long history: the Romantic, then modernist, struggle to focus the light of art on all that ordinary life tries to obscure. There is, of course, a strain in the attempt to link Warhol to such Romantics as William Blake and Eugène Delacroix, such Utopian modernists as Piet Mondrian and André Breton. With deadpan—and persistently charming—wit, Warhol displaces visionary impulses from the inner to the outer world, from the realm of exalted thought and emotion to that of everyday banality, the part of life that even high art tends to censor. There is a quality of genius to Warhol's passive manipulation. Certainly he is one of the most influential artists of the last two decades. In America and Europe, his version of Pop has provided numerous younger artists with starting points for their own, often highly successful careers. Most recently, he has served as a major source for a much-heralded "return of the figure." Needless to say, the figure in question is an inhabitant of Warhol's world of consumer products, celebrity photos, and blue-chip art styles, not the academy's life class.

Warhol dedicates his art to the only beauty specific to our times —the allure of the transient, the disposable, the "merely" glamourous. We are still alive to the refinement of Western art's antique beginnings, to the intellectual rigor of the Renaissance and the heroism of the early modern. Yet we are, of necessity, most intimate with the present. Warhol teaches us to accept this intimacy,

to see the late twentieth century—all of it—as astonishingly rich in its flirtation with nothingness. His most powerful images lead directly to the heart of ordinary experience which, like it or not, we all share. More than any other artist of the postwar period, Warhol has reinvented the premises of the aesthetic enterprise.

N O T E S

1. *Andy Warhol*, exhibition catalog (Stockholm: Moderna Museet, 1968), n.p.

2. Andy Warhol, *The Philosophy of Andy Warhol (From A to B and Back Again)*, p. 2.

3. Ibid., p. 21.

4. Jean Stein, with George Plimpton, *Edie: An American Biography* (New York: Alfred A. Knopf, 1982), p. 185.

5. *Philosophy*, pp. 21–22.

6. *Edie*, pp. 185, 187.

7. *Philosophy*, p. 22.

8. *Edie*, p. 187.

9. Ibid., p. 189.

10. James Fitzsimmons, "Irving Sherman, Andy Warhol," *Art Digest* 26 (July 1952): 19.

11. Andy Warhol and Pat Hackett, *POPism: The Warhol Sixties*, pp. 11–12.

12. Parker Tyler, "Andy Warhol," p. 59.

13. Calvin Tomkins, "Raggedy Andy," in John Coplans, *Andy Warhol*, p. 10.

14. *Edie*, pp. 194–95.

15. *POPism*, p. 6.

16. Ibid., p. 3.

17. Ibid., p. 24.

18. Gene R. Swenson, "Andy Warhol," p. 15.

19. *Edie*, p. 208.

20. Ibid., p. 206.

21. *POPism*, p. 60.

22. *Edie*, p. 206.

23. Ibid., p. 201.

24. *POPism*, p. 42.

25. *Andy Warhol*, Stockholm, n.p.

26. *Edie*, p. 243.

27. Ibid., p. 228.

28. Ibid., p. 234.

29. *Philosophy*, p. 44.

30. *Edie*, p. 226.

31. *POPism*, p. 17.

32. Ibid., pp. 17–18.

33. Ibid., p. 113. When Warhol entered his "retirement," he was just making the changeover from silent to sound movies. *Lonesome Cowboys* (1967), *Blue Movie* (1968), *Flesh* (1968), and *Trash* (1970) are color movies with sound tracks. Their technical quality began to approach a commercial level as a film maker named Paul Morrissey became the alter ego of Warhol-the-director—much as Gerard Malanga had been for Warhol-the-painter. With his versions of *Dracula* (1974) and *Frankenstein* (1974), Warhol made a bid for marketplace success. Although they did moderately well at the box office, these movies have an afterlife only as cult objects. Their appeal even when new may

have owed as much to Warhol's aura as to their scariness, which is not convincing.

34. *POPism*, p. 131.

35. Ibid., p. 133.

36. Ibid., p. 134.

37. Ibid., p. 149.

38. Ibid., p. 247.

39. Ibid., p. 277.

40. Ibid., p. 285.

41. "People," *Time* 94 (October 17, 1969): 48.

42. Peter Gidal, *Andy Warhol, Films and Paintings*, p. 11.

43. Andy Warhol, *Exposures*, p. 196.

44. Ibid., p. 19.

45. Ibid., p. 48.

46. Peter Schjeldahl, "Warhol and Class Content," p. 118.

47. Robert Rosenblum, *Andy Warhol: Portraits of the 70s*, p. 20.

48. *Philosophy*, p. 69.

49. *POPism*, p. 294.

50. Thomas Lawson, "Andy Warhol," p. 75.

51. *POPism*, p. 248.

52. Robert Hughes, "The Rise of Andy Warhol," p. 8.

53. *Philosophy*, p. 7.

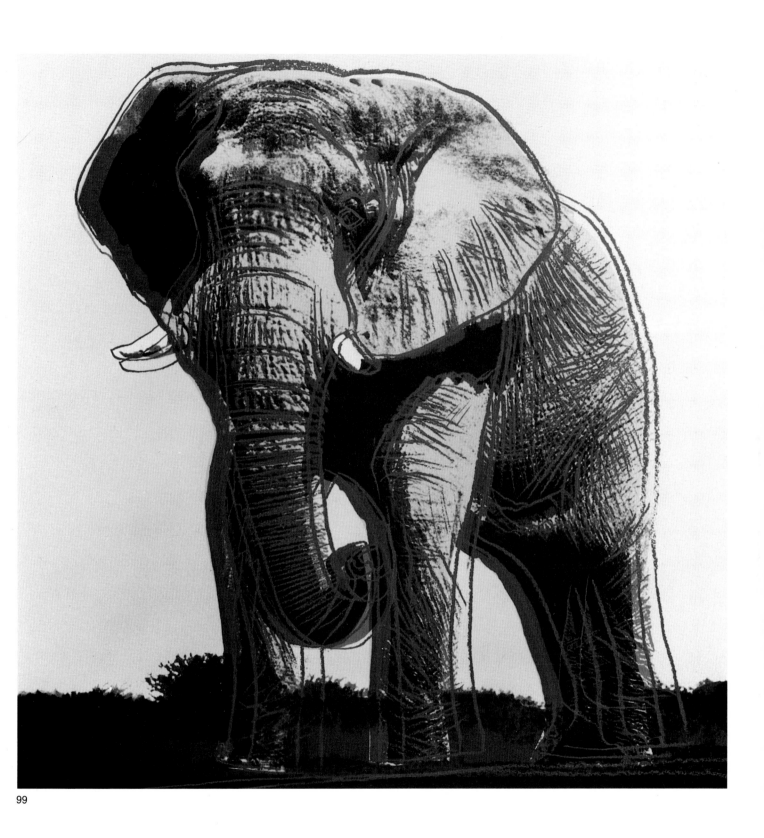

99

99. *Endangered Species: African Elephant*
(Loxodonta Africana), 1983
Silkscreen on museum board, 38 x 38 in.
Courtesy Ronald Feldman Fine Arts, New York

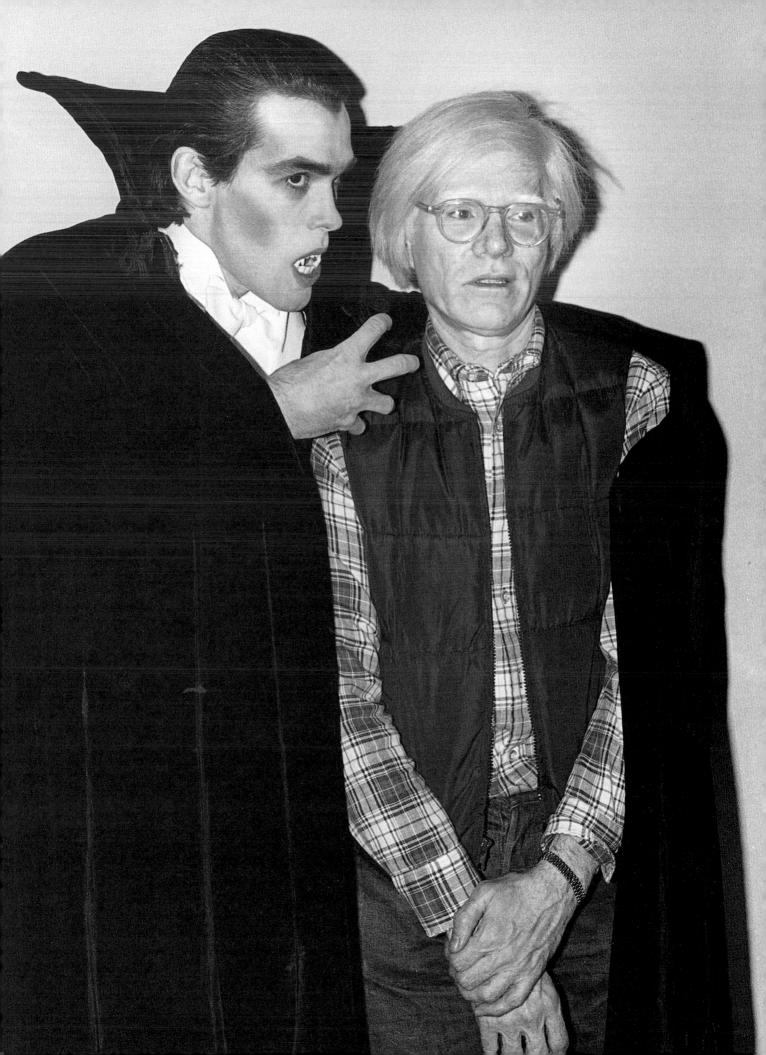

Artist's Statements

The interviewer should just tell me the words he wants me to say and I'll repeat them after him.

Andy Warhol, Kasper König, Pontus Hultén, and Olle Granath, *Andy Warhol*, 1970 (statements made in 1968), n.p.

I don't worry about art or life. I mean, the war and the bomb worry me but usually there's not much you can do about them. I've represented it in some of my films and I'm going to try and do more. Money doesn't worry me, either, though sometimes I wonder where is it? Somebody's got it all!

Ibid.

When I look at things, I always see the space they occupy. I always want the space to reappear, to make a comeback, because it's lost space when there's something in it. If I see a chair in a beautiful space, no matter how beautiful the chair is, it can never be as beautiful to me as the plain space.

My favorite piece of sculpture is a solid wall with a hole in it to frame the space on the other side.

Andy Warhol, *The Philosophy of Andy Warhol (From A to B and Back Again)*, 1975, p. 144.

Usually, all I need is tracing paper and a good light. I can't understand why I was never an abstract expressionist, because with my shaking hand I would have been a natural.

Ibid., p. 150.

During the 60s, I think, people forgot what emotions were supposed to be. And I don't think they've ever remembered. I think that once you see emotions from a certain angle you can never think of them as real again. That's what more or less has happened to me.

Ibid., p. 27.

100. Andy Warhol and Dracula at The Factory, in connection with the Myths series.
Photograph by Barbara Goldner

People's fantasies are what give them problems. If you didn't have fantasies you wouldn't have problems because you'd take whatever was there. But then you wouldn't have romance, because romance is finding your fantasy in people who don't have it. A friend of mine always says, "Women love me for the man I'm not."

Ibid., p. 55.

I always wanted to be a tap dancer, just like Betty Ford and Barbara Walters. When I was a kid not growing up in Pittsburgh, I saved my pennies, wolfed down my salt and pepper soup, and ran downtown to see every Judy Garland movie. That's why it's so great to be good friends with her daughters, Liza Minelli and Lorna Luft.

Andy Warhol, *Andy Warhol's Exposures*, 1979, n.p.

I always wanted Tab Hunter to play me in a story of my life.

Andy Warhol and Pat Hackett, *POPism: The Warhol Sixties*, 1980, p. 248.

The Factory was a place where you could let your "problems" show and nobody would hate you for it. And if you worked your problems up into entertaining routines, people would like you even more for being strong enough to say you were different and actually have fun with it.

Ibid., p. 222.

When somebody threatens me, I don't listen to them anymore.

Ibid., p. 295.

The 1980s are so much like the '60s it's sort of peculiar. Time is sort of funny. I don't understand it. Today the kids are painting the same way we did twenty years ago, like it's new to them or something. When Salvador Dali used to come around in the '60s, he thought he had done everything we were doing. We thought it was new, but we were doing things he had already done.

Interview with the author, April 23, 1980.

I go to lots of people's houses and see their art and they say, "Well, it's what I like." You still meet a lot of people like that. They just buy what they like and they don't worry about its value. But paintings are like stocks and a dealer is like a broker. Someone makes money, then there's someone else who's really good at investing in stocks, and he tells the investor what to buy. If someone tells you to go to a good gallery rather than one that's not so good, you'll get a painting that might turn out to be worth something, a painting you like that's also a good investment. It's like having a broker tell you what stocks to buy.

Ibid.

101. *Dance Diagram: Fox Trot*, 1962
Acrylic on linen, 72 x 54 in.
Courtesy Leo Castelli Gallery, New York

This country is so great. It's the only one where you can really sell your talent. Which is kind of wonderful. And it's great for young kids because, if they're really talented, they can get rich overnight.

Interview with the author, January 2, 1983.

If you're not making money with your art, you have to say it's art. If you are, you have to say it's something else.

Ibid., 1980.

START

101

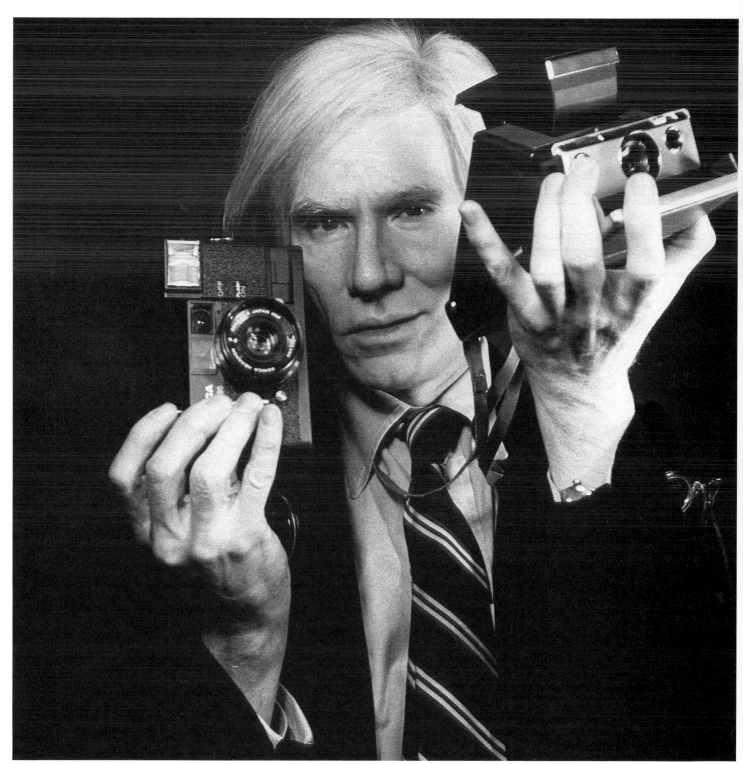

Notes on Technique

During the 1950s, when Andy Warhol worked as a commercial artist, he produced ink-on-paper images using a monotype process. He would draw on a glazed, nonabsorbent paper, which he would then press against an unglazed sheet. This transferred the ink outline, still wet, to the softer paper, creating a scratchy, blotted effect. This method was personal and impersonal at once. It preserved the stylish flair of Warhol's touch, while interposing a degree of detachment between the original drawing and the final product. Warhol could not, of course, predict exactly how the ink would blot or precisely which elements of his design might be completely lost. If the results didn't suit him, he would re-ink the original and try again. An acceptable image combined elegance with a suggestion of happy accident—the artist's hand meshing with the demands of mass production. Nearly all of Warhol's commercial designs are black on white and thus transfer to the magazine page or book jacket with a minimum of difficulty.

For his illustrated booklets and the drawings he showed in New York galleries during the 1950s, Warhol used the same process. For the books, especially, he often filled in his ink outlines with watercolor. Warhol's first Pop paintings, the comic-strip images of 1960–61, show a completely new technique. Here the artist worked on stretched canvas, first using an opaque projector to project motifs from "Popeye," "Dick Tracy," or "Nancy" onto the surface, then tracing the image with a pencil. With that outline in place, he would go over it with oil paint and brush. The next step was to fill in some of the picture's open areas with flat colors, leaving other areas blank. In these paintings, outline has the impersonality of the comic-strip source—solid, mechanically produced line. The colors often show a bit of texture, Warhol's restrained and ironic version of the Action painter's surfaces. Using thinned paint and a loaded brush, he occasionally let color drip down the canvas. These signs of process soon disappeared. By the early 1960s it was only in Warhol's pencil drawings—executed in a rough manner very different from that of his commercial art—that any personal textures persisted.

In 1962 Warhol began to make gridded paintings—row upon row

102. Andy Warhol, 1978
Photograph by Christopher Makos

111

of dollar bills, coke bottles, and other familiar images. The earliest of these were like immense sheets of stamps (*7¢ Airmail Stamp, S & H Green Stamps*), with perforations indicated by dots of paint. These canvases bring subject and technique extremely close, for Warhol applied the image to the surface with a rubber stamp. Then, in August of 1962, he abandoned this method. It "suddenly seemed too homemade. I wanted something stronger that gave more of an assembly-line effect."[1] For the Dollar Bills, the Coke Bottles, and *Handle With Care—Glass—Thank You*, he used a silkscreen technique. Though fine artists have used silkscreen printing widely in recent decades, it was developed as a low-cost commercial method. The designer stretches a porous material, either silk or fine-mesh metal screening, across a rectangular frame. Then he applies an impermeable material to the areas to be left blank in the final image. Next, the screen is lowered over the paper or fabric to be imprinted and, with a rubber blade called a squeegee, the printer forces ink through the uncovered portions of the image. This is a negative-to-positive process: filled-in areas of the screen read as blank in the resulting image, while the areas left open on the screen are covered with a layer of flat color.

Having selected an image, Warhol would send it to a commercial silkscreen shop to be transferred to a stencil by the traditional hand-cutting method. Back at the Factory, the artist and his assistants applied the stencil to canvas. In several of the Coke Bottle paintings, Warhol brushed on some brownish color first, so that the bottles look full—or, here and there, half-empty. For the Marilyn series, which came still later in 1962, he turned to photographic silkscreens. Though the same in principle as hand-cut screens, photo-screens are more complicated to produce. The first step is to transfer a photographic image to a sheet of clear acetate. Next, the craftsman lays the sheet over a screen treated with a light-sensitive material. Exposing the screen to a strong light, he then develops it, bringing out the photographic image. When the screen dries, it is ready to be used in the manner of a hand-cut stencil. Photo-screens consist of a minuscule pattern of dots, as in newspaper photos, so that it is possible to present a full range of light and dark tones. This method preserves the contours of Marilyn's face and hair, for example, which appear over flat color areas that Warhol laid on with a brush.

Ever since the Marilyn series, Warhol has nearly always used photographic silkscreens. In the series of prints called *Ladies and Gentlemen* (1975), the faces are photo-screen images, while the collage effects were applied with traditional stencils—cut by hand to follow Warhol's originals. Photographic silkscreens produce an even stronger "assembly-line effect" than hand-cut stencils do, which raises questions about Warhol's part in producing the artworks he signs. After all, his assistants sometimes brush background colors onto his canvases or perform the labor required by the screen-printing process. These are thoroughly mechanical tasks, however, which would permit none of the artist's touch to come through even if he carried them out unaided. (Warhol does supervise every step very closely and is known to be imperious in rejecting results that do not satisfy him completely.) His art consists

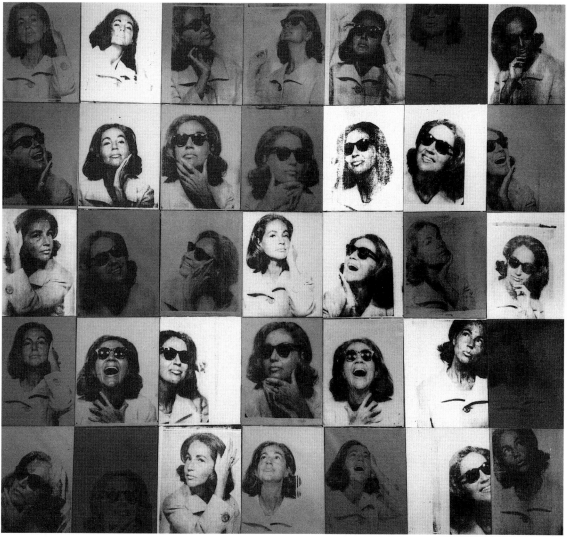

103

103. *Portrait of Ethel Scull*, 1963
Silkscreen on canvas, 35 panels, each 20 x 16 in.
Private collection

of selecting and arranging his images and colors—and, of course, he must paint a portrait background himself if it is to be brushy and expressionistic. The line drawings that began to appear in his paintings and prints in the mid-1970s are also his alone.

Paintings with more than one ground hue raise the question of register. Sometimes the photographic image matches up with the contours of the underlying color patches, though very often it does not. Especially in the 1960s, Warhol sought a slightly out-of-register look. During that decade, he would occasionally touch up the silkscreen imprint, but those emendations are rare. In some of the portraits done early in the 1970s, particularly the Mao paintings, Warhol covered an appreciable amount of the photo-image with brushwork, a practice he has abandoned in recent years.[2] Silkscreening is a mechanized process, but not an entirely predictable one—especially if the artist permits the screen to get clogged with color. In that case, the imprint is very faint. Or, if the artist lays down too much paint, the image nearly disappears under a thick smear. Warhol cultivated these accidents until the time of his

"retirement" from painting in 1965. Turning to movies, he made comparable—and equally premeditated—mistakes in his use of the 16mm. camera.

The artist is vague about the sources of his most famous images, although in some cases their origins are obvious. Warhol's Marilyns and Lizes of the mid-1960s began as movie studio publicity stills. The pictures of Elvis and Troy Donahue seem to be from fan magazines. Warhol's Mona Lisa, like Marcel Duchamp's, derives from one of the innumerable reproductions of Leonardo's painting, while the paintings and prints of Chairman Mao originated with a handout from the Chinese State Press Agency. The Disasters are from newspaper photos. Warhol's earliest portraits (the *Self-Portrait* of 1964; *Ethel Scull 36 Times*, 1963) are blow-ups of four-for-a-quarter arcade snapshots. The portraits of the 1970s and '80s are all made from Polaroid prints taken by the artist himself. Warhol has described this process as follows:

> When I do a portrait, the first thing is the make-up person puts on a sort of light make-up, so it gets rid of people's suntans and things like that. It's just to cut through the suntan. Then I start taking Polaroids. The Polaroid gets rid of everybody's wrinkles, sort of simplifies the face. I take at least five rolls. I shouldn't do that. I should only take one. A good photographer takes only two or three shots. That's how you can tell he's good. But I take lots because it's part of the whole thing. People expect it. They like it, even though it's painful—the bright lights, the flashcubes. I try to make everybody look great. A few people give me a hard time about that. They say, "Where's my big nose" or something like that, which I can't understand. But I put it back in if that's what they want.[3]

Warhol is at heart a graphic artist, and his large body of silk-screen prints—works on paper—follows directly from his paintings on canvas. In fact, a number of his images have appeared in both media. His print techniques are in many respects identical to those of his paintings. The chief difference is that the ground colors of his canvases are applied with a roller, while each hue of a work on paper is a separate silkscreen imprint. For the 712 unique images of the Sunset series (1972), Warhol used a process called a "rainbow roll," in which different colored inks appear on the paper in an endlessly varied progression. The Flowers of 1974 show the delicacy with which photo-silkscreens can be used, capturing the subtlest nuances of Warhol's ten freehand drawings. Each image appears twice on a single sheet. The artist hand colored the right-hand bouquets in pale shades of watercolor.

As is customary with graphics by a fine artist, Warhol's prints are numbered and the screens removed from circulation once an edition is published. Warhol has not been so careful with his paintings. No one, neither the artist nor his dealer, knows precisely how many examples of his early Pop images exist. The Soup Cans and Marilyns, the Flowers of 1964, and other well-known motifs of that period belong, in effect, to unnumbered editions of silkscreen prints on canvas. In Warhol's version of Pop, the ideal of the unique, handmade art object came in for cavalier treatment.

For the pioneers of the New York School, as for many of their modernist forebears, a painting was a highly particularized reflection of the artist's personal state, his historical moment, his transcendent yearnings—or all three at once. Exchanging this fun-

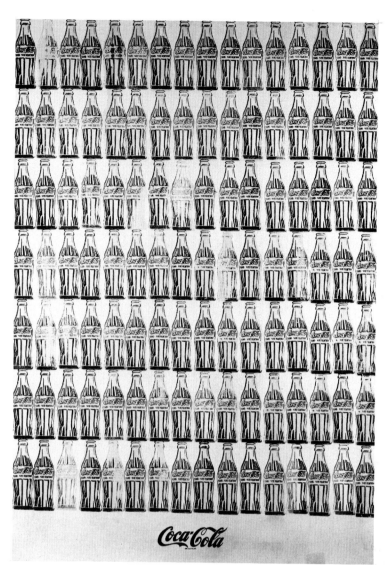

104

damentally Romantic conception of the artist for a depersonalized, even mechanical model, Warhol invented a new kind of object—the multiple painting, which permits the same image to be repeated time and time again, sometimes with shifts in size and color, sometimes not. Silkscreen technology was basic to this new kind of painting, which throws traditional ideals of originality into a relentlessly ironic light. Yet there is a further irony. Despite his mechanization of the painting process—and his stated desire to be a machine—Warhol produces images that are immediately recognizable as his. In subverting accepted techniques, he undercut the implications of his own methods. A silkscreen Marilyn by Andy Warhol is as personal in its own deadpan way as any of Willem de Kooning's Women, to choose an example from the painterly wing of the New York School with which Pop art seems, at first glance, to be at such odds.

1. Andy Warhol and Pat Hackett, *POPism: The Warhol Sixties*, p. 22.
2. Warhol recently commented about these paintings: "I thought I should change the look of the portraits in the early 1970s so I made them brushier. Some of them aren't that great. Abstract painting technique is something you just have to have intuitively." Interview with the artist, January 2, 1983.
3. Ibid.

104. *Green Coca-Cola Bottles*, 1962
Silkscreen on canvas, 83 x 57 in.
Collection of the Whitney Museum of American Art, New York
Gift of the Friends of the Whitney Museum of American Art

Chronology By Anna Brooke

1928 September 28—Andrew Warhola born in Forest City, Pennsylvania (a small town northeast of Scranton), to Ondrej (Andrew) and Julia Zavacky Warhola. (Warhol insists that a birth certificate giving a 1930 date is a forgery; in other sources the year of his birth ranges from 1929 to 1931.) Has two brothers, Paul and John, one older and one younger. His father had come to the United States from Czechoslovakia in 1912, and sent for Julia in 1921. His father works as a construction worker and later as a coal miner; he travels extensively while Andy is growing up.

Late 1930s His father goes to West Virginia to work in the coal mines.

1938–40 Andy has three nervous breakdowns.

1942 Father dies after a three-year illness. To earn money, Andy sells fruit from a truck and works in a dime store.

1945 June—graduates from Schenley High School, Pittsburgh.

1945–49 Attends Carnegie Institute of Technology, Pittsburgh. Meets Philip Pearlstein, a fellow student. Works during the summers as a window decorator for Joseph Horne department store.

1948 Art editor of the student magazine.

1949 June—graduates with a B.F.A. July—moves to New York City and shares apartment with Philip Pearlstein on St. Mark's Place off Avenue A for about eight months. Lives in an apartment with a group of people on 103rd Street and Manhattan Avenue. Uses name Warhol. Meets Tina Fredericks, art editor of *Glamour* magazine. September—drawings for "Success Is a Job in New York" and women's shoes published by *Glamour*. Does advertisements for various magazines, department stores, record companies, including Tiber Press, Columbia Records, *Vogue*, *Glamour*,

Harper's Bazaar, I. Miller, and Tiffany (until 1960). Does book jackets for New Directions. Does window displays for Eugene Moore at Bonwit Teller. Designs Christmas cards and stationery. Uses monotype process to create blotted ink line.

1950s Moves into apartment on East Seventy-fifth Street. His mother arrives and lives with him. Fritzie Miller becomes his agent. Buys a television set.

1952 June—first solo exhibition held at Hugo Gallery, New York, of drawings to illustrate stories by Truman Capote. Illustrates *Amy Vanderbilt's Complete Book of Etiquette* with Fred McCarroll and Mary Suzuki.

1953 With Ralph Ward publishes *Love Is a Pink Cake* and *A Is an Alphabet* by Corkie and Andy.

1953–55 Works for a theater group on the Lower East Side, directed by Dennis Vaughan; designs sets and becomes familiar with work of Bertolt Brecht. Dyes his hair silver about this time.

1954 Serendipity, a shop on Fifty-eighth Street, sells his drawings and books. Publishes a limited edition of *Twenty-five Cats Name* [sic] *Sam and One Blue Pussy*, printed by Seymour Berlin.

Mid-1950s Moves with his mother to a duplex at 242 Lexington Avenue between Thirty-third and Thirty-fourth streets. Has eight cats named Sam. Later moves to a house on East Eighty-seventh Street.

1955 With Ralph Pomeroy publishes *A la Recherche du Shoe Perdu*.

1956 Travels around the world with Charles Lisanby, a television set-designer. April—included in first group exhibition, *Recent Drawings U.S.A.*, held at Museum of Modern

Art, New York. Receives Thirty-fifth Annual Art Directors Club Award for Distinctive Merit, for I. Miller shoe advertisement. Publishes *In the Bottom of My Garden*.

1957 Receives Thirty-sixth Annual Art Directors Club Medal and Award of Distinctive Merit, for I. Miller shoe and hat advertisements. January—*Life* magazine publishes his illustrations in an article, "Crazy Golden Slippers." Publishes *The Gold Book*.

1959 With Suzie Frankfurt publishes *Wild Raspberries*, a joke cookbook.

1960 Makes first paintings based on comic strips: *Dick Tracy*, *Saturday's Popeye*, *Superman*, and two of Coca-Cola bottles. Fairfield Porter paints a portrait of Bob Carey and Andy Warhol.

1961 Designs window display for Lord and Taylor using the Dick Tracy comic strip. Shows work to Irving Blum and Walter Hopps of Ferus Gallery, Los Angeles. Buys drawing by Jasper Johns at Leo Castelli Gallery, New York; shows work to Ivan Karp.

1962 Makes paintings of dollar bills and Campbell soup cans. July—Irving Blum shows his paintings of soup cans at Ferus Gallery. August—makes first silkscreens and Marilyns. October—included in important exhibition of Pop art, *The New Realists*, held at Sidney Janis Gallery, New York. November—Eleanor Ward shows his paintings at Stable Gallery; exhibition creates a sensation. Begins the Disaster series.

1963 Rents studio space in a firehouse on East Eighty-seventh Street. June—meets Gerard Malanga, who becomes his assistant. Summer—buys a 16mm. movie camera. Makes his first film, *Tarzan and Jane Regained . . . Sort of*. Fall—drives to Los Angeles with Wynn Chamberlain, Taylor Mead, and Gerard Malanga for second exhibition at Ferus Gallery.

106. Andy Warhol and the Great Wall, China
Photograph by Christopher Makos

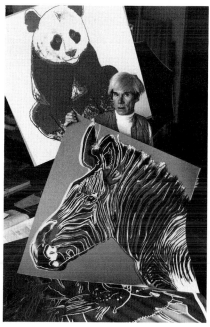

107. Andy Warhol and Endangered Species
Photograph by Christopher Makos

November—finds a loft at 231 East Forty-seventh Street, which becomes his studio, known as "The Factory." December—makes *Red Jackie*, first of Jackie series.

1964 January—shows Flower series at first solo exhibition in Europe, held at Galerie Ileana Sonnabend, Paris. Receives commission from architect Philip Johnson to make mural *Thirteen Most Wanted Men* for New York State Pavilion at New York World's Fair. April—mural is painted over for political reasons. Wins Independent Film Award from *Film Culture* magazine. September—four of his films are shown at the New York Film Festival at Lincoln Center for the Performing Arts. November—first solo exhibition held at Leo Castelli Gallery. December—makes first sound film, *Harlot*. Makes Brillo Boxes and other sculpture. Begins first Self-Portrait series. Buys first tape recorder.

1965 March—called in to arbitrate a customs dispute over importing the Brillo Boxes, staff members at the National Gallery of Canada rule that his work is not original art; as a result the Canadian Tariff Act is amended. May—goes to Paris with Edie Sedgwick, Gerard Malanga, and Chuck Wein for the Sonnabend exhibition of Cow Wallpaper; returns via Tangier. Summer—meets Paul Morrissey, who becomes his advisor and collaborator. Begins to work with video tape. October—first solo museum exhibition held at Institute of Contemporary Art, University of Pennsylvania. Announces his retirement from painting. Meets the Velvet Underground, a rock group. December—interviewed on television for "Hollywood on the Hudson."

1966 Visits San Francisco. Summer—makes film *The Chelsea Girls*, which in December becomes the first underground film to be shown in a commercial theater. April—manages and

produces a multimedia show featuring the Velvet Underground plus Nico, a German singer and actress; they are first known as the Erupting Plastic Inevitable and later as the Exploding Plastic Inevitable, and perform at the Dom, a dance hall on St. Mark's Place. Leo Castelli Gallery exhibits Cow Wallpaper and Silver Pillows.

1967 April—goes to Los Angeles for opening of *The Chelsea Girls* at Cinema Theater and to San Francisco. Spring—goes to Cannes Film Festival with *The Chelsea Girls*, but it is not shown. Six Self-Portraits are exhibited at the United States Pavilion at Expo '67, Montreal. August—goes to Los Angeles to lecture at colleges. October—Allen Midgette is hired to lecture at colleges impersonating Andy Warhol. Meets Fred Hughes, who works for the de Menils in Texas; he later becomes president of Andy Warhol Enterprises and *Interview* magazine. Moves the Factory to 33 Union Square West.

1968 February—first solo European museum exhibition held at Moderna Museet, Stockholm. Spring—with Viva and Paul Morrissey goes to the West Coast to lecture; they also film *Surfing Movie* in California. June 3—shot by Valerie Solanis, founder and sole member of S.C.U.M. (Society for Cutting Up Men). Spends nearly two months in the hospital. Creates *Clouds*, the set for *Rainforest*, a Merce Cunningham ballet.

1969 September—film *Blue Movie* ruled obscene. Fall—first issue of *Inter/View* magazine appears; John Wilcock, publisher of *Other Scenes*, is copublisher.

1970 Selects exhibition for Museum of Art, Rhode Island School of Design, Providence, *Raid the Icebox I with Andy Warhol*. Poses for portrait painter Alice Neel.

1971 *Pork*, his play, opens in London at the Round House Theater.

1972 Begins painting again. Makes primarily portraits, particularly of celebrities. Moves Factory to 860 Broadway about this time.

1975 Buys house on Lexington Avenue near Eighty-ninth Street about this time and lives there with his mother. Major retrospective exhibition of his work held at the Kunsthaus, Zurich.

1976 Does the Skulls and the Hammer and Sickle series.

1977 September—exhibition of his collection of folk art held at the Museum of American Folk Art, New York.

Late 1970s His mother dies.

1979–80 November—*Portraits of the 70s* exhibition held at the Whitney Museum of American Art. Does Reversals, Retrospectives, and Shadows series.

1980 Becomes executive producer of "Andy Warhol's TV" on cable television. Uses diamond powder in Diamond Dust Shoes.

1981 Does Myths series.

1982 Exhibits Oxidation series and paintings of Nazi architecture at Documenta 7, Kassel, Germany.

1983 Does Endangered Species series.

1985 Does Ads series.

1987 February 22—dies following surgery in New York.

Exhibitions

1977

Retrospective Exhibition of Paintings by Andy Warhol from 1962–1976, Pyramid Galleries, Washington, D.C., January 17–February 19.

Andy Warhol: The American Indian, Musée d'Art et d'Histoire, Geneva, October 28–January 22, 1978.

Athletes by Andy Warhol, Coe Kerr Gallery, New York, December 9–January 7, 1978.

1978

Athletes by Andy Warhol, Virginia Museum, Richmond, January 23–February 26.

Andy Warhol: Portraits, University Gallery, Meadows School of the Arts, Southern Methodist University, Dallas, February 19–March 19.

Andy Warhol, Kunsthaus, Zurich, May 26–July 30.

Andy Warhol Athletes, Institute of Contemporary Art, London, July.

Andy Warhol: 'Torsos,' Ace Venice, Venice, California, September 24–October 21.

Andy Warhol, Louisiana Museum, Humlebaek, Denmark, October 6–November 26.

Andy Warhol: Early Paintings, Blum-Helmann Gallery, New York, December–January 13, 1979.

1979

Andy Warhol 'Shadows,' Heiner Friedrich, New York, January 27–March 10.

Andy Warhol: 'Torsos,' Ace Gallery, Vancouver, April.

Andy Warhol Space Fruit: Still Lifes, A Suite of Serigraphs, Michael Zivian, New York, May 15–June 16.

Andy Warhol: Multiple Images: Landscape, City Spaces, Country Places, Arts Gallery, Baltimore, November 15–December 13.

Andy Warhol: Portraits of the 70s, Whitney Museum of American Art, November 20–January 27, 1980.

1980

Andy Warhol, Boehm Gallery, Palomar College, San Marcos, California, February 11–March 6.

Andy Warhol Reversals, Bruno Bischofberger Gallery, Zurich, May 14–June 11.

Joseph Beuys by Andy Warhol, Centre d'Art Contemporain, Geneva, June 7–30.

Andy Warhol: Fotografien, Museum Ludwig, Cologne, August 20–September 28.

Andy Warhol: 'Exposures'—Fotos, Stedelijk Museum, Amsterdam, August 28–October 26.

Andy Warhol: Ten Portraits of Jews of the Twentieth Century, Lowe Art Museum, University of Miami, Coral Gables, Florida, September 6–28.

Andy Warhol: Photographs, Lisson Gallery, London, September 16–October 18.

Andy Warhol: Ten Portraits of Jews of the Twentieth Century, Jewish Museum, New York, September 17–January 4, 1981.

Andy Warhol: Oeuvres récentes 'Reversal,' Daniel Templon, Paris, September 20–October 23.

Andy Warhol: Paintings and Prints, Portland Center for the Visual Arts, Portland, Oregon, September 26–November 7.

1981

Warhol '80: Serie reversal, Museum Moderner Kunst, Museum des 20. Jahrhunderts, Vienna, April 9–May 10.

Andy Warhol at Colorado State University, Colorado State University, Fort Collins, September 1–25.

Andy Warhol: Bilder 1961 bis 1981, Kestner Gesellschaft, Hannover, October 23–December 13, and tour to Städtische Gallerie im Lenbachhaus, Munich.

Andy Warhol: A Print Retrospective, Castelli Graphics, New York, November 21–December 22.

1982

Andy Warhol, Leo Castelli Gallery, January 9–30.

Andy Warhol: Dollar Signs, Daniel Templon, Paris, March 6–31.

Andy Warhol: Schweizer Portraits, Kunst Sammlung der Stadt Thun, Thun, Switzerland, June 17–August 22.

Andy Warhol: Guns, Knives, Crosses, Galerie Fernando Vijande, Madrid, December 20–February 12, 1983.

1983

Andy Warhol: Portrait Screenprints 1965–80, Wansbeck Square Gallery, Ashington, Northumberland, England, January 10–28, and tour to University of York, York; Usher Gallery, Lincoln; and Aberystwyth Arts Center, Aberystwyth, Wales. Organized by the Arts Council of Great Britain.

Warhol's Animals: Species at Risk, American Museum of Natural History, New York, April 12–May 8, and tour to Cleveland Museum of Natural History.

Selected Group Exhibitions

1956

Recent Drawings U.S.A., Museum of Modern Art, New York, April 25–August 5. Organized by the Junior Council.

1962

New Paintings of the Common Object, Pasadena Art Museum, Pasadena, California, September 25–October 19.

The New Realists, Sidney Janis Gallery, New York, October 31–December 1.

1963

Six Painters and the Object, Solomon R. Guggenheim Museum, New York, March 14–June 12.

Popular Image, Washington Gallery of Modern Art, Washington, D.C., April 18–June 2.

Popular Art: Artistic Projections of Common American Symbols, Nelson Gallery-Atkins Museum, Kansas City, Missouri, April 28–May 26.

Pop Art USA, Oakland Art Museum, September 7–29.

The Popular Image, Institute of Contemporary Art, London, October 24–November 23.

1964

Amerikanst pop-konst, Moderna Museet, Stockholm, February 29–April 12, and tour.

In Focus: A Look at Realism in Art, Memorial Art Gallery of the University of Rochester, Rochester, New York, December 28–January 31, 1965.

1965

Pop art, nouveau réalisme, Palais des Beaux-Arts, Brussels, February 5–March 1, and tour.

New American Realism, Worcester Art Museum, Worcester, Massachusetts, February 18–April 4.

Pop and Op, Sidney Janis Gallery, December 1–31.

1966

The Photographic Image, Solomon R. Guggenheim Museum, January 1–28.

Recent Still Life, Museum of Art, Rhode Island School of Design, Providence, February 23–April 4.

1967

Contemporary American Painting and Sculpture, Krannert Art Museum, University of Illinois, Champaign-Urbana, March 5–April 9.

American Painting Now, United States Pavilion, Expo '67, Montreal, April 28–October 27, and tour.

IX Bienal de São Paolo, Museu de Arte Moderna, São Paulo, Brazil, September 22–January 8, 1968.

1967 Pittsburgh International Exhibition of Contemporary Painting and Sculpture, Museum of Art, Carnegie Institute, Pittsburgh, October 27–January 7, 1968.

Annual Exhibition of Contemporary Painting, Whitney Museum of American Art, New York, December 13–February 4, 1968. Also included in 1969.

1968

Social Comment in American Art, Lawrence University, Appleton, Wisconsin, February 25–March 15, and tour. Organized by the Museum of Modern Art.

Documenta 4, Museum Fridericianum, Kassel, West Germany, June 27–October 6. Also included in 1982.

Serial Imagery, Pasadena Art Museum, September 17–October 27, and tour.

1969

Painting and Sculpture Today, Indianapolis Museum of Art, May 4–June 1. Also included in 1970.

Pop Art, Hayward Gallery, London, July 9–September 3. Organized by the Arts Council of Great Britain.

New York Painting and Sculpture: 1940–1970, Metropolitan Museum of Art, New York, October 18–February 1, 1970.

Painting in New York: 1944–1969, Pasadena Art Museum, November 24–January 11, 1970.

108. *The Kiss*, 1963
Silkscreen on paper, 30 x 40 in.
Richard L. Weisman

108

1970

Das Ding als Objekt: Europaïsche Objektkunst des 20. Jahrhunderts, Kunsthalle Nürnberg, Nuremberg, West Germany, July 10–August 30.

1971

Métamorphose de l'objet: Art et anti-art 1910–1970, Palais des Beaux-Arts, Brussels, April 22–June 6, and tour.

1972

The Modern Image, High Museum of Art, Atlanta, Georgia, April 15–June 11.

1973

Art in Space: Some Turning Points, Detroit Institute of Arts, May 15–June 24.
American Art Third Quarter-Century, Seattle Art Museum, August 22–October 14.

1974

American Pop Art, Whitney Museum of American Art, April 6–June 16.

1975

25 Stills, Whitney Museum of American Art, Downtown Branch, October 30–December 3.

1976

Twentieth-Century American Drawing: Three Avant-Garde Generations, Solomon R. Guggenheim Museum, January 23–March 21.
Seventy-second American Exhibition, Art In-

stitute of Chicago, March 13–May 9.
Zweihundert jahre amerikanische malerei 1776–1976, Rheinisches Landesmuseum, Bonn, West Germany, June 6–August 1, and tour. Organized by the International Communications Agency.
XXXVI Biennale, Venice, July 14–September.

1977

Jubilation: American Art during the Reign of Elizabeth II, Fitzwilliam Museum, Cambridge, England, May 10–June 18.

1978

Salute to Merce Cunningham, John Cage Collaborators, Thomas Segal Gallery, Boston, February 8–March 4.
Art about Art, Whitney Museum of American Art, July 19–September 24, and tour.
American Painting of the 1970s, Albright-Knox Art Gallery, Buffalo, December 8–January 14, 1979, and tour.

1979

Emergence and Progression: Six Contemporary American Artists, Milwaukee Art Center, October 11–December 2, and tour.

1980

Printed Art since 1965, Museum of Modern Art, February 14–April 1.
Pop Art: Evoluzione di una generazione, Palazzo Grassi, Venice, March–July.

The Figurative Tradition, Whitney Museum of American Art, June 25–September 28.
American Drawing in Black and White 1970–1980, Brooklyn Museum, November 22–January 18, 1981.

1981

A New Spirit in Painting, Royal Academy of Arts, London, January 13–May 18.
Contemporary American Realism since 1960, Pennsylvania Academy of the Fine Arts, Philadelphia, September 18–December 13.

1982

Joseph Beuys, Robert Rauschenberg, Cy Twombly, Andy Warhol: Sammlung Marx, National Galerie, Staatliche Museen Preussischer Kulturbesitz, Berlin, March 2–April 12.
Pop Art: Prints and Multiples, Glenbow Museum, Calgary, Canada, March 13–April 25, and tour. Organized by the Art Gallery of Ontario, Toronto.
Attitudes, Concepts, Images, Stedelijk Museum, Amsterdam, April 9–July 11.
Castelli and His Artists: 25 Years, La Jolla Museum of Contemporary Art, La Jolla, California, April 23–June 6, and tour. Organized by the Aspen Center for the Visual Arts, Aspen, Colorado.
Zeitgeist: Internationale Kunstausstellung, Martin-Gropius Bau, Berlin, October 15–December 19.

Public Collections

109

Aachen, West Germany, Neue
 Galerie-Sammlung Ludwig
Aarhus, Denmark, Aarhus Kunstmuseum
Basel, Switzerland, Kunstmuseum Basel
Boston, Massachusetts, Institute of
 Contemporary Art
Cambridge, Massachusetts, Fogg Art
 Museum, Harvard University
Chicago, Illinois, Art Institute of Chicago
College Park, Maryland, University of
 Maryland Art Gallery
Cologne, West Germany,
 Wallraf-Richartz-Museum
Darmstadt, West Germany, Hessisches
 Landesmuseum
Des Moines, Iowa, Des Moines Art Center
Detroit, Michigan, Detroit Institute of Arts
Hartford, Connecticut, Wadsworth Atheneum
Houston, Texas, Rice University
Humlebaek, Denmark, Louisiana Museum
Kansas City, Missouri, William Rockhill
 Nelson Gallery of Art and Mary Atkins
 Museum of Fine Arts
Krefeld, West Germany,
 Kaiser-Wilhelm-Museum
London, England, Tate Gallery
Los Angeles, California, Los Angeles County
 Museum of Art
Milwaukee, Wisconsin, Milwaukee Art
 Center
Minneapolis, Minnesota, Walker Art Center
Mönchengladbach, West Germany, Städtisches
 Museum Mönchengladbach
New Haven, Connecticut, Yale University Art
 Gallery
New York City, New York, Metropolitan
 Museum of Art
New York City, New York, Museum of
 Modern Art
New York City, New York, Solomon R.
 Guggenheim Museum
New York City, New York, Whitney Museum
 of American Art
Pasadena, California, Norton Simon Museum
 of Art

Philadelphia, Pennsylvania, Philadelphia
 Museum of Art
Princeton, New Jersey, Art Museum,
 Princeton University
Stockholm, Sweden, Moderna Museet
Stuttgart, West Germany, Staatsgalerie
 Stuttgart
Tehran, Iran, Museum of Contemporary Art
Tokyo, Japan, Tokyo Kokuritsu
 Hakubutsukan
Toronto, Canada, Art Gallery of Ontario
Turin, Italy, Galleria Civica d'Arte Moderna
Vienna, Museum Moderner Kunst
Waltham, Massachusetts, Rose Art Museum,

Brandeis University
Washington, D.C., Corcoran Gallery of Art
Washington, D.C., Hirshhorn Museum and
 Sculpture Garden, Smithsonian Institution
Washington, D.C., National Gallery of Art
Washington, D.C., National Museum of
 American Art, Smithsonian Institution
Zurich, Switzerland, Kunsthaus

109. *Black and White Disaster*, 1963
Acrylic and silkscreen on canvas, 96 x 72 in.
Los Angeles County Museum of Art,
Gift of Leo Castelli and Ferus Gallery, through
the Contemporary Art Council

Selected Bibliography

Interviews, Statements, and Writings

Blinderman, Barry. "Modern 'Myths': An Interview with Andy Warhol." *Arts Magazine* 56 (October 1981): 144–47.

Canaday, John. Interview in the *New York Times*, May 9, 1971, sec. 2, p. 23.

Castle, Frederick. "Occurrences: Cab Ride with Andy Warhol." *Artnews* 66 (February 1968): 46–47, 52. Interview.

Glaser, Bruce. "Oldenburg, Lichtenstein, Warhol: A Discussion." *Artforum* 4 (February 1966): 20–24. Interview.

Goldberger, Clenn; Romer, Joanna; and Lavasseur, Jan. "We Talk to Warhol." *Mademoiselle* 65 (August 1967): 325.

Kent, Leticia. "Andy Warhol: Movieman 'It's Hard to Be Your Own Script.' " *Vogue* 155 (March 1970): 167, 204. Interview.

Lyon, Ninette. "Robert Indiana, Andy Warhol. A Second Fame: Good Food." *Vogue* 145 (March 1, 1965): 184–86. Interview.

Malanga, Gerard. "A Conversation with Andy Warhol." *Print Collectors Newsletter* 1 (January–February 1971): 125–27.

Pomeroy, Ralph. "An Interview with Andy Warhol, June 1970." *Afterimage*, Autumn 1970, pp. 34–39.

Shapiro, David. "Polvere di diamanti." In *Pop Art: Evoluzione di una generazione*, exhibition catalog. Milan: Electa Editrice, 1980, pp. 131–48. Interview.

Swenson, G. R. "What Is Pop Art?" *Artnews* 62 (November 1963): 24–27, 60–63. Interview. Reprinted in John Russell and Suzi Gablik. *Pop*

Art Redefined. New York: Frederick A. Praeger, 1969. Excerpted in Barbara Rose, ed., *Readings in American Art: 1900–1975*. New York: Praeger, 1975, pp. 155–56.

Tuchman, Phyllis. "Pop! Interviews with George Segal, Andy Warhol, Roy Lichtenstein, James Rosenquist, and Robert Indiana." *Artnews* 73 (May 1974): 24–29.

Vijande, Rodrigo, and Nadaff, Alfred. "Una Interview con Andy Warhol." In *Andy Warhol: Guns, Knives, Crosses*, exhibition catalog. Madrid: Galeria Fernando Vijande, 1983, n.p.

Warhol, Andy. "Crazy Golden Slippers." *Life* 42 (January 21, 1957): 12–13.

———. "My Favorite Superstar: Notes on My Epic 'Chelsea Girls.' " *Arts Magazine* 41 (February 1967): 26. Interview with Gerard Malanga.

———. *Andy Warhol's Index Book*. New York: Random House, 1967. Contains "An Interview with Andy Warhol."

———, and Malanga, Gerard. *Screentests: A Diary*. New York: Kulchur Press, 1967.

———. *Intransit: The Andy Warhol-Gerard Malanga Monster Issue*. New York and Eugene, Ore.: Toad Press, 1968.

———. *A: A Novel*. New York: Grove Press, 1969.

———. "Dirty Half Dozen . . . An Album." *Esquire* 62 (May 1969): 144–47. Photographs by Andy Warhol.

———. *The Philosophy of Andy Warhol (From A to B and Back Again)*. New York: Harcourt, Brace, Jovanovich, 1975.

———. *Andy Warhol's Exposures*. New York:

Andy Warhol Books/Grosset and Dunlap, 1979.

———, and Hackett, Pat. *POPism: The Warhol Sixties*. New York: Harcourt, Brace, Jovanovich, 1980.

———. "An Andy Warhol Interview with Alex Kayser." In *Artists' Portraits by Alex Kayser*. New York: Harry N. Abrams, 1981, n.p.

———. Statements. In Stein, Jean, with Plimpton, George. *Edie: An American Biography*. New York: Alfred A. Knopf, 1982.

Weinraub, Bernard. "Andy Warhol's Mother." *Esquire* 66 (November 1966): 99, 101, 158. Interview.

Illustrated Books

Warhol, Andy; McCarroll, Fred; and Suzuki, Mary. *Amy Vanderbilt's Complete Book of Etiquette*. Garden City, N.J.: Doubleday and Company, 1952.

———, and Ward, Ralph. *A Is an Alphabet*. By Corkie and Andy. [New York, 1953].

———, and Ward, Ralph. *Love Is a Pink Cake*. By Corkie and Andy. [New York, 1953].

———. *Twenty-Five Cats Name* [sic] *Sam and One Blue Pussy*. [New York: Printed by Seymour Berlin, c. 1954].

———. *A la Recherche du Shoe Perdu*. [New York, c. 1955].

———. *In the Bottom of My Garden*. [New York, c. 1956].

———. *The Gold Book*. [New York, 1957].

———, and Frankfurt, Suzie. *Wild Raspberries*. [New York, 1959].

Monographs and Solo-Exhibition Catalogs

Andy Warhol, exhibition catalog. Philadelphia: Institute of Contemporary Art, University of Pennsylvania, 1965.

Andy Warhol, exhibition catalog. Zurich: Kunsthaus, 1978.

Andy Warhol Mick Jagger 1975, catalog. New York: Multiples and Castelli Graphics, 1975.

Andy Warhol Myths, catalog. New York: Ronald Feldman Fine Arts, 1981.

Aprà, Adriano. *Il Cinema di Andy Warhol*. Rome: Arcana, [1972].

Brown, Andreas, comp. *Andy Warhol: His Early Works 1947–1959*, exhibition catalog. New York: Gotham Book Mart Gallery, 1971.

Coplans, John; Mekas, Jonas; and Tomkins, Calvin. *Andy Warhol*, exhibition catalog. Greenwich, Conn.: New York Graphic Society for the Pasadena Art Museum, 1970.

Crone, Rainer. *Andy Warhol*. New York: Praeger, 1970; London: Thames and Hudson; Frankfurt am Main: Büchergilde Gutenberg. Includes catalogue raisonné.

_____ . *Andy Warhol: Das zeichnerische Werk, 1942–1975*, exhibition catalog. Stuttgart: Württembergischer Kunstverein, 1976.

_____ , and Wiegand, Winifred. *Die revolutionäre Asthetik Andy Warhols*. Darmstadt: Melzer Verlag, 1972.

Dolezal, Georg J. *Andy Warhol: Schweizer Portraits*, exhibition catalog. Thun: Kunst Sammlung der Stadt Thun, 1982.

Gablik, Suzi. *Andy Warhol: Portrait Screenprints 1965–80*, exhibition catalog. London: Arts Council of Great Britain, 1981.

Gidal, Peter. *Andy Warhol, Films and Paintings*. New York: E. P. Dutton and London: Studio Vista, 1971.

Green, Samuel Adams. *Andy Warhol*. New York: Wittenborn, 1966. Reprinted in Gregory Battcock. *The New Art*. New York: E. P. Dutton, 1966, pp. 229–34.

Haenlein, Carl. *Andy Warhol: Bilder 1961 bis 1981*, exhibition catalog. Hannover: Kestner Gesellschaft, 1981.

Haftmann, Werner, and Roters, E. Foreword to *Andy Warhol*, exhibition catalog. Berlin: Nationalgalerie und Deutsche Gesellschaft für Bildende Kunst, 1969.

Hahn, Otto. *Warhol*. Paris: Fernand Hazan, 1972. Includes statements.

Janus. *Andy Warhol: Ladies and Gentlemen*. Milan: Gabriele Mazzotta, 1975.

Koch, Stephen. *Stargazer: Andy Warhol's World and His Films*. New York: Praeger, 1973 and Paris: Editions du Chêne, 1974.

Krohg, Morten. *Andy Warhol*, exhibition catalog. Oslo: Kunstneres Hus, 1968.

Lebel, Jean-Jacques. *Warhol*, exhibition catalog. Paris: Ileana Sonnabend, 1964.

Licht, Ira. *Andy Warhol: Ten Portraits of Jews of the Twentieth Century*, exhibition catalog. Coral Gables, Fla.: Lowe Art Museum, University of Miami, 1980.

Morphet, Richard. *Warhol*, exhibition catalog. London: Tate Gallery, 1971.

Pacquement, Alfred, text, and Brownstone, Gilbert, preface. *Andy Warhol*, exhibition catalog. Paris: Musée d'Art Moderne de la Ville de Paris, 1971.

Patalas, Enno. *Andy Warhol und seine Filme: Eine Dokumentation*. Munich, 1971.

Ronte, Dieter, and Stuckey, Charles F. *Warhol '80: Serie reversal*, exhibition catalog. Vienna: Museum Moderner Kunst, Museum des 20. Jahrhunderts, 1981.

Rosenblum, Robert, and Whitney, David, ed. *Andy Warhol: Portraits of the 70s*, exhibition catalog. New York: Random House for Whitney Museum of American Art, 1979.

Salzano, Giancarlo. *Andy Warhol*. Rome: Magna, 1976.

Salzmann, Siegfried. *Kultstar Warhol Starkult*. Duisburg: Museumsverein, 1972.

Solomon, Alan. Introduction to *Andy Warhol*, exhibition catalog. Boston: Institute of Contemporary Art, 1966.

Vijande, Rodrigo, and Nadaff, Alfred. *Andy Warhol: Guns, Knives, Crosses*, exhibition catalog. Madrid: Galeria Fernando Vijande, 1983. Includes interview.

Warhol, Andy; König, Kasper; Hultén, Pontus; and Granath, Olle, eds. *Andy Warhol*, 3rd ed. Boston: Boston Book and Art Publisher, 1970. Catalog for the exhibition at the Moderna Museet, Stockholm, 1968. Includes statements.

Wilcock, John. *The Autobiography and Sex Life of Andy Warhol*. New York: Other Scenes, 1971.

Wünsche, Hermann. *Andy Warhol: Das Graphische Werk 1962–1980*. Cologne: Bonner Universitat Buchdrukerei, 1980[?]. Distributed by Castelli Graphics. A catalogue raisonné of Warhol's prints.

Periodicals, Books, and Group-Exhibition Catalogs

Alloway, Lawrence. *American Pop Art*. New York: Collier Books in association with the Whitney Museum of American Art, 1974, pp. 104–14.

Antin, David. "Warhol: The Silver Tenement." *Artnews* 65 (Summer 1966): 47–49, 58–59. Review of exhibition at Leo Castelli Gallery.

Battcock, Gregory. "An Art Your Mother Could Understand." *Art and Artists* 5 (February 1971): 12–13.

_____ . "Andy Warhol: New Predictions for Art." *Arts Magazine* 48 (May 1974): 34–37.

Bergin, Paul. "Andy Warhol: The Artist as Machine." *Art Journal* 26 (Summer 1967): 359–63.

Bourdon, David. "Plastic Man Meets Plastic Man." *New York* 2 (February 10, 1969): 44–46. Warhol and Les Levine's *Star Machine*.

_____ . "Andy Warhol and the Society Icon." *Art in America* 63 (January 1975): 42–45.

_____ . "Andy Warhol: Flower." *Arts Magazine* 50 (November 1975): 86–87. Review of exhibition of flower drawings at Locksley Shea Gallery, Minneapolis.

Canaday, John. "Art: Huge Andy Warhol Retrospective at Whitney." *New York Times*, May 1, 1971, p. 21.

_____ . "Brillo Boxes, Red Cows, and the Great Soup Manipulation . . ." *New York Times*, May 9, 1971, sec. 2, p. 23. Review of exhibition at the Whitney Museum of American Art.

Carroll, Paul. "What's a Warhol?" *Playboy* 16 (September 1969): 132–34, 140, 278–82.

Coplans, John. "Early Warhol." *Artforum* 8 (March 1970): 52–59.

_____ . "Andy Warhol and Elvis Presley: Social and Cultural Predictions of Warhol's Serial Image." *Studio International* 181 (February 1971): 49–56.

Deitch, Jeffrey. "The Warhol Product." *Art in America* 68 (May 1980): 9–13.

Fagiolo dell'Arco, Maurizio. "Warhol: The American Way of Dying." *Metro* 14 (June 1968): 72–79.

Field, Simon. "Marilyn, Andy, and Mao." *Art and Artists* 7 (February 1973): 38–41.

Fitzsimmons, James. "Irving Sherman, Andy Warhol." *Art Digest* 26 (July 1952): 19. Review

of drawing exhibition at Hugo Gallery.

Gardner, Paul. "Gee, What's Happened to Andy Warhol?" *Artnews* 79 (November 1980): 72–77. Includes statements.

Geldzahler, Henry. "Andy Warhol." *Art International* 8 (April 1964): 34–35.

Gidal, Peter. "Problems 'Relating to' Andy Warhol's 'Still Life 1976.' " *Artforum* 16 (May 1978): 38–40.

Gilles, Xavier. "Warhol, Mao, Warhol, Mao." *Oeil* 226 (May 1974): 26–29. Review of exhibition at Musée Galliera. Includes statements.

Glueck, Grace. "Art Notes: Boom?" *New York Times*, May 10, 1964, p. 19. Review of exhibition at Stable Gallery.

————. ". . . Or, Has Andy Warhol Spoiled Success?" *New York Times*, May 9, 1971, sec. 2, p. 23. Review of exhibition at the Whitney Museum of American Art.

Guest, Barbara. "Warhol and Sherman." *Artnews* 51 (September 1952): 47. Review of drawing exhibition at Hugo Gallery.

————. "Clarke, Rager, Warhol." *Artnews* 53 (June 1954): 75. Review of drawing exhibition at Loft Gallery.

Hess, Thomas B. "Andy Warhol." *Artnews* 63 (January 1965): 11. Review of exhibition at Leo Castelli Gallery.

Hopkins, Henry T. "Andy Warhol: Ferus Gallery." *Artforum* 1 (September 1962): 15.

Hughes, Robert. "King of the Banal." *Time* 106 (August 4, 1975): 65–66.

————. "The Rise of Andy Warhol." *New York Review of Books* 29 (February 18, 1982): 6–10. Review of *Andy Warhol: Das Graphische Werk 1962–1980*, by Hermann Wünsche, and an exhibition at Castelli Graphics.

Johnson, Ellen H. "The Image Duplicators—Lichtenstein, Rauschenberg, Warhol." *Canadian Art* 23 (January–February 1966): 12–19.

Josephson, Mary. "Warhol: The Medium as Cultural Artifact." *Art in America* 59 (May–June 1971): 40–46.

Judd, Donald. "Andy Warhol." *Arts Magazine* 37 (January 1963): 49. Review of exhibition at Stable Gallery.

Koch, Stephen. "Warhol." *New Republic* 160 (April 26, 1969): 25–27.

————. "The Once-Whirling Other World of Andy Warhol." *Saturday Review World* 1 (September 25, 1973): 20–24.

110

Kozloff, Max. "Abstract Attrition." *Arts Magazine* 39 (January 1965): 47–50. See p. 50. Review of exhibition at Leo Castelli Gallery.

————. "Andy Warhol and Ad Reinhardt: The Great Acceptor and the Great Demurrer." *Studio International* 181 (March 1971): 113–17. Reply by Jeanne Siegel, *Studio International* 182 (July 1971): 4. Includes statement.

Kramer, Hilton. "Andy's 'Mao' and Other Entertainments." In *The Age of the Avant-Garde*. New York: Farrar, Straus and Giroux, 1973, pp. 538–42.

Kroll, Jack. "Raggedy Andy." *Newsweek* 86 (September 15, 1975): 67–69.

Lawson, Thomas. "Andy Warhol." *Artforum* 20 (April 1982): 75.

Leider, Philip. "Saint Andy: Some Notes on an Artist Who for a Large Section of a Younger Generation Can Do No Wrong." *Artforum* 3 (February 1965): 26–28. Includes Larry Bell. "From a Statement Written by Larry Bell in September 1963, upon First Seeing an Exhibition of Warhol's Work." Reprinted in John Russell and Suzi Gablik. *Pop Art Redefined*. New York: Frederick A. Praeger, 1969, pp. 115–16. Excerpted in Barbara Rose, ed. *Readings in American Art: 1900–1975*. New York: Praeger, 1975, pp. 175–76.

Leonard, John. "The Return of Andy Warhol."

New York Times Magazine, November 10, 1968, pp. 32–33, 142–51. Includes statements.

Livingston, Jane. "Andy Warhol." In *A Report on the Art and Technology Program of the Los Angeles County Museum of Art, 1967–1971*. Los Angeles: Los Angeles County Museum of Art, 1971, pp. 330–37.

Masheck, Joseph. "Warhol as Illustrator: Early Manipulations of the Mundane." *Art in America* 59 (May–June 1971): 54–59.

Pavlov, L. "Andy Warhol's 'Factory' of Modernism." *Studio International* 184 (November 1972): 159–60. Translation and reprint from *Literaturnaya Gazeta* (Moscow) 24 (June 14, 1972).

Perreault, John. "Andy Warhol." *Vogue* 155 (March 1970): 164–67, 204–6.

————. "Andy Warhola: This Is Your Life." *Artnews* 69 (May 1970): 52–53, 79–80. Reply by John Coplans, *Artnews* 69 (September 1970): 6. Includes statements.

Pincus-Witten, Robert. "Turner, Museum of Modern Art; Andy Warhol, Leo Castelli Gallery." *Artforum* 4 (June 1966): 52–54.

110. *Rauschenberg*, 1963
Silkscreen on canvas, 82 x 82 in.
Private collection

125

Plagens, Peter. "The Story of 'A.'" *Artforum* 14 (February 1976): 40–42.

Pomeroy, Ralph. "The Importance of Being Andy Andy Andy." *Art and Artists* 5 (February 1971): 14–19.

Preston, Stuart. "Art: North of the Border." *New York Times*, December 5, 1959, p. 20. Review of exhibition at Bodley Gallery.

Ratcliff, Carter. "Starlust: Andy's Photos." *Art in America* 68 (May 1980): 120–22. Review of *Andy Warhol's Exposures*.

Rosenberg, Harold. "The Art World: Art's Other Self." *New Yorker* 47 (June 12, 1971): 101–5.

Rublowsky, John. *Pop Art*. New York: Basic Books, 1965, pp. 108–27.

Schjeldahl, Peter. "Warhol and Class Content." *Art in America* 68 (May 1980): 112–19.

"Soup's On." *Arts Magazine* 39 (May–June 1965): 16–18. Statements by Ivan Karp made at a meeting of the Society of Illustrators.

Stanton, Suzy. "Warhol at Bennington." *Art Journal* 22 (Summer 1963): 237–39. Includes statements.

Stein, Jean, with George Plimpton. *Edie: An American Biography*. New York: Alfred A. Knopf, 1982.

Stuckey, Charles F. "Andy Warhol's Painted Faces." *Art in America* 68 (May 1980): 102–11. Review of exhibition at the Whitney Museum of American Art.

————. "Warhol Backwards and Forwards." *Flashart* 101 (January–February 1981): 10–18. Reprinted in *Warhol '80: Serie reversal*, exhibition catalog. Vienna: Museum Moderner Kunst, Museum des 20. Jahrhunderts, 1981.

Swenson, G. R. "Andy Warhol." *Artnews* 61 (November 1962): 15. Review of exhibition at Stable Gallery.

Thorpe, Lynn Teresa. "Andy Warhol: Critical Evaluation of His Images and Books." Ph.D. dissertation, Cornell University, Ithaca, N.Y., 1980.

Tillim, Sidney. "Andy Warhol." *Arts Magazine* 38 (September 1964): 62. Review of exhibition at Stable Gallery.

Tomkins, Calvin. "The Art Incarnate." *New Yorker* 56 (May 5, 1980): 114–18.

Tyler, Parker. "Andy Warhol." *Artnews* 55 (December 1956): 59. Review of exhibition at Bodley Gallery.

Vance, Ronald. "Andy Warhol's 'Drawings for a Boy-Book'. . . ." *Artnews* 55 (March 1956): 55. Review of exhibition at Bodley Gallery.

Wirth, Günther. "Andy Warhol: Das zeichnerische Werk, 1942–1975." *Kunstwerk* 29 (June 1976): 31–32.

Films about Warhol

Andy Warhol, Roy Lichtenstein. Directed and produced by Lane Slate. National Educational Television and Radio Center, 1966. 16mm.

Super-Artist. Bruce Torbet Films, 1967. 16mm.

Films by Warhol

1963

Tarzan and Jane Regained. . . Sort of. 2 hours, b/w, sound.
Kiss. 50 minutes, b/w, silent.
Sleep. 6 hours, b/w, silent.
Andy Warhol Films Jack Smith Filming "Normal Love." 3 minutes, color, silent.
Dance Movie (also known as *Roller Skates*). 45 minutes, b/w, silent.
Haircut. 33 minutes, b/w, silent.
Eat. 45 minutes, b/w, silent.
Salome and Delilah. 30 minutes, b/w, silent.

1964

Batman Dracula. 2 hours, b/w, silent.
Empire. 8 hours, b/w, silent.
Henry Geldzahler. 100 minutes, b/w, silent.
Couch. 40 minutes, b/w, silent.
Shoulder. 4 minutes, b/w, silent.
Mario Banana. 4 minutes, b/w, silent.
Harlot. 70 minutes, b/w, sound.
The Thirteen Most Beautiful Women. 40 minutes, b/w, silent.
Soap Opera (also known as *The Lester Persky Story*). 70 minutes, b/w, silent.
Taylor Mead's Ass. 70 minutes, b/w, silent.

1965

The Thirteen Most Beautiful Boys. 40 minutes, b/w, silent.
Fifty Fantastics and Fifty Personalities. Time unknown, b/w, silent.
Ivy John. 35 minutes, b/w, sound.
Suicide. 70 minutes, color, sound.
Screen Test #1. 70 minutes, b/w, sound.
Screen Test #2. 70 minutes, b/w, sound.
The Life of Juanita Castro. 70 minutes, b/w, sound.
Drunk. 70 minutes, b/w, sound.
Horse. 105 minutes, b/w, sound.
Poor Little Rich Girl. 70 minutes, b/w, sound.
Vinyl. 70 minutes, b/w, sound.
Bitch. 70 minutes, b/w, sound.
Restaurant. 35 minutes, b/w, sound.

Kitchen. 70 minutes, b/w, sound.
Prison. 70 minutes, b/w, sound.
Face. 70 minutes, b/w, sound.
Afternoon. 105 minutes, b/w, sound.
Beauty #2. 70 minutes, b/w, sound.
Space. 70 minutes, b/w, sound.
Outer and Inner Space. 70 minutes, b/w, sound.
My Hustler. 70 minutes, b/w, sound.
Camp. 70 minutes, sound.
Paul Swan. 70 minutes, color, sound.
Hedy (also known as *The Most Beautiful Woman in the World*, *The Shoplifter*, or *The Fourteen Year Old Girl*). 70 minutes, b/w, sound.
More Milk Yvette (also known as *Lana Turner*). 70 minutes, b/w, sound.
Lupe. 70 minutes, sound.

1966

The Velvet Underground and Nico. 70 minutes, b/w, sound.
Bufferin (also known as *Gerard Malanga Reads Poetry*). 35 minutes, b/w, sound.
Eating Too Fast (also known as *Blow-Job #2*). 70 minutes, b/w, sound.
The Chelsea Girls. 3 hours, 15 minutes, color and b/w, sound.
******. (also known as *Four Stars*). 25 hours, color, sound. Includes over thirty reels of film with various titles including *Group One, Sunset Beach on Long Island, High Ashbury, Tiger Morse, International Velvet, Alan and Dickin, Imitation of Christ, Courtroom, Gerard Has His Hair Removed with Nair, Katrina Dead, Sausalito, Alan and Apple*.

1967

The Loves of Ondine. 86 minutes, color, sound.
I, a Man. 100 minutes, b/w, sound.
Bike Boy. 96 minutes, color, sound.
Nude Restaurant. Time unknown, color, sound.
Lonesome Cowboys. 110 minutes, color, sound.

1968

From 1968 on, all Warhol films were directed by Paul Morrissey.
Blue Movie. 90 minutes, color, sound.
Flesh. 105 minutes, color, sound.

1970

Trash. 103 minutes, color, sound.

1972

Women in Revolt. 97 minutes, color, sound.
Heat. 100 minutes, color, sound.

1973

L'Amour. 90 minutes, color, sound.

1974

Andy Warhol's Dracula. 90 minutes, color, sound.
Andy Warhol's Frankenstein. 95 minutes, color, sound, 3-D.

Index